Behind the Lens

CONSTABLE

First published in Great Britain in 2019 by Constable

1 3 5 7 9 10 8 6 4 2

A CIP catalogue record for this book
is available from the British Library.

ISBN: 978-1-47213-028-0

Designed by Sian Rance at D. R. ink
Printed and bound in Italy by L.E.G.O. SpA

Papers used by Constable are from well-managed forests and other responsible sources.

Constable
An imprint of
Little, Brown Book Group
Carmelite House
50 Victoria Embankment
London EC4Y 0DZ

An Hachette UK Company
www.hachette.co.uk

www.littlebrown.co.uk

Behind the Lens

My Life

David Suchet

CONSTABLE

For Sheila

Contents

Introduction

I've been asked, several times, if I would ever consider writing my autobiography. I have, I admit, been tempted, but not sufficiently so to actually put pen to paper, until now. I suppose the nearest I've got so far was writing the book *Poirot and Me* with Geoffrey Wansell. But that was very much about one specific time in my life: my twenty-five years as Poirot.

Behind the Lens is not the kind of autobiography in which we start at my birth and move chronologically through every year of my life. 'Then I did this' and 'Then I did that'. That kind of autobiography doesn't interest me. Yes, I want you to know about my family, past and present, about my education, career and interests, and stories from my life as an actor. But I also want you to know about me as a person; I want you to see the world through my eyes.

My grandfather, celebrated Fleet Street press photographer James Jarché, told me that the best lens through which anyone can view any subject is the one that God has given you: your eye. Consequently, everyone sees life according to their own likes, or dislikes. A photographer is no different; they use a camera to capture particular images, according to his – or her – personality

and take on the world. Understanding how I see the world – what does David Suchet like to look at? What does David Suchet react to emotionally? – seeing the world from behind the lens, my lens, you will get to know me.

You will learn how I really feel about things – how I really see things – my London upbringing and love of the city, my Jewish roots and how they have influenced my career, the importance of my faith, how I feel about fame, my love of photography and music, and my processes as an actor. And, of course, we'll dig a little deeper on Poirot and how I feel about him now.

I hope you enjoy learning more about me, David Suchet, from behind the lens.

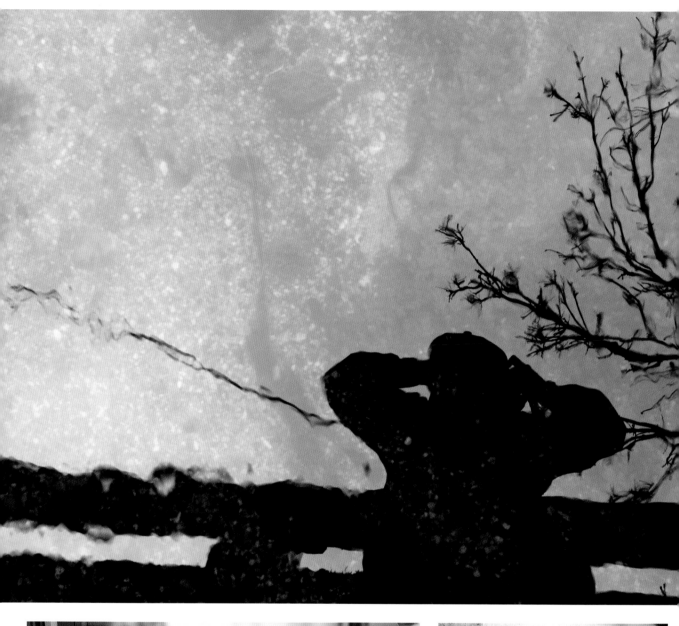

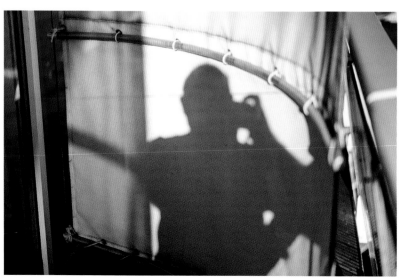

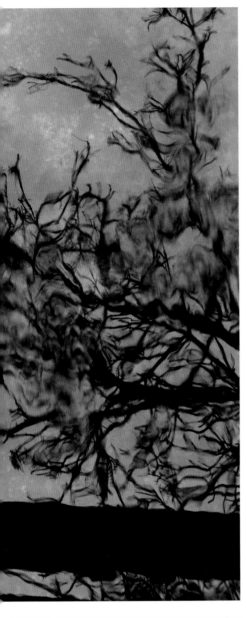
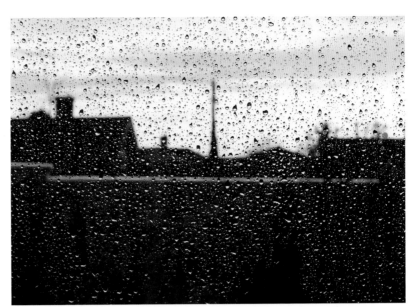
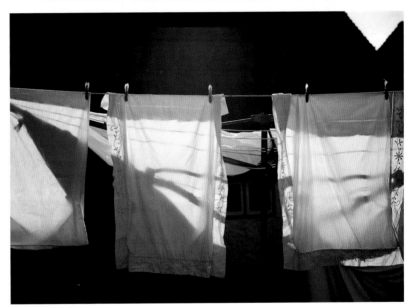

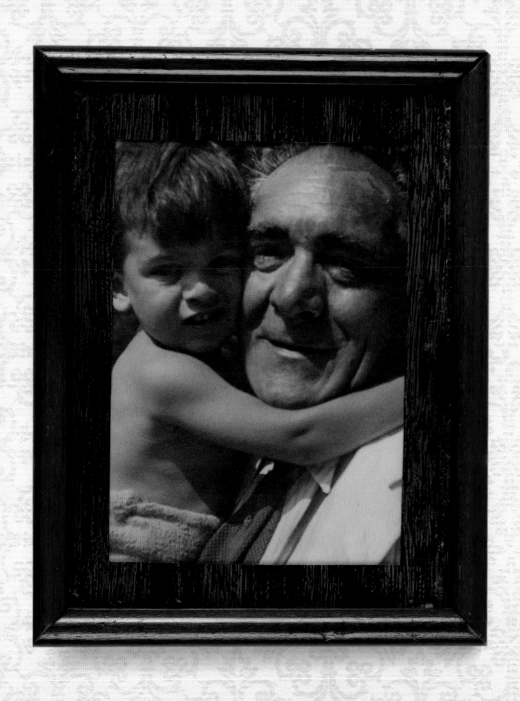

Family: part i

Let me start with my maternal grandfather, James Jarché, Jimmy, as he liked to be known, and my relationship with him. If I go back very far, right to my earliest memories, the first thing I remember is his smell, a comforting, warming smell. And his smell was that of a particular pipe tobacco that he always loved; it was Balkan Sobranie, which was a blend of three tobaccos, including the dark Syrian 'latakia'. Later on in life, when I used to get his pipe tobacco for him, I always had to make sure that I also got Three Nuns tobacco, as that's what he mixed it with; he mixed it on a table, and would always ensure it was two-thirds Balkan Sobranie to one-third Three Nuns. That particular smell was on all his clothes and whenever I now smell it – which you hardly ever do, because not many people smoke pipes any more – it takes me right back to my time with him.

Jimmy was very physical with me, in that he held me a lot as a child, my arms tightly wound around his neck. I can't remember doing much of that with my dad. And as I grew up, and developed, I used to tell Jimmy things that I knew I couldn't talk about with Dad, because Dad was a different sort of person. He was removed and distant and not a very emotional man. Jimmy and I were incredibly close, in a way that my father and I never were. He was almost my surrogate father, and I adored him. To this day, I keep a little photo of him close by, which I look at almost daily.

Jimmy had been born in Rotherhithe in 1890. His father used to photograph dead bodies pulled from the Thames for the police. Jimmy used to help him, and that developed his love of photography. He went on to become a press photographer, later a very celebrated one, best known for taking the very first photographs of Edward VIII and the then-unknown Wallis Simpson in a nightclub. Jimmy was a real East Ender; he became the world champion at 'catch-as-catch-can' wrestling. He was tough. As a press photographer

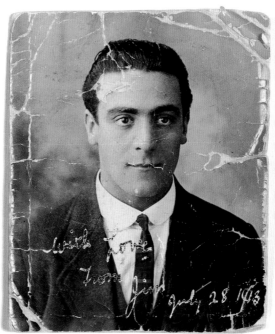

Jimmy

in those days, you had to be. It wasn't 'paparazzi', as such, but he was a newsman, so he had to fight for his stories.

It was Jimmy who introduced me to photography, my dearest hobby – by the time I was eight, he was already teaching me everything he knew. Those discussions about photography are really what brought Jimmy and me together. Later in life – I used to drive him around after he retired – he lectured for Ilford Photos, the title of his talk being 'People I Have Shot'. That became the name of a documentary that I did for ITV in 2012, in which I recreated some of Jimmy's photographs. The idea of the film was to celebrate Jimmy's career, and to highlight the great change Britain has undergone in the last one hundred years.

Making *People I Have Shot* was very emotional for me, because I was entering my grandfather's world and trying to find the exact places where he stood so that I'd be able to take a similar photograph myself. I've kept many of my reproductions to this day. It doesn't really matter too much to me what they are of, or where they were taken; they're just interesting images that

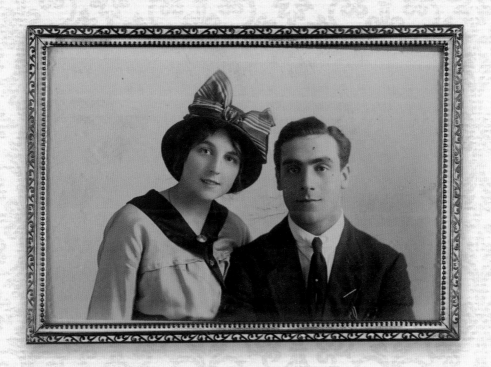
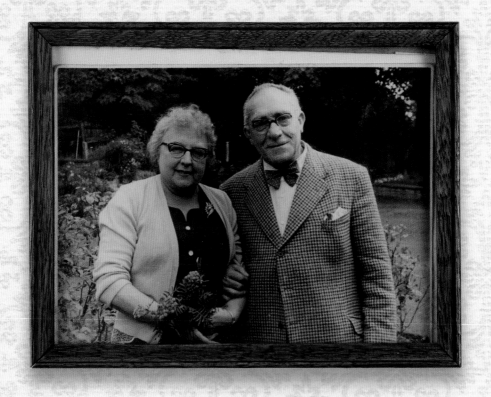

are special to me because he photographed them first. There's a street scene out in Wales that took me an hour to recreate. The director was going, 'Come on, where did he stand? Where did he stand?' And in the end, we realised he'd put a pair of stepladders on a narrow ledge on a wall. Because he was a little bit taller than me, I couldn't get the height, so I had to ask, 'Have you got a chair or a taller pair of stepladders?' And then we had it. That's what he would've done. I was entering his world and it gave me a further understanding of him.

He always used to sleep with a suitcase packed under the bed, in case the editor rang him in the middle of the night to say, 'You're off. There's a story.' And something I always remember him saying to me was, 'Always go out with a camera. Never, ever go out without it, and whatever camera you have, just shoot what you react to.' That's my style of photography, thanks to him.

I hope I've equally inherited his philosophy on life and his ability to be able to talk to people from any level of society. He adored people. He once said he would have loved to have been an actor, but he wouldn't have known how to go about it. But – much more than I do – if he went to a party, he would suddenly become the centre of attention, telling stories about this, that and the other. He would meet so many people from so many different walks of life that he always had a good story to tell.

He was able to chat to Queen Elizabeth the Queen Mother; to politicians and prime ministers; to theatre writers like George Bernard Shaw and to celebrated actors. Equally, he could talk to miners after they'd come up from the mine and were washing in a tin bath in their two-room cottage; or to somebody begging in the street: he would sit down next to them and just have a chat, ask them if they were all right and could he help, things like that. This has had a huge impact on my own life, and it's also given me my attitude to the level of fame I have enjoyed

Jimmy and Elsie

as an actor. I may have had a wonderful career, but I make sure that I don't reject anybody. That's Jimmy, and that's Jimmy's influence on me.

He was warm, was Jimmy, a very warm person. I'd like to think I'm a warm person too, rather than standing aloof. I don't like that in people. It makes me feel very insecure when I'm with someone like that. I always feel they're judging. I want to be there for everybody or anybody. That's Jimmy. It's fair to say he's been the greatest influence on my life; not just my early years, but right through to this very day.

One of my fondest memories is going on holiday with Jimmy and his wife – my grandmother – Elsie Jezzard, for their fiftieth wedding anniversary, their Golden Anniversary, in 1964. We were in Italy. I can't quite remember where exactly, but I remember them walking ahead of me, holding hands. If only I'd had my camera. That's the image of my grandparents that I still now remember, almost as much as anything else: the back of them, just holding hands, on their fiftieth wedding anniversary. It was very evocative; very, very evocative. They were always so close, even in old age. It makes me well up when I think about it.

There's a lovely story about how my grandparents met. Jimmy was living in Rotherhithe at the time, and one evening he went with some friends to the Hackney Empire for a spot of musical entertainment. The acts that evening included one called The Sisters Robertson, starring my grandmother, Elsie, who did what was called a 'soft-shoe shuffle'. She would also sing and dance to violin music played by her acting partner. Anyway, Jimmy was enchanted by the beautiful young Elsie and wanted to meet her. I suppose today he'd be called a 'Stage Door Johnny', because he went around to the back of the theatre and waited for her to come out. A bit of a Cockney was my Jim – what some might call a wide boy – and he said, 'Would you like to come for a drink, duck?' in his

lovely London accent. Well, she looked at him and said – how shall I put it? – something that wasn't very nice, basically telling him to go away. But he was not to be deterred. He came around to the stage door of the Hackney Empire every single night: Monday, Tuesday, Wednesday, Thursday, Friday, each time getting exactly the same reaction.

On the final night, he hired, so he told me, a white tie, tails and a top hat, and waited again by the stage door. He also got hold of a red rose. And when Elsie came out of the stage door, he pushed the rose in front of her, and said, 'This is the last time I'm ever going to ask you for a drink, and this is the last chance you'll have to say yes.' Well, she was so knocked out by the effort he'd made that she said, 'All right, all right, just one drink.' So they went to the pub next door, which is still there today, right next to the Hackney Empire, and had a drink, and the rest is history: they ended up getting married. And without that relationship, of course, I wouldn't be here.

My grandmother Elsie was also the most wonderful character. Before marrying Jimmy, Elsie was a musical performer and an actress. She appeared in the music hall, as well as in pantos and the odd play. She used to be the principal boy in local pantomimes. 'Her legs started by her ears,' Jimmy always used to say. 'She was gorgeous, just gorgeous.' Elsie was playing in *Aladdin* up in Scotland right before her wedding day to Jimmy. On the train back down to London, her theatre company filled her train carriage with roses and waved her off with a 'See you next season!' Of course, because of her marriage, she never trod the boards again. But she was so proud that she had done it.

Elsie had a London/Kent accent, was always in her hairnet and rollers and always with a little cigarette hanging out of the corner of her mouth. When I went to drama school myself, I wanted to know more about her time on the stage. So I knocked on her door one day – she and Jimmy lived in

a flat at the top of our house at that time – and there she was, in her dressing gown, hairnet and rollers, cigarette in place. 'Oh, hello, duck,' she said. I explained that now I was at drama school, I wanted to know more about her time in entertainment, what she'd done, and so on, because I didn't really know anything about it. 'Oh, dontcha? Cor blimey,' she said, and proceeded to show me all her scrapbooks, which included write-ups of every performance she'd ever done, even when she was a child.

'But what did you do in the music hall?' I asked. 'I was a sand dancer,' she replied. 'What's that?' I wanted to know. 'Well, I had a big tray filled with sand. I'd hop into it and do the soft-shoe shuffle and then start singing with me partner.' 'I just don't understand!' I cried. I just couldn't picture it at all. 'Cor blimey, all right, I'll show you then.' She took the cigarette out of her mouth and put it on the cooker so that it wouldn't go out. Then she took a big bag of granulated sugar, emptied the whole thing out on to her lino kitchen floor. And she stood on the floor, in the sugar, and showed me the soft-shoe shuffle. It's similar to tap dancing but, of course, sliding on sand (or in this case, sugar), so it makes a lovely swishy noise. Aged seventy-four!

When she'd finished her little intro, she continued dancing in the rhythm and also began to sing, her face instinctively turned upwards, towards the gods. I can't tell you what a heartwarming moment between my grandmother and me that was. She was quite a girl. Both Jimmy and Elsie were very, very dear to me, and I still miss them hugely.

I was lucky to have Jimmy and Elsie until I was a young man. I think of my own young grandchildren, all under five, and I'm seventy-three. Everyone does things later in life today, including having a family. And it's such a shame, because I would like to give my own grandkids another fifteen to twenty years of real cognitive life. If the powers that be give me

> She took the cigarette out of her mouth . . . took a big bag of granulated sugar, emptied the whole thing out on to her lino kitchen floor. And she stood . . . in the sugar, and showed me the soft-shoe shuffle.

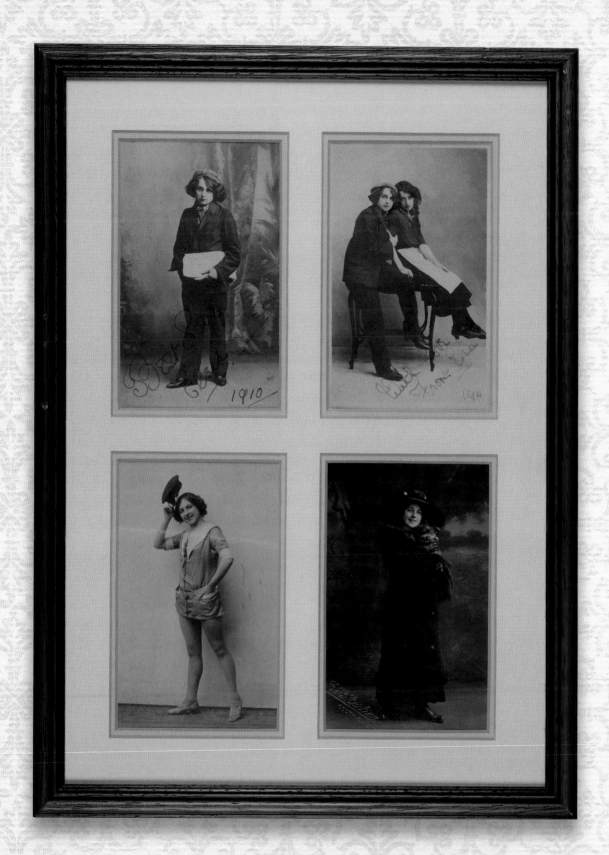

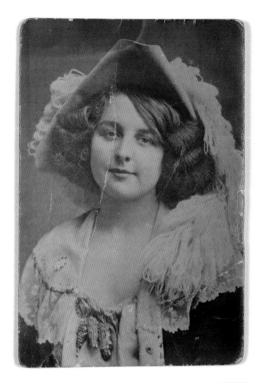

Mum & partner
"The Sisters
Robertson"

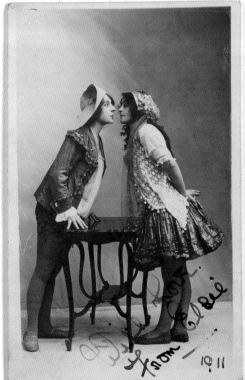

"Tivoli"
Manchester

Dearest Mem & Dad
Have arrived
at about safe
a sound. Will write
better tomorrow,
I am so tired not
left Co till Sat. night
at 10 o'clock finish
Mon- York this night
have not faced room
yet. Love Elsie

Mrs W. Jezzard
"Bay Tree"
Vicarage ...
Stratford
London E

Elsie in The Sisters Robertson

sufficient longevity, I'd like to give them a true sense of their grandparents that they can hold on to in the future. Maybe I could influence them a little bit, just as Jimmy and Elsie influenced me.

It's not the candlelit dinners or the holidays that make a marriage work, it's the ability to climb over the hills together.

I talk about my grandparents because my relationship with them was so important to me. Because I was sent to boarding school at the age of eight, my relationship with my family, until I left school at eighteen, became a holiday relationship. Coming home from boarding school, there would always be my grandparents and there would always be Mum, but my dad, being a gynaecologist and obstetrician, was hardly ever at home. When he did come home, his appearances were always brief; he used to come in and have a huge meal at, say, six o'clock, and then dash out again. We hardly saw him, not even at Christmas.

When we reached a certain age, my brothers John and Peter and I used to join him on his rounds, but Dad never talked to us about things. He really was a workaholic. A brilliant man, brilliant surgeon, brilliant doctor, and he could talk to anybody in his consulting rooms, but not outside his consulting rooms. So we never saw that side of him at home.

My mother, however, was my grandfather's daughter; she had his personality. So I was very close to Mum, used to share everything with her about things that happened at school; when we got punished, or that kind of thing. I couldn't talk about that with Dad, but I could with Mum and I could with Jimmy. So, my relationship with my parents was very different. I don't want to seem too cold about my father, but I really don't feel I had a father/son relationship with him.

Irrespective of the distance I felt from my father, family was the single most important influence in my early childhood, and family remains, without a doubt, the single most important thing in my life now, particularly since I met my wife Sheila

and started my own family. I really believe in marriage and I really believe in family. When I think of family, I like to think of a pair of horses pulling a carriage. The pair of horses are the husband and wife and they're joined by a harness, and pulling a carriage. That carriage represents the children and, together, the horse and carriage represent family.

If, at any point, the horses should split and run away, the people who will end up suffering are the people in the carriage. That's the way I look at it. Sheila and I have what we call a 'rep mentality', because we started with absolutely nothing, and we used to save up for everything. For the best part of twenty years, that was how it was. It's not the candlelit dinners or the holidays that make a marriage work, it's the ability to climb over the hills together. Family will always come first for me.

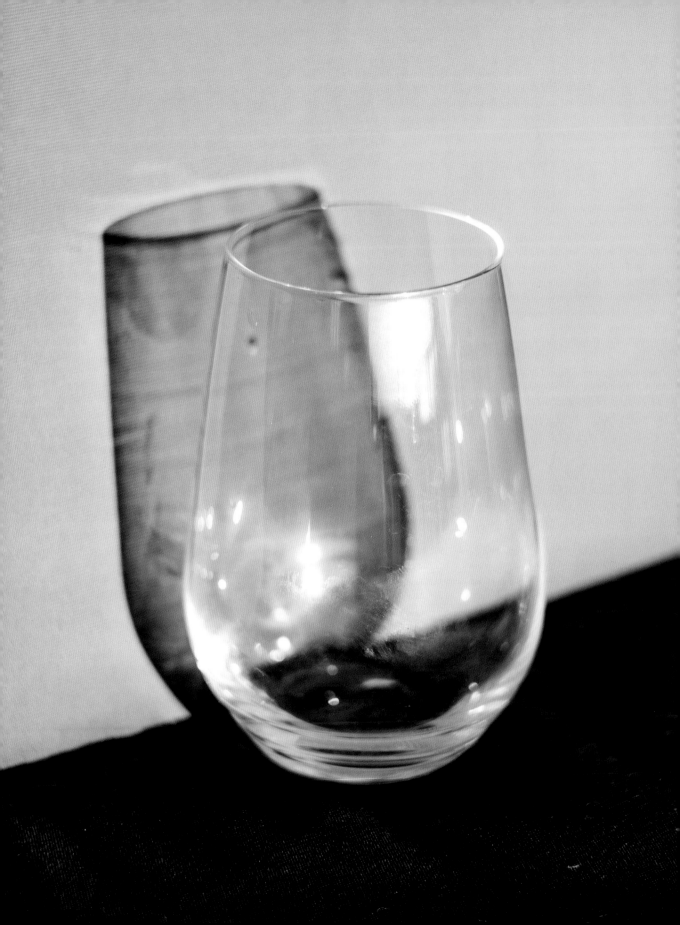

On photography

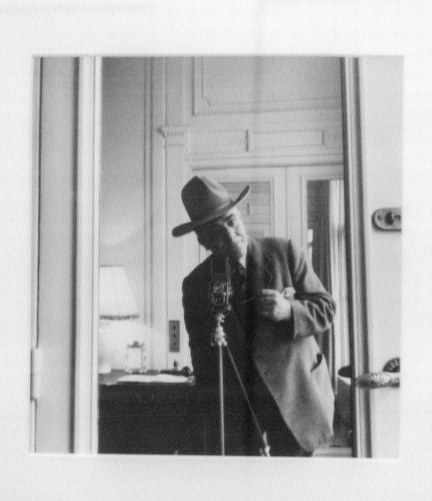

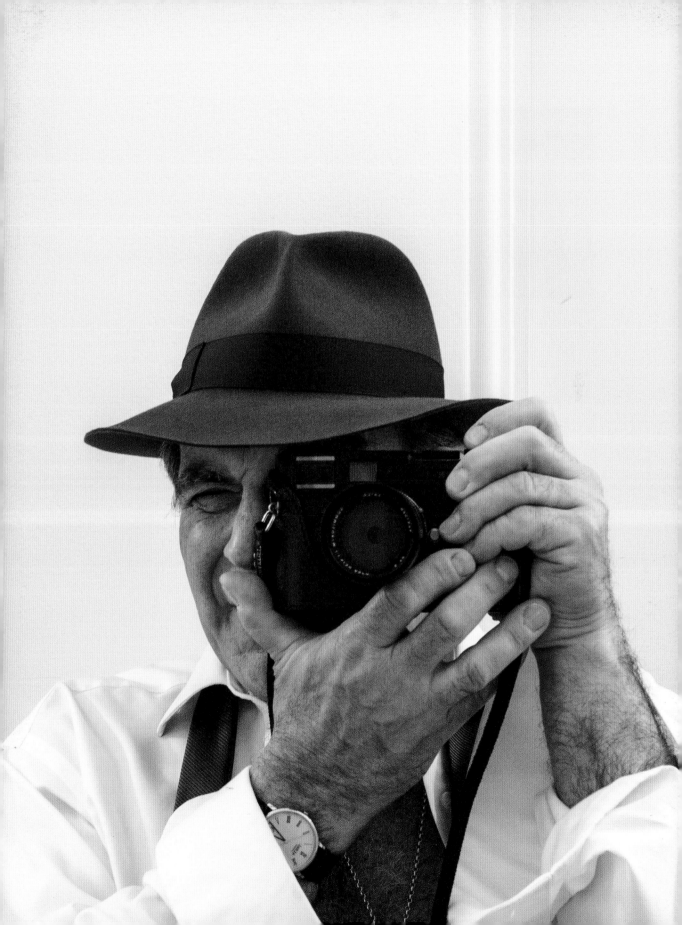

Jimmy always referred to the most important lens being our eye. It took me many years to understand what he meant.

Photography has always been important to me, ever since Jimmy taught me about camera technique and the like when I was a young boy. Remember, cameras weren't automatic or digital back then; such developments were many years away.

It was also just one lens in those days. I couldn't change lenses. Very few cameras at that time had interchangeable lenses. The whole thing was manual. Jimmy would get the rolls of film developed in Fleet Street, when he was working, and would bring the prints back and spend hours with me talking about each photograph, saying what was wrong or right with it and teaching me to see through the lens, to capture through the lens what I want to see, rather than just, 'Snap, there's a picture.' Eventually Jimmy had a dark room of his own and taught me how to develop photographs myself.

Jimmy always referred to the most important lens being our eye. It took me many years to understand what he meant. My early days of photography were really about recording incidents and events: family life and so forth. Our many photograph albums – about forty of them, to be exact – have become my wife's and my pride and joy, and we've always said, if there was a fire in our house, we would run and grab these, our most prized possessions, to save for all time, because they go right back to when I met Sheila in 1972. They document much of our life together.

It was only, I think, when I started doing *Poirot* in 1987, that my interest in photography reawakened in a more artistic way. Photographers regularly came to the set wanting a picture of me, and I always gave them time, because of Jimmy, really, and his connection to that world, because he would have photographed actors and actresses. I often got talking to them about photography, and I began to buy some different cameras. Rather than just point-and-shoot ones, I invested in the latest technology, and started putting into practice what

(Overleaf, left) Julie Walters and (right) Emma Thompson

Jimmy had taught me all those years ago. I started to look through my eyes, not just at things I wanted to record, but at how I wanted to interpret them.

And, over the years, this has grown and developed. From 1987, I would say that photography has been my main hobby. My camera of choice now is a digital camera but I still have Jimmy's Leica M3 and a Rolleiflex, both of which always have a roll of film in.

In recent years, and with the help of my colleague Robin Sinha, who works for Leica (as well as being a very talented independent photographer), I've found the confidence to look through the camera in a way that I know I want to, rather than taking pictures just to document my life. The family photograph albums are the most important thing we own, but they're not artistic photographs. Now, I have the confidence to go right back to Jimmy and the things he taught me.

Gradually, I've revisited the technical aspects of photography until they've become part of me; almost second nature. I look at things – objects, people and faces – in a different way now. When I do portraiture, for example, I don't just want to record a face; I want to catch who people are, at ease and relaxed. Not obviously posed portraits, but those captured in the moment; offbeat, spontaneous. I do take straight portraits sometimes – people I've acted with, for instance – but my favourite portraits happen when I suddenly say to someone, 'Oh, just stay where you are', and I catch a particular moment. Sometimes it's just a little gesture of affection between people; that alone can bring a photograph to life and inject emotion into it.

The most important thing for me in photography now is not just seeing something and snapping it, as reportage, but actually being affected emotionally by what I'm looking at. It can be anything: the shadow of a glass against a wall; a landscape; triffid-like trees with gnarled and knotted roots – anything that makes me react.

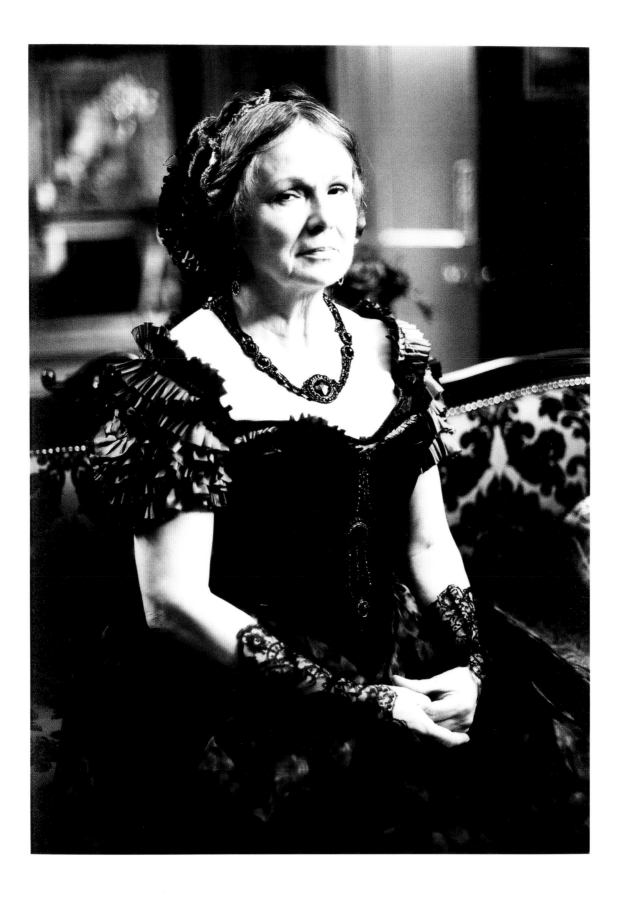

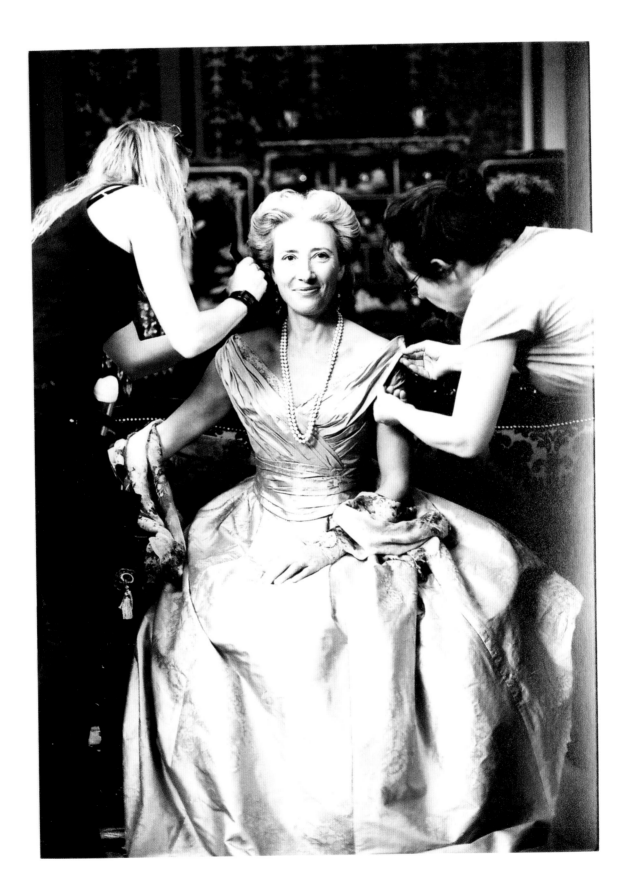

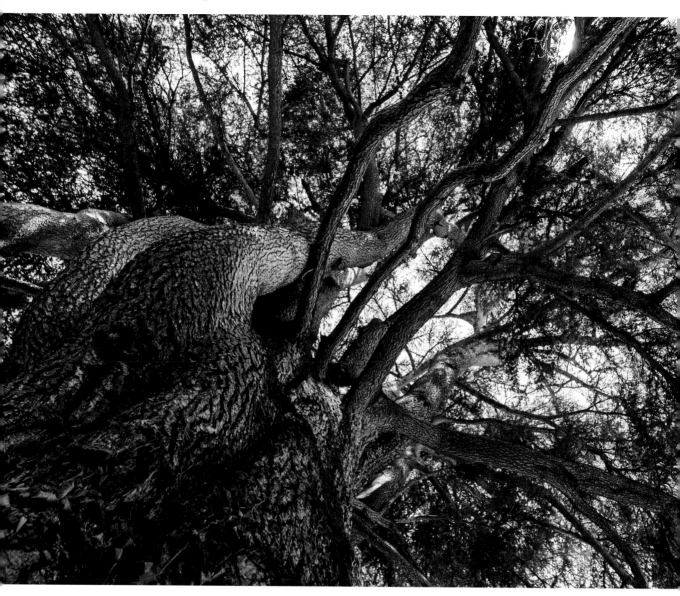

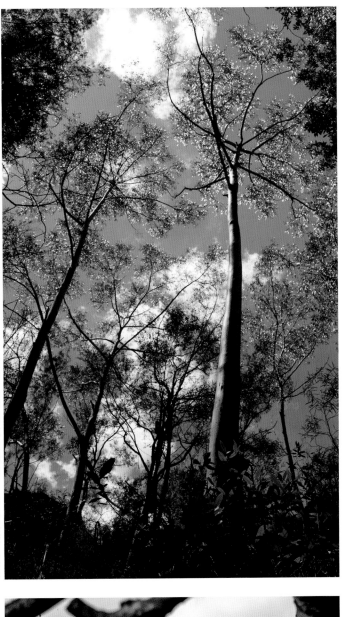

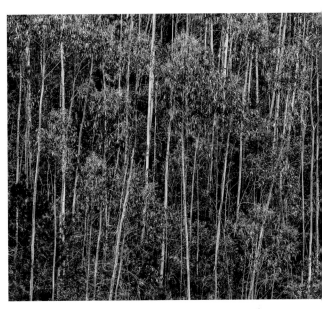

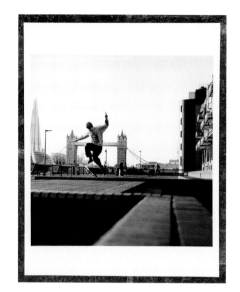

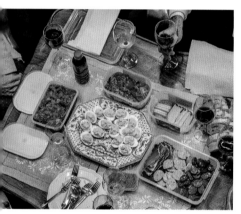

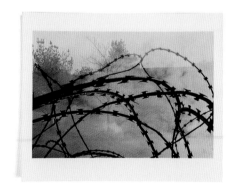

I'm fascinated in particular by what light does: how it falls on objects and people; the contrast between light and shade. The way it casts shadows; its different levels of intensity – now harsh, now soft; the different-colour tones it brings out: I react emotionally to that. The early morning sun shining on to an umbrella. A streetlamp silhouetted against the night sky. The dappling of the leaves caused by the sun during a forest walk. The way light shines through a window into a room. The way it creates reflections and silhouettes. I think that the impact of light is one of the main reasons that I love photography.

Sometimes it is colour that speaks to me – the colours of a meal, beautifully laid out on a wooden table: a representation of people coming together for a social occasion. A pure white swan against a dark pool of water. The orange and red hues of a sunset. Although I have to say that black and white photography has always been my favourite.

Other times it's an interesting angle. A portrait taken through the gap of someone's arm rather than conventionally straight on. Shapes. Barbed wire or a loop of cable. A coffin in a graveyard which, from a certain angle, looks like a skull. I like simplicity, a bit of mystery. I love photographing architecture. London is a particular source of inspiration to me and I'm often struck by the ability London has to marry past and present. A skateboarder in front of Tower Bridge, for example.

Nature is a constant stimulus. Particularly trees. I'm fascinated by them; captivated by their shape and their contribution to our planet. The shape and density of a group of trees growing together; a canopy of leaves above thin trunks that are reaching upwards.

I also take pictures while I am at work. I like taking photographs backstage of a theatre or film set, or even photographs from offstage during a performance, and what I can see – obviously my view of the play is very different to that of the audience. Sometimes it's simply my point of view, but other times I see

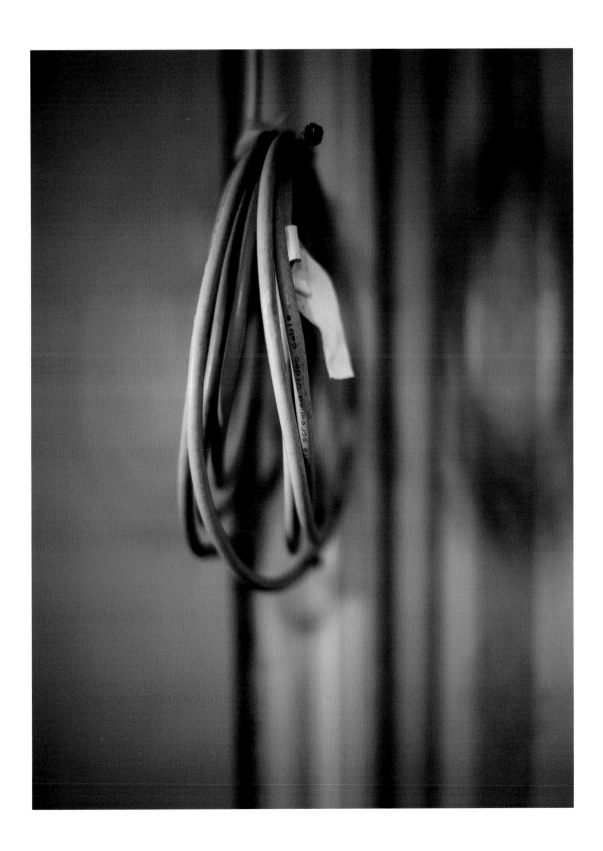

something which just speaks to me – the stage lights from an unusual angle, or an electric wire creating an interesting shadow. When I was playing Gregory Solomon in Arthur Miller's *The Price* in London at the beginning of 2019, I almost got into trouble for the lengths I went to in taking a photograph. For many weeks, my attention had been caught by what we call 'leading lines'; they're sort of joins in the floor of the set. Well, the only way I could take that photograph was to lie on my belly. I was in full costume, so I had to lie on a towel to avoid getting dirty. But I liked the result because I'd achieved the effect I'd wanted: an out-of-focus beginning, with the leading lines getting sharper as you moved along.

I will also take photographs of my dressing rooms. I call them my 'estate agent' pictures, because they make the room look far more beautiful, and bigger, than it actually is. As with those estate-agent photos, when you actually get to see the properties, there's barely room to swing a cat inside – which is just like a standard dressing room.

Of course, I still like to take photographs of my family – and, luckily my wife Sheila is always a willing model! Among the normal family snaps, I also now approach family photography in a more artistic way. For example, I once took a photo of Sheila as we arrived in Venice for a much-treasured family holiday. We were going into Venice by boat; Sheila was sitting in the front, and the rest of the family and I were behind her in the back. Suddenly, there was a moment when Sheila turned around and, on seeing us, her family, waved and laughed with joy. I always have my camera round my neck so . . . snap! It's not a typical family photo but for me it is a family photo, because of what Sheila's happiness represents. That image, for me, is our whole week's holiday summed up: a really joyous time. There's another photo of Sheila standing halfway up some stairs, looking down at her mobile phone. It's not a typical portrait, but it always touches me, whenever I look at it.

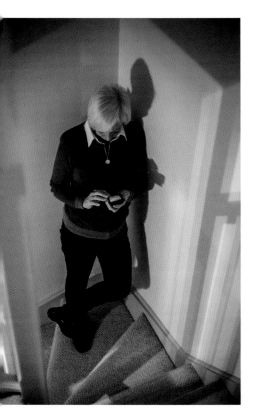

I don't take pictures simply because something seems interesting. What stirs me is the feeling in my gut of, 'Oh, God, I've got to get that.' I'm responding, emotionally, and that's why my photography is so eclectic. When I look at my photographs as a collection, I see many different types of photographs – I can see portraits, I can see landscapes, I can see photographs that represent my work – I don't really have any particular style at all. Although my photography tutor, Robin, would disagree: he says my style is becoming more impressionistic, more abstract. I'm not aware of that when I'm taking pictures. All I'm aware of is how I want to see something, and then I will choose a lens for my camera designed to reproduce that same image I have in my head. As much as anything else, my style is whatever catches my eye and makes me respond in some sort of emotional way.

It's not what you see, but how you see; there's a big difference. The same way that there's a big difference in what you are and how you are. Very different. So, what I see and how I see are very different, and that affects my photography now, as much as anything, and it's as simple as that.

I don't take photographs for them to be seen. That's something I really, really want to emphasise. But I use my photographs as a form of expression – my camera is my paintbrush; photography is painting with light; my camera is my tool for representing emotions. The best way for you to get to know me, I think, is through my photography because it's *how* I see as well as *what* I see. I'm hoping you can look at my photographs and say, 'Why did he take that?' And my answer would be, 'Work out what it was, how I saw it, and then you will learn about me.' I can see a tree, and not take a photograph of it. But sometimes I can see the shape of a tree and the light on the tree in a way that can suddenly change my perspective – *what* I see is still a tree, but *how* I see it is as, say, an animal. Or a person, diving into the ground. Or I see what the tree represents: a home for innumerable animals and insects; a

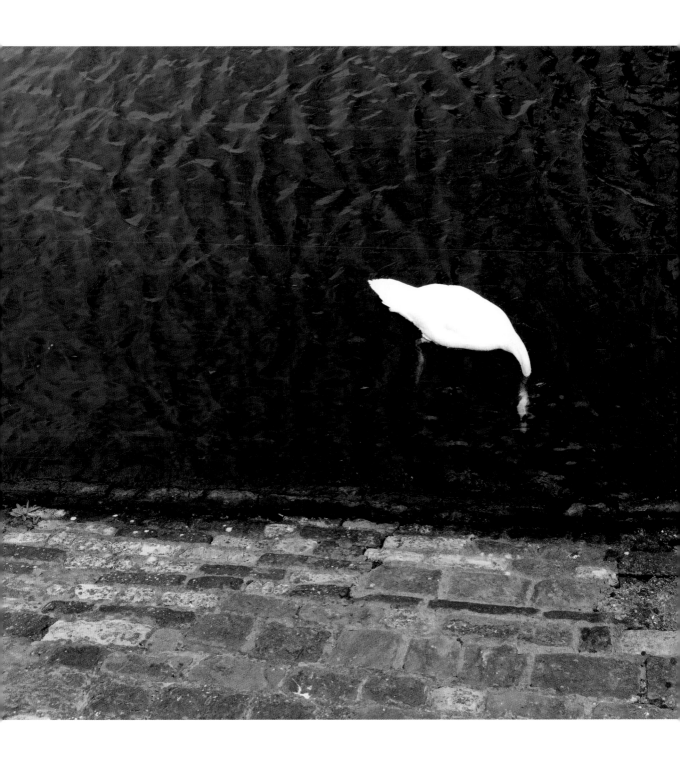

shelter from the rain; or somewhere perhaps you can run to and escape if being chased by wild animals. Not just a tree. I want my photographs to mean something to me.

I don't classify myself as a great photographer, or even a good one. I just take photographs because they represent how I see the world. I have over eight thousand pictures on my hard drive, and that number is growing. Looking back through them, I can see how I've developed as a person, mainly through the way I perceive things. I'm a very visual man. What I see affects me. If I walk into my study and it's chaotic, papers everywhere, I will feel chaos deep within me. When I learn lines for a character or study for a role, I can't do so until I've got rid of such clutter and start with a completely naked desk. I have to get rid of chaos, because it affects me. I have to feel calm and ordered, deep inside. Only then can I branch out and release.

> I don't classify myself as a great photographer, or even a good one. I just take photographs because they represent how I see the world.

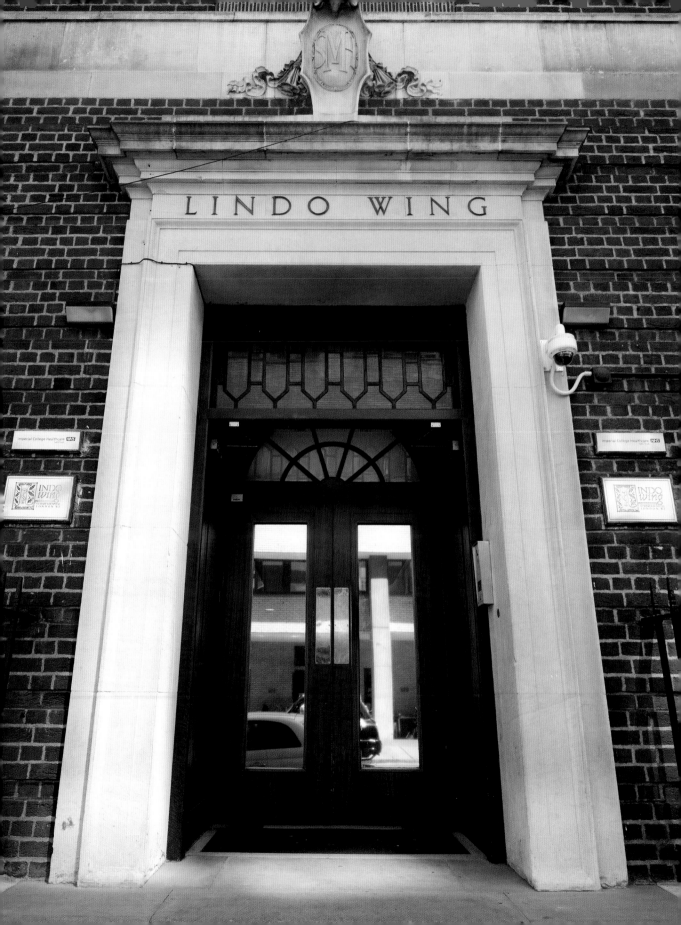

Family: part ii

My father, Jack, was an eminent gynaecologist and obstetrician at St Mary's Hospital, where most of the royal babies are born. He was born in Cape Town in 1908 and emigrated from South Africa to London in 1932. He started training at St Mary's the next year, in 1933, and that's how my brothers John, Peter and I all came to be born in the private Lindo Wing there. When our father was just starting out at the hospital, as a junior doctor and technician, he'd worked with Alexander Fleming in his discovery of penicillin. In fact, a picture of Dad (unnamed, sadly) alongside Fleming and other doctors appeared in the newspapers. It was taken by my grandfather, Jimmy. A blue plaque in honour of Fleming hangs on the wall of the hospital, in Praed Street.

There's a lovely little story associated with all that. The Greyhound Derby was held at White City every year, a big event for which people would turn up in evening dress, black tie, the lot. On one occasion, very soon after penicillin had been discovered, the dogs due to be running that year went down with a disease; I can't remember what it was. Anyway, Fleming turned to Dad and said, 'Look, I'd like to test out the penicillin on these dogs,' so my dad headed off to White City Stadium and injected them, and soon they were all cured. As a result, my dad was made an honorary member of the White City Stadium, and we used to get invited every year to the Greyhound Derby. Dad would actually go with us – unusually taking some time off – and we would all dress up in evening clothes and be lauded, because of what my dad had done for those dogs. It was only afterwards that penicillin was tested on humans.

My darling mum, Joan, was an Epping girl, born there to Jimmy and Elsie in 1916. She wanted to be an actress at one time, and once performed in *Lilac Time* with Evelyn Laye in the West End, but she struggled to cope with the constant rejections and eventually heeded Jimmy's advice that this wasn't the profession for her. But she continued doing amateur

Mum and Dad

dramatics, which I remember hearing about as a young boy. She was thrilled to bits when I decided that I wanted to be an actor and was wonderfully supportive of me. Without her encouragement, I probably would never have become an actor at all. My father was always very disapproving about my chosen career.

She was a force of personality, wherever she went. She was the shining light in every room, always positive, always happy. She had the sunniest disposition, the complete opposite of my father's.

They say 'opposites attract' and, if that is the case, then my parents are the proof. Dad was often quite strict with Mum – during a winter's night, she and Elsie would always sit in the lounge, probably chain-smoking, with a three-bar electric fire on for warmth. As soon as they heard Dad's car in the driveway, they would immediately switch it off because they knew the first thing he'd say would be, 'Have you had that fire on?'

Mum would always stand up for herself though. Nobody put her down. She was very vocal and had a terrifically strong personality. She was devastated when we three boys went off to boarding school at such a young age. She felt very lonely, rattling around in the house on her own. She'd been an only child and was very close to her parents. So she insisted that they come and live in the flat at the top of our house at the time to keep her company.

From the day I was born up until I was eight, we lived in a 1920s block of flats called Chiltern Court. It got its name because trains used to run from the nearby Marylebone Station to and from the Chiltern Hills. In fact, I believe the block was owned by British Rail; they were the landlords. The flat is still there today, above Baker Street Station, with shops below – our flat was obscured by scaffolding last time I was in that area.

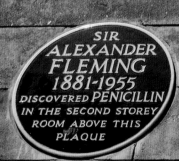

SIR
ALEXANDER
FLEMING
1881-1955
DISCOVERED PENICILLIN
IN THE SECOND STOREY
ROOM ABOVE THIS
PLAQUE

PRAED
STREET W2

CITY OF WESTMINSTER

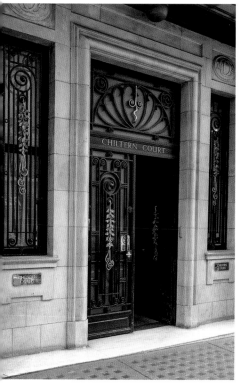

I often used to stay in my grandparents' flat, because they also lived in Chiltern Court, so I'd go there for sleepovers, as they are now called. I will always remember hearing the chime of a 1927 grandfather clock Jimmy owned. I have it still, and every time I hear that chime, I'm taken back to my early years and memories of my grandfather and grandmother.

When I was eight, my father became a private gynaecologist in addition to his work at St Mary's Hospital, and he took on consulting rooms in Harley Street. He bought this magnificent house in Rosecroft Avenue; it was called 'Croft House'. A very large and elegant house, it's where I lived from the age of eight until I was in my twenties. We went there in 1954 and left, I think, in 1971, just after my grandmother died. So, we were there a long time. It was very near Hampstead Heath, a hugely special area of London to me, even now. It was such a privilege to grow up in that house. Of course, I was at boarding school for most of that time, but I would return there in my holidays, and it was a very happy home.

I'm the middle brother in my family. I wonder, occasionally, about middle child syndrome. I'm sure a lot of people will identify with this. My brother John is two years older than me, and my younger brother, Peter, seven years younger. So, for seven years after I was born, I was the youngest of two. Then my younger brother came along and, very soon after, I was sent away to prep school. I always remember it as a great tragedy. I thought I was being punished, that my parents didn't want me. I was being sent away. They had a new little baby.

I only saw Peter during school holidays, so I never really got to know him in the way I knew John, having spent all my early years growing up with John and going to the same school: Grenham House, in Kent. John and I had left by the time Peter went there. I've always felt sad that my younger brother and I never shared our early lives in the same way I did with my elder one.

(Left) Chiltern Court today and (below) Croft House

We've got closer since, but we can't share the same memories – we haven't got that early link, that cord that binds us together. There was quite an age gap between us; one that seemed especially big when we were boys. A ten-year-old and seventeen-year-old . . . they don't share all that much in common.

I remember, later, when I was going out with a lovely young actress called Mel Martin during my time at drama school – I was twenty-one and we'd become very close – I used to go down to Peter's school – King's, Canterbury – and take him out from time to time. I wanted to foster that brotherly relationship.

> I've always tended to feel a bit of a dunce compared to my elder brother. He has been so supportive in my career, though.

John was always considered the intellectual of the family, and he got into Uppingham, the famous public school near Leicester, passing the notoriously difficult Common Entrance exam easily. I didn't pass Common Entrance, so I've always tended to feel a bit of a dunce compared to my elder brother. He has been so supportive in my career, though.

John was a newsreader. He started as a foreign correspondent in Reuters and was in Paris for a while; then he joined the BBC News and did some writing for them. Afterwards, he became a news reporter for ITN. He would be out in the field reporting, and he had the most amazing experiences. He covered the Soviet invasion of Afghanistan; was put up against a wall with rifles pointing at him. He got through it all, then went on to become a news anchorman. He did that for a long time, and that's what people remember him for. Now, of course, he's the morning anchor for Classic FM, from nine o'clock in the morning.

We brothers are all very different. Neither John nor Peter reckon they could be an actor, although we've all inherited the same gift of being good at speaking in front of people. John can hold a room, and does so. He speaks at concerts and festivals around the country about the lives of the great

Peter (left) and John

composers he has written biographies about, Beethoven, Mozart, Tchaikovsky and so on – a constant reminder to me of how, when we were boys, he used to drive me mad with Tchaikovsky's Violin Concerto which he played until he wore the record out. Or maybe I threw his gramophone out the window! Peter has spent most of his life on the agency scene, particularly as a director of Saatchi & Saatchi. He then worked for the *Daily Telegraph* and created 'Fantasy Football', before moving across to the charity sector where he became a director of fundraising and marketing for a number of leading charities. We're all communicators in our own way. I do it mainly through acting, but one time when I was at the Royal Shakespeare Company, I was chosen to speak to university English professors about my interpretation of roles. I went home and prepared a two-hour lecture, and I've also given lectures on Caliban, on Iago, on Bolingbroke, on Shakespeare.

It goes back again to Jimmy, I think. He was a great communicator; he could hold a room and entertain people magnificently. My father was also a great lecturer, mind you. He gave lectures on medicine all over the place, and actually told me once that he wished he'd gone to university and become a lecturer. Communication: that's the common thread between us all.

Finding my rhythm

My hobbies

When I was in my late teens, John and I used to go during our school holidays to the London Jazz Club, known as Jazz Shows Jazz Club. It was located at 100 Oxford Street, and became more famously known as the 100 Club. I really liked percussion at the time, and taught myself to be a jazz drummer. My brother had learnt to play the trombone when he was at Uppingham School, and he formed a jazz band, which I joined as the drummer.

I'd learnt to drum during my time at Wellington School. There was a jazz teacher at school – he taught himself jazz drumming and I loved this so much that I bought myself a pair of sticks. I used to drum on books and learn how to do things like riffs and paradiddles, and rolls, and ruffs, and so on. I've always been interested in rhythm. I still am. I have bongos now, but I

used to bang out rhythms on my books all the time. I'd drive people mad sometimes doing so.

The great jazz musicians – trad jazz at that time – Acker Bilk, Kenny Ball, and countless others, used to appear at the Jazz Shows Jazz Club, which was very famous, and John and I would go there because we really loved trad jazz.

I recall there was one particular jazz band – probably people wouldn't necessarily remember it now: Terry Lightfoot and his All Stars – and I got chatting with them on a break, and talked to their drummer, Johnny Richardson, and we became quite friendly. I mean, how old was I: sixteen? Seventeen? He must have been late twenties/early thirties. Anyway, Johnny took me under his wing and he taught me a lot about drumming. Taught me how to do jazz rhythms, just on a book, while he was having a beer, and he used to bring me his sticks and he'd say, 'Yeah, yeah, come on, come on, you've got to syncopate, syncopate, syncopate, syncopate.' He taught me so well that occasionally, when Johnny went off to have a drink, Terry Lightfoot asked me to sit in. So, as a sixteen- or seventeen-year-old, I was playing with this band, in front of the London Jazz Club audience. All of a sudden, during the numbers they were playing, he would turn around to me, and say, 'You,' and I had to do a drum solo. I didn't have a clue how to do it, so it could have been absolutely appalling. But perhaps it wasn't that bad, for sometimes, when the band stood down to have a break, I would play drum solos until they came back. Whenever I returned there subsequently, they'd recognise me and welcome me warmly.

I also sat in with Kenny Ball once. They recorded a very famous bit of jazz, trad jazz, that became part of *Top of the Pops*, called 'Midnight in Moscow', and I remember them discussing this at the London Jazz Club, about how it should start. Some time afterwards, when Kenny Ball was having a drink at the bar, I said, 'I love "Midnight in Moscow",' and told him that I

loved to drum. So he said, 'Come on, we'll play it,' and I sat in while they played, starting the piece off. Big pause, big pause, knock-knock, then, 'We're off!' and I played 'Midnight in Moscow' with Kenny Ball. I played a few times with Acker Bilk as well, not as their main drummer, but as a stand-in, and had a wonderful time.

With me, nothing ever just stays as it is, and my drumming made me realise not only that I had a talent for it, but also that rhythm is a huge part of my life. I really respond to rhythm and when I listen to music – not necessarily orchestral music, but modern jazz, trad jazz, or anything – I only hear the drum and one other instrument, the clarinet, the playing of which has also become a great hobby of mine.

In late 1981, I was doing a pantomime, the only one the Royal Shakespeare Company ever did at the Barbican Theatre. We did *The Swan Down Gloves*, a pantomime written for the RSC as the opening play in front of Her Majesty the Queen. The RSC's London base had been the Aldwych since 1960 and they were to move to the Barbican Arts Centre in the early 1980s – I'd had the privilege of performing the last ever lines at the Aldwych Theatre, playing Shylock and Bolingbroke, and now I had the first lines at the Barbican. I was the first person on stage in the pantomime, and my role, although I cover my head in embarrassment when I say this, was playing 'Mazda', who was a light bulb.

On the way to a matinee performance of *The Swan Down Gloves*, I was in my car. We could park in London in those days, and I was driving along Western Avenue, coming from

West London into town, and my radio was on, and I heard a piece of music that affected me so much that I started to cry. I'm greatly affected by music. I can listen to a piece and well up with tears or shout for joy, depending on how it makes me feel. I once did a one-man adaptation of a short story by Tolstoy, *The Kreutzer Sonata*, and, whilst researching the role, I learnt that Tolstoy hated music, because he didn't like the way it affected him emotionally. That's not me at all. Anyway, I had to stop the car and listen to the rest of this piece of music, then ring up the RSC to tell them I was going to be late. There were no mobiles in those days, of course; I had to call at someone's house and say, 'May I use your telephone?' A different world.

'Wow, I was wrong!' exclaimed the teacher. 'It's not too late.' And he took me on. I got to Grade Six, and fulfilled my greatest musical ambition.

The piece of music I loved so much was the slow movement of Mozart's Clarinet Concerto. I was around forty at the time. I rang a clarinet teacher afterwards, Maurice Cowling, and I'll never forget the conversation. 'Are you a clarinet teacher in Acton?' I asked – I was living there at the time. 'Yes,' he said. 'Well,' I continued, 'I would love to learn the clarinet.' But he clearly didn't hear me correctly, for he replied, 'How old's your son or daughter?' 'No, no, it's not for them,' I said, 'it's for me.' 'And may I ask how old you are?' he responded. I told him. 'Well,' he answered, 'I don't know whether you can. I think you may have left it too late.'

I was so upset, because the music had really affected me. I'd only ever played drums and, suddenly, here was a chance to learn music. We never had an orchestra at Wellington School when I was there, which is very rare. Now they have a terrific orchestra, and play wonderful music, but I couldn't learn something like the clarinet during my time there.

Anyway, this teacher came over, with his clarinet, and I had my younger brother's old clarinet somewhere in the loft, and I got it down. And because I'm an actor and do voice exercises most days of my life, I have huge lung capacity, and lip and

tongue control, so I was able to produce notes on the clarinet straightaway. 'Wow, I was wrong!' exclaimed the teacher. 'It's not too late.' And he took me on. I got to Grade Six, and fulfilled my greatest musical ambition: to learn the first few bars of Mozart's slow movement of the Clarinet Concerto.

I've forgotten it now, sadly, but I am going to try playing more now that Sheila and I are a bit less busy. I've got my clarinet and she her piano, so we're going to start playing together again. Which is something we really, really love to do, even though we're not very good at reading music. Neither of us is good at maths, either, so we struggle sometimes with the timing. We're not all that musically literate, but music brings us great joy.

Memories of school

Birchington-on-Sea Station

I started at boarding school, Grenham House, in Birchington-on-Sea, Kent, in 1954, at the age of eight, and I didn't enjoy it at all. It was, perhaps, one of the unhappiest times of my life. My brother John and I really loathed the school – it was Victorian in attitude. Perhaps not all the boys who went there will recall it in the same way, but it was not a pleasant place to be. We used to dread saying goodbye to our parents at Victoria Station and boarding the steam train for Birchington.

Conversely, one of my happier memories is of John and me standing on the platform of Birchington Railway Station, craning our necks to get the first glimpse of the stream train coming into the station that would take us back to London Victoria. As a young schoolboy, I was always so excited to see the train that would take us home.

It wasn't a big school, so there weren't many students there; probably about sixty altogether, all boys. I kept a little leather wallet of photographs by my bed the whole time I was there, from eight to thirteen. Photographs of my grandparents, my parents and my brothers and our dog, Mitzi, as well as a little poem I wrote shortly after I started at Grenham House called 'The Family'. We were allowed a tumbler of water on our bedside tables but, often, particularly during the winter, the water would freeze overnight.

I have emotional memories of Grenham. One memory is of the seaweed-strewn beach at Minnis Bay. We schoolboys, aged between eight and thirteen, would be taken to swim there. We had to walk from the school, finally descending a little path leading down to the beach, which is still there today. I can remember how our plimsolls used to slide and slip on the seaweed beneath our feet as we reached the beach. Then, dressed in flannel bathing trunks, we had to walk out into the sea without stopping. We were expected to be brave; just walk in up to our shoulders and start swimming. My brother and I used to sing, 'When you walk through a storm, hold your head up high.' It used to give us courage as that freezing cold water hit us.

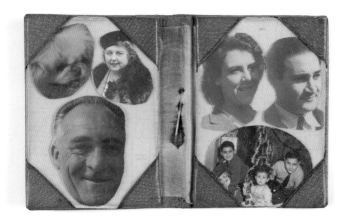

The+fam²

THE FAMILY.

Top left is Mitzi, a dog² of note,
 is
alittle Pège-pat she. All blond
And hair and tongue and pant galore
She died in 5₹ fifty-three.

Top is Elsie. All wrapped in furs
is she. A gentle smile, a kindly smile,
Her soul is in her heart. But what
is shown is in her eyes: happy all the while.

Below her sits Jim. Big and bold
and strong. A man among men, a friend
of kids, a help to all he knew. And to
Her above a husband kind; to her the
dearest dear.

Opposite is Mum and Dad. And what a pair
they are. Two in a million are what they are,
and very dear to me. Below them kneel
Their children three; there's John and Peter
And me.

The left has gone; the right is here, for
How long no-one knows. But here in photo-
Form they live for anyone to see. There's
Mitzi, Elsie, Jim, and Mum and Dad and John
and Pete and me.

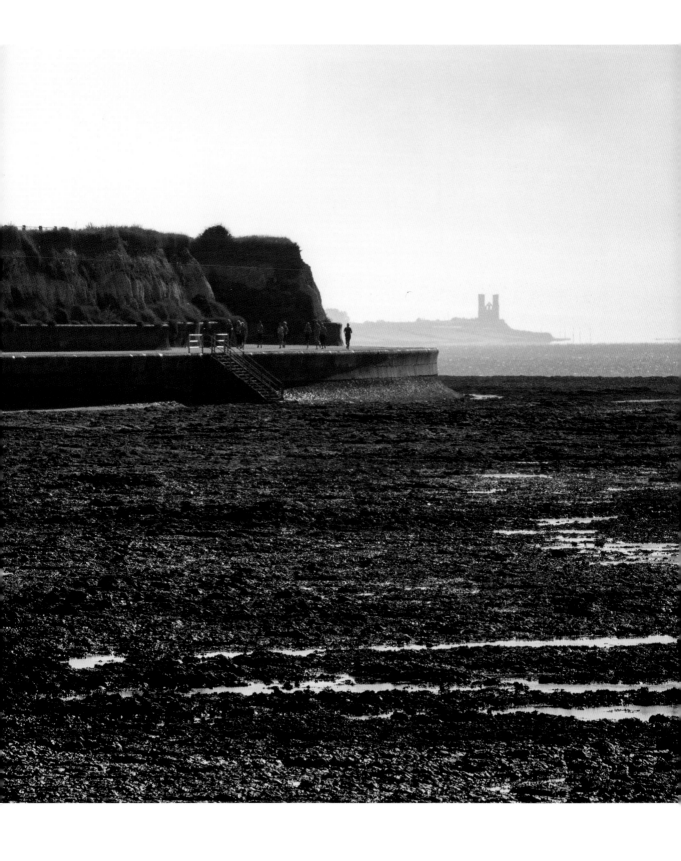

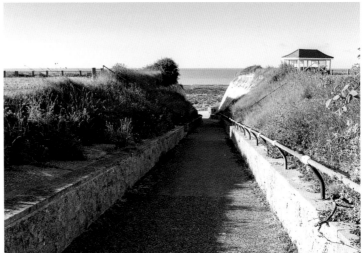

Memories of Grenham House

I got six strokes of the cane for having that Mars Bar in my shoe.

Close by were the ruins of an old castle called Reculver, and we used to go on official school walks to and from there; sometimes the whole school, occasionally just the senior boys. It was a long walk.

Mum used to bring sweets with her when she came down to visit us with Jimmy and Elsie. I love sweets. Chocolate and such like. Why? Because they were forbidden at Grenham House. We were allowed six ounces of sweets per week; the headmaster would come in and weigh them out, putting them into a little bag, and that had to last us the week. We were not allowed extra sweets from any outside source, just that six ounces. We used to ask for sherbet bonbons because they were the lightest, and you got a bigger bag.

So, Mum, at half-term, or quarter-term, when she visited us, used to give us sweets that we could surreptitiously hide in our lockers. I tried hiding a Mars Bar once in my shoe. The headmaster used to go around the lockers after the parents had left, though, to see if any boys had sweets, and he found it. I got six strokes of the cane for having that Mars Bar in my shoe.

The hugely strict discipline of my first boarding school is one of my strongest childhood influences; both John and I suffered at the hands of an education system in which we could be beaten for the simplest of things. The discipline didn't make us any less naughty, but it made us realise that when we did something wrong, it would be painful. As a result, I suppose, I'm a real mixture of being a conformist – doing the right thing – yet also terrifically nonconformist, hence my acting: the ability to play lots of different roles. There's a huge rebel, deep within me, as well as the social conformist.

I went to Wellington School, Somerset, in the early 1960s, when I was thirteen, and boarded in Willows House. I became a prefect in Willows when I was seventeen. My study is now a laundry room, and an ironing board is stored where my desk used to be. How times change.

Mum took me to my Wellington interview. There was this fantastic master there, who was going to retire very shortly, called Bert Nichol, and he was the first master I ever met who treated me like a human being. We called Grenham House 'Colditz', after the German prisoner-of-war camp, because all the masters there were so strict. Because the headmaster couldn't interview me, Bert Nichol did so instead, and he shook my hand and he said, 'Hello, old son,' and I thought, 'Woo, you're nice.' It was a very warm interview. He looked at me and said, 'You haven't done very well in your exams, have you, old son?' and I said, 'No, sir, I haven't.' So he said, 'What are you good at? What do you enjoy?' and I thought, 'God, a schoolmaster is talking to me.' So I said, 'Well actually, I like sport. I've got my cricket colours.' 'Do you enjoy cricket?' he asked. 'Yes, I'm in the first team,' I answered, 'and I also play soccer, and I played Junior Wimbledon when I was twelve.'

Mr Nichol said, 'Well, that's hugely impressive. I think we could do with someone who's very interested in sport, and has got their colours.' He showed me around the school with my mum, and then he asked me to leave the room and talked to her, and on the train home Mum said, 'I think you're going to get in. He likes you very much.' And that's how I got into Wellington School. Nothing to do with brains. Wellington might be a public school now but, back then, it was a direct grant school, which Dad wasn't happy about at all. I simply didn't have the brains to get into any of the top-rate public schools or university.

Still, Wellington was a wonderful place, which will give you an idea of the conservative and privileged way in which I was brought up. It has a beautiful chapel and lovely cricket pavilion. I continued to enjoy sport at school, particularly rugby. I became the youngest ever member of the First XV, aged, I think, around fifteen or sixteen. I was also a member of the Colts at Richmond Rugby Club around that time. Sport was so important to me because it was really the only thing that

gave me any self-regard at prep school. My time at Grenham House had given me a terrible inferiority complex; it was sport that saved me, sport that got me into Wellington, and sport that continued to be my greatest source of self-confidence. That kind of negative experience I'd had at Grenham House, so young, really shapes a person, so going to Wellington was an important part of my psychological development. Even now, sometimes, I feel a nagging sense of insecurity which I think dates from my experience at Grenham House. And then it wasn't until I discovered acting that I truly began to develop as a person.

It was at Wellington that I took my first real steps into acting, literally on stage in the Great Hall there, in Shakespeare's *Macbeth*. On 14 January 2010, by which time I'd become an OBE, I officially opened Southside Theatre at the school, dedicated to Joe Storr, the English master and drama teacher who had such a great influence on my life when I was there. I always remember Wellington School very fondly indeed.

Privilege is a thorny issue today. There is a huge amount of discrimination both for and against those seen to be privileged. If I look back at my early life, I do see an enormous amount of privilege – a comfortable family life, good schools and so on. But I don't believe that privilege guarantees success. Privilege can go either way – being privileged doesn't protect you from problems. Of course, my upbringing has formed the sort of person I am today, but who I am is a result of growing up in the world, as much as having privilege. I'm grateful for what I had and where I came from.

Southside Theatre
opened by
David Suchet OBE
14th January 2010
Dedicated to Joe Storr

(Opposite) Wellington School and
(above) Willows House

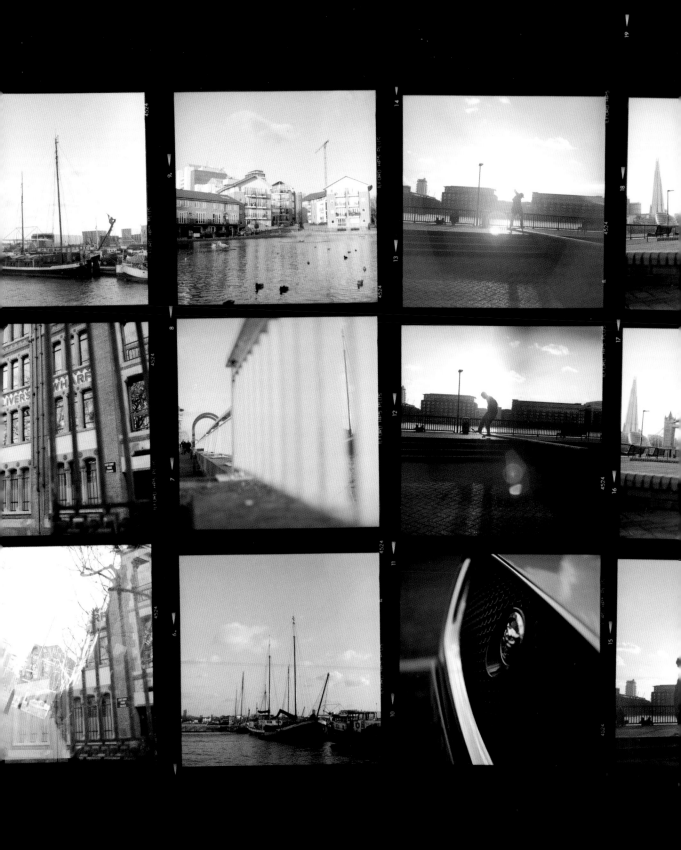

An ode to London

I was born and bred a Londoner, and even as boys, both John and I were in love with the city. We remember going on the buses, to the zoo, shopping in Selfridges with Mum. Before we moved to Hampstead, we used to enjoy going to the children's boating lake in Regent's Park. And when we went to boarding school, at the age of eight, we not only missed Mum and Dad, we missed London too. Yes, we both love the countryside, but we are very much town mice. No matter where I've been or how far I've travelled, coming back to London is still a great event.

When John and I were boarding at Grenham House, we weren't allowed home during the school terms, and our parents could only visit us at half-term or quarter-term, so we just got to see them once or twice every few months during term time. That made the going away from London very painful and I, in particular, was extremely homesick. Coming home, by contrast, was a great joy, and John and I used to have a little bet: whoever saw the first London bus, from the train, would get a Mars Bar. So, when we got close to Victoria Station, we would both be peering out of the window, on both sides of the train. In those days, of course, steam trains had individual compartments, with a corridor down the side, so we were continually coming out of our compartment to look through the opposite window, desperate to be first to see the red bus.

I went back to Birchington recently, by train, and spent some time there photographing where the school had been – it's long since closed and is now a housing estate – and the other places I remembered. Then, travelling home, I waited eagerly for my first glimpse of a London bus. The sight of one still gives me pleasure, because it takes me right back to those steam train journeys John and I used to have, and our London bus contest. When we spotted one, to yells of delight, we felt we were 'home'.

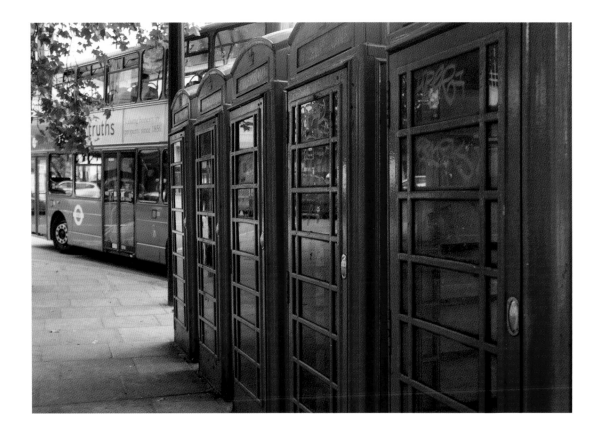

London, for me, is represented not just by its iconic sights – Tower Bridge, the Houses of Parliament, Buckingham Palace, and so forth – but equally by the old Victorian postboxes which were still around when I was a child, red telephone boxes and double-decker buses. A simple picture of a phone box or a London bus makes me very emotional, filling me with joy. So much about London is iconic; no wonder it's one of the most visited and popular places in the world.

I don't know how true this is, but I've heard it said that you can go out in London, every single night of the year, to a different place of entertainment. That's amazing. Peter Brook, the famous theatre director, once said that if the world were to be merged into one unit, London would be its theatre and place of entertainment. What is it about London? What is it about the United Kingdom that creates this great world of art

I adore my city.
I think it's the
greatest city in the
world, and I'm 100
per cent biased.

and entertainment? We talk about the Royal Opera House, the art galleries and so much else: in international terms, they're right up there. It's easy to become complacent about them because, as Londoners, they're right on our doorstep. But London is extraordinary, unique. We're a leader in fashion too, and, recently, a French chef was quoted as saying that London is the gastronomic capital of the world. The city is so cosmopolitan, and the more it becomes so, the more I love it. I'm not one of those Londoners who say, 'We don't want outsiders coming to our city.' I think we should welcome everybody with open arms.

Not everything's perfect of course. Take the Underground. We've been a bit slow in keeping up to date there, but we are trying to catch up – it's not our way to do things quickly and people have to understand that we'll get there eventually. People complain about all the disruption caused by the building of new lines, but we've got to try and keep up with the rest of the world. Recently, I've been enjoying another form of transport London has to offer – the Clipper boats on the River Thames. What a great way that is of getting about the city. The first time I ever went on one, I was astonished, because you can get a cup of coffee, or, if you're travelling in the evening, perhaps a glass of wine on the way home.

I adore my city. I think it's the greatest city in the world, and I'm 100 per cent biased. There's something about this glorious city that makes it not only home for me, but almost the centre of my universe.

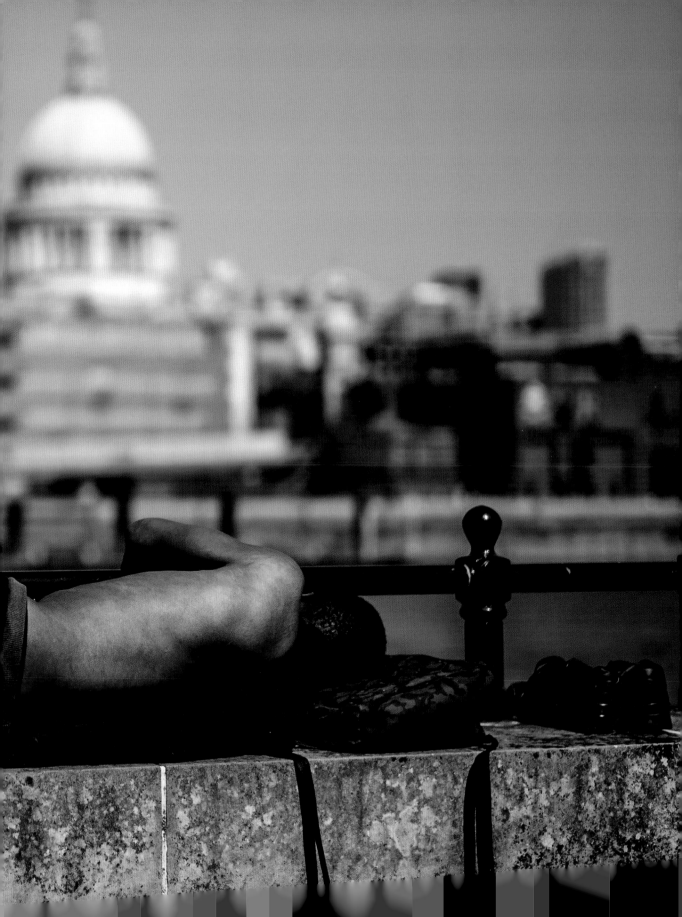

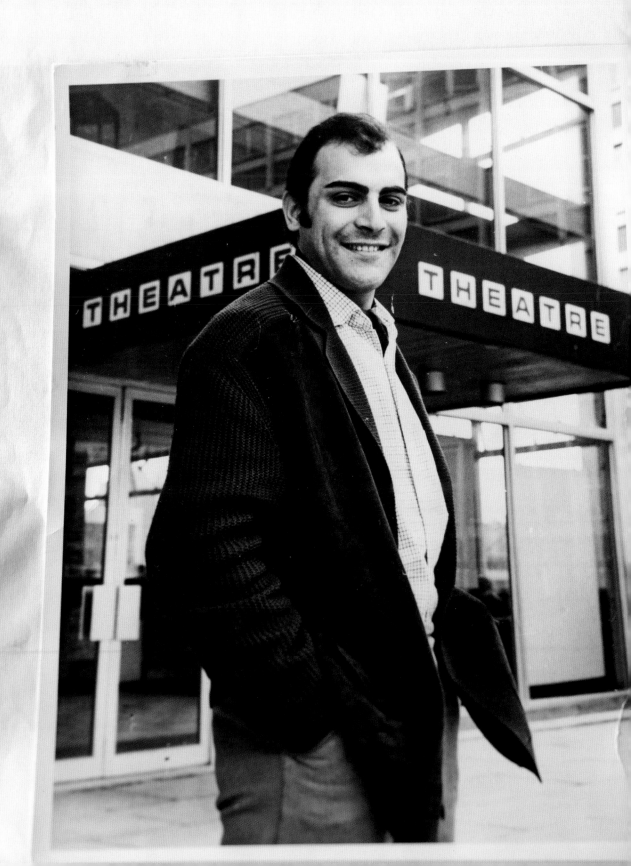

Learning the craft

*M*acbeth was my first proper taste of acting, but you might enjoy hearing about the very first role I was ever cast in. When I was about eight years old, Grenham House put on a production of *Alice Through the Looking Glass*. There were four of us playing oysters. We had to come on with the backs of our shells facing forwards, because the director didn't want the audience to see us but to see the shells. Well, the other three did that, but I wanted to see where my mum and dad were sitting, so I came on facing the wrong way round, and the next thing I knew was this booming voice from the director at the back of the stalls shouting, 'Suchet, turn round,' which, of course, I did. Luckily it didn't put me off permanently!

I was very hesitant about the idea of acting. Because I could read well, out loud, in class – Shakespeare and suchlike – and

had won reading prizes, the English master at Wellington, Joe Storr, said, 'I want to do a school play called *Macbeth* and I'd like you to play Macbeth.' I was very unsure about it – prep school had left me feeling insecure – and questioned whether I'd be able to learn the lines. 'Well,' he said, 'have a go. I'll direct you.' And he was so good and encouraging that I found, unbelievably, I was suddenly doing something I enjoyed, and I learnt the lines in about four or five days, the whole of *Macbeth*.

It just went in. I thought, 'I love doing this', and found myself thinking about the character all the time. We put on three performances, I think it was, in the Great Hall, and at the end the headmaster said to my mum and dad, 'I think this is the first time I've ever said this about any pupil in my school, but I think you could have an actor on your hands.' Mum, of course, was thrilled to bits. But it was not welcome news for Dad.

Joe Storr suggested, on the strength of my performance as Macbeth, that I should audition for Michael Croft at the National Youth Theatre in Eccleston Square. Joe really did believe that I could become a professional actor, and he set up my interview with Michael. Following my audition, I got in. I was around sixteen at the time and I stayed there until I was eighteen.

I'd actually wanted to be a documentary-cinematographer. Well, the first thing I'd wanted to be was a surgeon, because that's what Dad did. But he never really encouraged us to go into medicine, and I didn't have the brain; I realised that very quickly. I could have got into documentary filmmaking; I wanted to be behind the camera, because of my love of photography, and of people. I'd made a home movie of the slums of London, travelling around the slums in Notting Hill Gate, where there were barefoot children, and washing strung out between houses. It's all gone now. Replaced by posh mews houses worth millions of pounds. But when I was making this 8-mm home movie and learning to edit and splice, I wanted

to do that. It was Catch-22 though: you couldn't go into cinematography without a union card and you couldn't get a union card without getting a job first. Nobody wanted to give me the chance to get started, so that idea fell by the wayside, and the only thing I was left with was acting.

When I was coming up to eighteen, I said to Michael Croft, 'I think I'm going to try to be a professional actor. I'd like to go to drama school.' He didn't want me to leave the National Youth Theatre, so he told me, 'You'll never make it,' and tried to put me off.

I didn't get into RADA. I didn't get into the Central School of Speech and Drama either, but I was offered a place at LAMDA, the London Academy of Music and Dramatic Art, immediately after my audition. And I mean *immediately*; I didn't have to wait for a letter. Norman Ayrton, who was the principal, said, 'Come here,' when I'd finished. 'I think you're going to be very good,' he continued … just like that. 'You're capable of being very good, and we're going to offer you a place.' I went home and told Mum and Dad, and Dad was horrified. Absolutely horrified. He'd tolerated the National Youth Theatre, but he never wanted me to become an actor and hardly ever came to see me, until I joined the Royal Shakespeare Company, when he decided the career was respectable. Even then, he would always stand outside my dressing room door; never come in. 'I don't understand anything about your world,' he used to say. That was hard but I just had to get used to it. That was Dad.

As Dad grew older, he did start to soften. When I started doing *Poirot* and became well known, he became much more interested. We became closer. Never fully. Our relationship was never going to be like my relationships with Mum or Jimmy and Elsie, but it did get better. He was ninety-three when he died. He ended up in a care home with dementia, which was heart-breaking for all of us. He was a deeply complex man. I know, deep down, that he was immensely proud of all three of

us. He had photos of us on the walls of his consulting rooms and, when patients came to see him there, he'd praise us to the stars. But never to our faces. In a sense, I've spent my whole life trying to impress him; get his approbation for what I was developing into at that time, what I became: a classical theatre actor.

But, of course, I always had Mum who was proud enough for the both of them. She put together scrapbooks about every single performance I did, right from when I was at school. Photographs, press clippings, everything. It's a tradition I've kept up. I'll always remember my graduation performance at LAMDA. She was there, right near the front, and, at the beginning of the second act, the lights were down, and the first lines were mine, from offstage, the whole auditorium in total darkness. My voice: 'Mother? Mother?' And my mum, completely instinctively and not intentionally at all, replied, 'Yes, darling?' The whole audience roared with laughter and we had to start Act Two all over again. From then on, the principal at the time, Norman Ayrton, had to make a point of saying to parents, 'Please do not talk during the show . . . or respond!'

The other thing she would always do, after I went pro, was do a very loud, artificial cough during my first dramatic pause, to let me know she was there. I'd be torn between joy and irritation! But it became her signature.

Mum is the only person for whom the director of the Royal Shakespeare Company held the curtain on a press night. I remember vividly Terry Hands coming into my dressing room – we were doing *Richard II* – and saying, 'It's time to go on but I'm holding the curtain because your mother isn't here yet.' Mum was like Jimmy – she had the charm of the devil and would talk to anyone. She used to sit and have a cup of tea with the people in the box office while I was rehearsing. Everyone loved her.

She almost burst when I got the part of Poirot and could do things like send a driver to collect her and bring her to the set. Sadly, she became very, very ill in 1989, but, even when she was in hospital, and I went to visit her, she would tell everyone I was coming because she felt so proud.

I was taught the basics of acting at LAMDA in Cromwell Road. The name of the building in which it was located was Tower House. I was there from 1966 to 1969, having gone straight from Wellington School. The LAMDA theatre, known as the MacOwan Theatre, was also situated, for a time, in Logan Place, Earl's Court, but sadly it's no longer there. The site has been developed into ten luxurious one- to four-bedroom flats. I enjoy going back to LAMDA to give talks and to meet and chat with current students – it's my way of giving something back and is very important to me.

I didn't know what drama school was going to be like at all. So, my first day, I actually turned up in a suit and was very surprised to see that most of the other students were wearing typical 1960s clothes: capes, flared jeans and caps and that sort of thing, mirroring what the Beatles were wearing. I really was a fish out of water. You can imagine how embarrassed I felt, turning up wearing that suit. On my first day I had an improvisation class, and the teacher was very harsh on me. He picked me out, probably because of my attire, and asked me to sit in the middle of the floor and pretend to be a baby. Looking back on it, I can still feel how my stomach churned at being asked to do that. I sat in the middle of the floor and pretended to be a newborn baby. Honestly, the things we had to do.

Equally memorable was my first movement class at LAMDA. I didn't know what a movement class was, but imagined it was going to be something like circuit training. So I turned up, wearing rugby gear from my kitbag, and walked into this classroom in which all the students, boys as well as girls, were

I sat in the middle of the floor and pretended to be a newborn baby. Honestly, the things we had to do.

The Royal Borough of Kensington and Chelsea
LOGAN PLACE, W.8.

ROYAL BOROUGH OF KENSINGTON & CHELSEA

LAMDA's
Michael MacOwan Theatre
Stood on this site between 1963-2011

The internationally renowned
London Academy of Music and Dramatic Art
spawned many of the UK's top actors

Founded in 1861, LAMDA
is the oldest drama school
in the UK

THE HERITAGE FOUNDATION

LOGAN HOUSE

Tower House
226 Cromwell Road

wearing body-hugging black leotards and tights, and there was me, in full rugby kit. Needless to say, I was teased quite a bit.

The moment I'd actually decided to become an actor was at the side of the stage of the Royal Court Theatre. It was the last performance I gave as Ezekiel Edgworth in *Bartholomew Fair* at the Royal Court Theatre in London in September 1966. It was the last thing my grandfather watched me in. I wanted to watch the scenery coming down, for some reason. So I went down to the side of the stage at the Royal Court, where I can – and often do – stand, even to this day. And I stood and I watched the lighting bars coming down over the audience seats, which were covered in sheets, and I saw all the scenery being dismantled, and I remembered us being on that stage, entertaining all those people, in those seats, and thought, 'What an extraordinary world. There we are indulging in make-believe, and there is the audience, and we're doing something so unique. This is where I want to spend my life.' It had nothing to do with acting in itself. I had to work out what I was going to do with the rest of my life, and the only thing I knew was acting, so that was the decision.

But then, having got into LAMDA, I knew being part of that world was a possibility. Only I had a terrible time there at first, until I worked with an actor who was directing us in *The Lady's Not for Burning*, by Christopher Fry. I was asked to play the old mayor, Hebble Tyson. I'd never before played anybody significantly older than myself. The character was supposed to be around fifty, and what was I? Twenty-three. Jeremy Spencer took me through the text looking for pointers to help me, and it all came from the text. I developed this character with Jeremy. When I came to leave, I won the best acting award, for that one role.

In 1969, I moved straight from drama school to the Gateway Theatre in Chester. The theatre was one year old at the time; it's disused now, sadly. There's a fantastic new repertory theatre in Chester today called the Storyhouse. But in my early days, the Gateway Theatre, Chester, was really state-of-the-art, and I felt very lucky and privileged to arrive there. I lived in a bungalow and right next door was an Indian restaurant called the Bombay Palace, and curry smells used to pour out from its extractor fan all over the bungalow. I used to wake up in the morning, if the window was open, thinking that I was sleeping in the restaurant. It was rather unpleasant. I went back recently, and the Bombay Palace is still there.

It was at Chester that I met my very best friend, Peter Farago, who was assistant director at the Gateway. We first met when I joined in 1969, and he directed me in my early plays. We soon became fast friends and remain so to this day. As well as being a dear friend, he's also an excellent theatre director.

On my first day at the Gateway, I was introduced to this group of actors, seasoned actors in repertory theatre, known as rep. Julian Oldfield, the director, said, 'This is David Suchet; he's joining our company. He won the award for Best Actor at the London Academy of Music and Dramatic Art.' I could see them all thinking, 'Yeah, yeah,' and their faces told me, quite clearly, that not only could they not be less interested, but that they thought, 'What a p-r-i-c-k!' We chatted for a bit, he chatted a bit, and then he looked at me and said, 'Now, the introductions are done so let's have a nice cup of tea, before we start rehearsing.' 'Thank you very much,' I said. 'No,' he retorted, 'you're making it.' That put me back in my place.

At Chester, I started as an acting assistant stage manager – an ASM. It's a role that no longer exists in show business, because there's no rep now. In those days, you could only become an actor if you belonged to Equity, the actors' union. That's all gone as well. There's still Equity, but anybody can become an

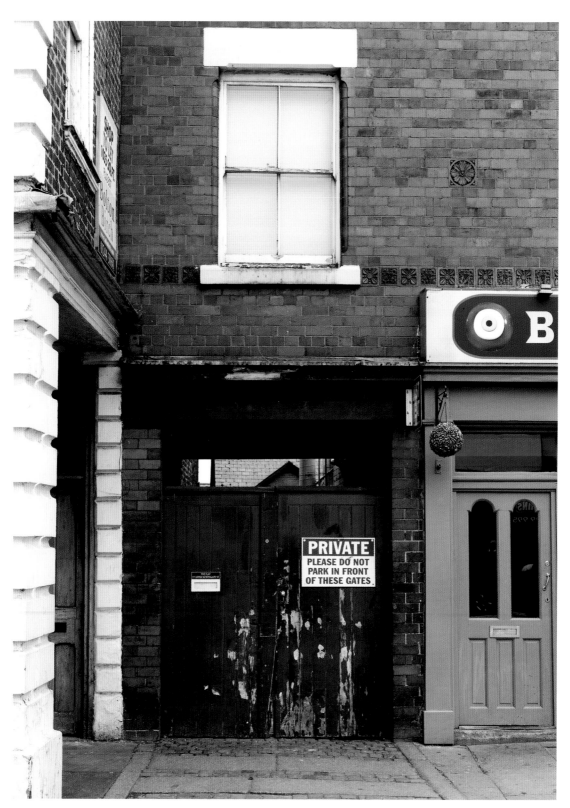

Gateway Theatre, Chester

actor and go onstage now; you don't have to belong. They like it if you do, but you don't have to.

In those days, we were on probation, and the only way I could get accepted by Equity was if I did a minimum of six months at an ASM job. I was allowed to play roles, but my main job was as a stage manager. I had to go in mornings and sweep the rehearsal-room floors, sweep the stage, put out all the props, and make sure that the professional full members of the company were well looked after. I had to learn to take up the curtain; how to cue the lights, how to do this and that, as well as act. And we would rehearse; in those days it was ten days of rehearsals for two weeks of performances. We would rehearse in the day, and perform in the evening. So, from ten o'clock until five, we'd be rehearsing the next play that would start in two weeks' time, and in the evenings I'd be performing and doing my stage-managing job. We used to get home at eleven o'clock at night. Over twelve hours every day for six days a week. And then we had to learn lines once we got home, for rehearsals the next day, so I was working until one o'clock in the morning for a whole year.

I remember one time making a particularly huge error. I was playing the mayor in a play called *The Family*; I can't recall who it was by. Anyway, I knew that for Act Three I had to take the curtain up, as well as playing a role. And I was first on. Right at the beginning of Act Three, I had to knock on the door and open it, but the ropes for the curtain were on the opposite side of the stage to the door that I had to knock on and open. So I waited, all dressed as the mayor, for the green light to come on, and then pulled on the ropes. Thinking that I'd spotted the little white marker that told me the curtain was up, I put the lock on, ran round the back of the stage, knocked on the door and opened it. But the curtain was only halfway up. We played the scene, trying not to be distracted by the fact that someone else had stepped in to slowly raise the rest of the curtain while we did so.

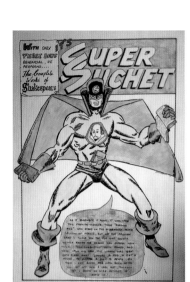

Julian Oldfield called me into his office the very next day, and said, 'You are such a lousy stage manager that I'm going to promote you to a full actor in the company.' And when he said that, after I'd spent nearly a year doing all that work, I wept with sheer relief and joy that those days were finally going to be over.

My first major role, as a non-ASM, was – at twenty-three years of age, for which I still hold the record today – Shylock, in *The Merchant of Venice*. I'm the youngest professional Shylock, so far, in the United Kingdom.

The next really important moment in my career was my time at the RSC – I was in the Royal Shakespeare Company virtually constantly from 1973 to 1986.

In my first year, I was understudying Bernard Lloyd, who's now, very sadly, no longer with us. He was one of the leading actors of the extraordinary Royal Shakespeare Company. I understudied all his roles: Orlando in *As You Like It*, Hotspur in *Henry IV*, Mercutio in *Romeo and Juliet*, and so on. Well, just before the press night of *As You Like It*, Bernard damaged his back, a serious injury from which he took many months to recover. So I had to learn, at the last minute, something like four or five roles, with hardly any rehearsal. It prompted one of the actors to come up with a cartoon of me, with a jokey 'Super Suchet' caption, because somehow I managed to pull it off. The powers that be moved me shortly after that, in my first season, from dressing room 12 to dressing room 1A, and I never, ever left that dressing room until I parted from the company in 1986, nearly thirteen years later. A new young actor jumping so far up the pecking order of dressing rooms must have been, for all the other members in the company, pretty galling – but I was delighted with my good fortune.

I want to mention here my wonderful friend Miriam Gilbert, who was a Shakespearean scholar at the University of Iowa in America. We got to know each other when I went on tour to

(Overleaf left) Peter Farago and (right) Miriam Gilbert

America with the Royal Shakespeare Company, many years ago, sometime around 1975. Later, in 1985, she was in England when I was cast as Iago in *Othello*, with Ben Kingsley taking the title role. Miriam and I would work on the play together, and have very lively conversations and discussions about the play. So once more thank you, Miriam, for all the help you gave me.

One of the many marvellous things about the RSC was the camaraderie with my fellow actors. In 1984, towards the end of my time there, I played Buller in the film *Greystoke: The Legend of Tarzan, Lord of the Apes*. We did some of the filming at Pinewood, and in one scene, I was the head of a sort of bar/café made out of bamboo and wood, as though we were in the jungle. It was like a club, a jungle club if you like, and I was the head man there; you know, sweaty, cigar-smoking, bearded chap. I can't remember exactly what happened, but the club catches fire in the film, and the rest of the sequence after that was set to be filmed in Africa. Only it was then decided that it would be cheaper if they didn't fly me out, but that I died in my club instead. The rest of the cast, most of them anyway, were from the RSC and mates of mine. One such was Ian Charleson, who played Ariel when I was playing Caliban in *The Tempest* at Stratford, and various other dear friends. I was known to them as Suche or La Suche; several, to this day, will greet me with, 'Hi, Suche.' And as we filmed my club burning down, they all ran out into the 'jungle' yelling, 'Oh, La Suche, La Suche, La Suche.' They had to go for a retake. It was a lovely film to make, because we were all mates.

Earlier this year, when I was playing Gregory Solomon in *The Price*, I received a lovely surprise from Greg Doran, director of the Royal Shakespeare Company. Greg had gone into the RSC photo library, and put together a photo-collage that encompassed some of my major moments at Stratford. Written on it is, 'Congratulations on fifty years in theatre, with

love from all at the RSC'. Without any pre-warning – I'm in my early seventies, sitting in my dressing room, in *The Price* – I get a delivery, and I open it, and what a surprise. I have to say, I welled up when I looked at it. I put it up in my dressing room and it's now in my study at home. It's one of the most special gifts ever sent to me, a real personal treasure.

On love and nature

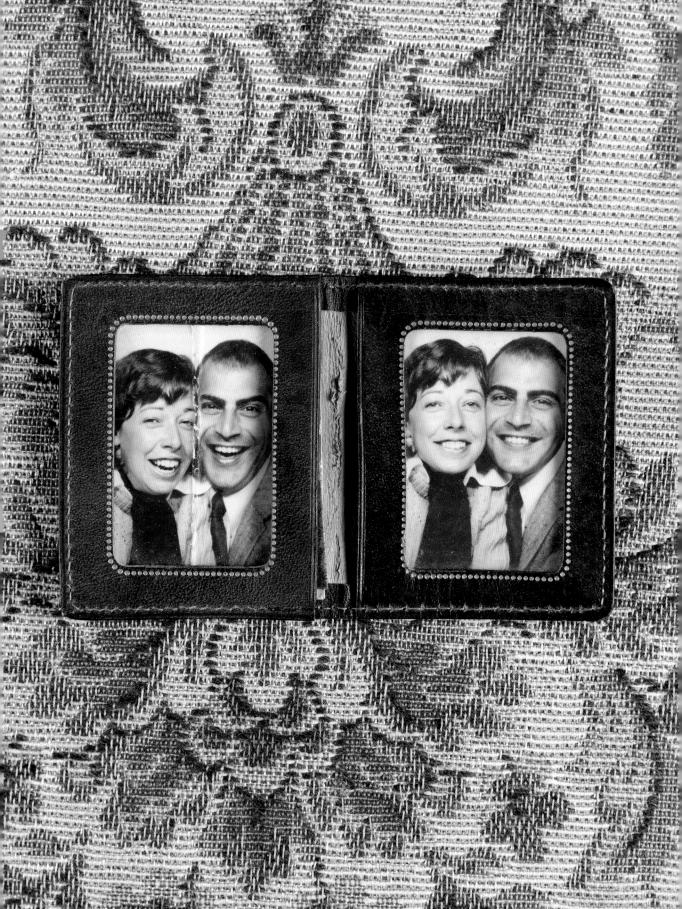

In 1972, I met my wife Sheila when we were both working at the Belgrade Theatre Company in Coventry. Sheila was an actress in that company, and when I met her, I have to say it was love at first sight. Yes, very romantic I know; no doubt those of a more cynical disposition reading this book will not believe it, or be squirming in embarrassment – whichever. But it was love at first sight. Shortly after we met, I had to have some passport photographs taken, and Sheila came into the booth with me, so we were able to capture an image of ourselves very early in our relationship. I suppose it's a selfie of a sort!

We were married on 31 July 1976, and celebrated our fortieth anniversary in 2016. I decided to surprise Sheila by going to the Savoy Hotel. Why the Savoy Hotel? Well, because, on our wedding day, we only had a one-night honeymoon, and that was given to us courtesy of my mum and dad, because I had to leave the very next day, 1 August, to take a train to Edinburgh for the Edinburgh Festival. I was going to take part in *Measure for Measure* there. But we had that night together first at the Savoy Hotel, and I decided to take Sheila back there for our ruby anniversary. I ordered forty red roses to be placed in our hotel room, one to celebrate every year of our marriage.

Sheila and I are huge canal enthusiasts. We often go to Braunston for the Historic Narrowboat Rally and I was privileged enough to help steer the very last unpowered working narrowboat – they were known as 'butties' – ever built in Britain, *Raymond*. A member of the team who constructed it in 1958 was Aubrey Berriman, one of the last of the great working boatmen of this country. He died in 2019, but he was with us on that day. They're going to put up a blue plaque at Braunston to honour his memory. A quite extraordinary man.

Our love of canals started soon after Sheila and I first got together in 1972. When I went to Stratford in 1973 to join the Royal Shakespeare Company, we soon decided that we were both sick

of theatre digs, so we decided to have a narrowboat built, which would become our first home. It was built by the late dear friend of ours, Mike Lamb, of Western Cruisers, Stratford-upon-Avon: a fifty-two-foot all-metal narrowboat called *Prima Donna*, which served as our main home for about six years. Finally, we decided to come and live back on dry land and, a couple of years later, we sold it when Sheila became pregnant with our son. But in those six years, *Prima Donna* enabled us to take our home to wherever we were working. Mainly it was Stratford, of course, but the company moved to the Aldwych Theatre in London for several seasons, and then we were able to take the boat down to Willow Wren Wharf in Southall and moor there during that time.

We had the boat in Birmingham, in Coventry, where Sheila was performing, and we did a lot of the canal system. Whenever we were going to be moored up for some time working, I would ring British Telecom, and they would come and install a telephone for us, because there were no mobile phones in those days. Everybody was very welcoming and kind to us, and since I wasn't known at all in those days, it had nothing to do with my profile as an actor. It stemmed from the generosity of people on the waterways looking after us. We paid our proper rates, mooring fees, and everything else. But we were well cared for and, as a result, canals have been a very important

Aubrey Berriman

part of our lives. Sheila and I support whatever's going on to promote them, and I'm the vice-president of the Lichfield & Hatherton Canal Restoration Trust. I believe the canals of this country are one of the brightest jewels in our heritage; quite unique, and I'm pleased to lend my name and face to help publicise them.

Canals are not just a hobby for me; it's my mission to restore our canals. They're the trunk roads of our past – they were a huge part of the Industrial Revolution as so many goods were transported by canal. There is nowhere in England where you will be far from a canal. There are more canals per square

mile in Birmingham than there are in the whole of Venice. If you look at a map of the canals of Britain, it looks like the veins of the human body. Every single small industrial town in the United Kingdom is linked by canal and, if they were all to be restored, you could get anywhere you wanted to by boat. They form the most extraordinary network.

Canals are now largely a pleasure ground for the present and future. But they are more than that – restoring canals benefits fishermen, walkers, cyclists, nature lovers and nature itself. The whole environment can be enhanced by a simple bit of canal restoration. It's something I feel very passionately about.

Since we got rid of *Prima Donna*, we've had two other narrowboats, and a Dutch barge. We can't seem to keep away from water.

When I was a young boy my passion was ornithology; I loved birds, and still do. Not to photograph; I'm not a nature photographer. I just love animals. In the same way that I don't read fiction, I don't watch drama on television but I do enjoy documentaries, especially David Attenborough's work, and my favourite voiceover jobs are always nature documentaries. I narrated a series called *A Year in the Wild* recently. It went through each season in places like Canada and Alaska. It was a lovely job to do but I had to make sure that I watched each film before I started voicing it, rather than watching the film as I narrated it; otherwise I'd get distracted by the beautiful imagery!

The beauty of nature is unsurpassed by anything else. I think that it's absolutely vital to look for the beauty of nature in the everyday, and not the ugliness of what we have created. We live in a wonderful world and – like many others – I feel frightened that we're destroying it. We're not taking that seriously enough, and when there are big nations not leading the way in conservation, recycling, renewables and so on, it sometimes feels very hard for the individual to make a

difference. We're all being asked to break habits that have been formed over many years. More laws should really be put in place to help save our planet.

I'm a visual person: I look for beauty. And it is there. Not just externally but within everybody. And we, as humans, are the only beings on this planet who have the ability to care, to love and to cherish. We are blessed, but we must make more use of that ability when it comes to nature.

Another thing I love is travel. I feel rather guilty that I've not been able to travel as much as I'd have liked with my family, due to the twenty-five years of my life taken up with *Poirot*. We used to shoot those series in the summer and, because of that, I was never really free in the summer holidays. But I couldn't say no to that series as an actor. I felt such a responsibility, dedication and loyalty to

that role. However, it did mean that for twenty-five years of my children's lives, the time when they were growing up, the only travel I could typically find time for involved my work. I want to travel more now, and go back to some of the places I've already visited.

I've been to most countries in the Eastern Bloc, because they were great locations for filming. I've filmed in Los Angeles, doing big Hollywood movies, as well as independent ones. I've filmed in France and travelled to Germany, Scandinavia, Greece, Morocco, Egypt, Africa, South America, China, Japan. There are very few places, actually, I haven't been. Back then we weren't aware of the terrible effects of air traffic on the environment.

So yes, travelling has been a huge part of my life, but it's usually been courtesy of my profession rather than me taking time out to enjoy places as a tourist. We've done the odd city break, things like that, but they've always been rushed. When I'm working in a particular country, the audience will see the wonderful sights behind me, but all I can see is the camera and the crew behind it! It's only on the odd day off that I'm able to enjoy my surroundings when travelling for work. Now, I'm finally enjoying more time as a tourist, relaxing and enjoying myself without having to hurry back and learn lines or be in my makeup chair at 5.30 in the morning.

Travel reminds us that the world is bigger than just our small island – and I think we tend to forget that. Only recently, on a canal holiday in France, I was struck by signposts to places like Antwerp, Brussels and a host of other places in Europe; we just don't see those in the UK. We don't see road signs for anywhere apart from other destinations in the United Kingdom. 'The North', 'The South', sometimes Wales or Scotland, but that's it. In Europe, you realise you're in a continent, whereas you don't in the UK. It's an island and there's a different mentality here. My bloodline is Eastern European, so Continental Europe is important to me. Whenever I set foot on the Continent, there's something in me that feels at home.

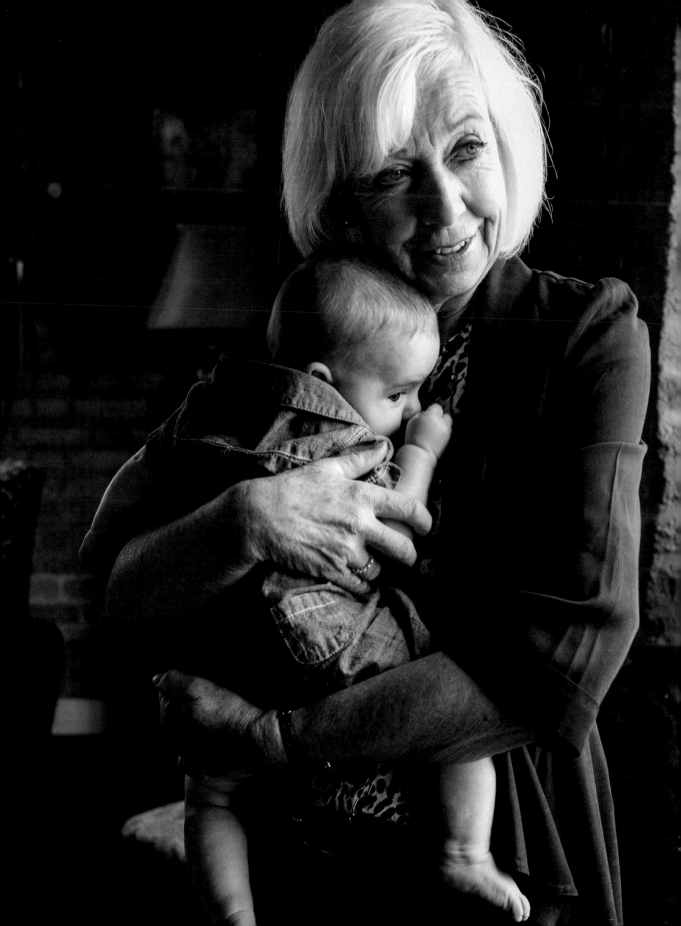

Family: part iii

I learnt a lot about my family history when I appeared in the programme *Who Do You Think You Are?* It was a deeply emotional experience for me. I knew already that a lot of my ancestors were from Russia and that there was a strong Jewish connection, both religious-wise and in that some of my relatives lived in Israel. What I didn't realise, and what came as a surprise, was that a lot of the males in our family were quite opportunistic and not always truthful about themselves. I'd no idea, either, that the family hailed from a little Jewish settlement – a *shtetl* – in Lithuania called Kretinga, not far from Memel.

I also learnt that my great-grandfather, on my father's side, was responsible for our surname, 'Suchet'. Just as in the UK, people's names often reflect the occupation of their ancestors – Carter, Potter, Smith, Thatcher, and so forth – so it was in Lithuania, and during the making of the programme we found out, through meeting various people, that our original family name was 'Shocket'. It means butcher, and it turned out that my great-grandfather, on my father's side, was actually a rabbinical butcher in Kretinga; the slaughterer who provided kosher meat for that little village.

Kretinga was in the Pale of Settlement, a prescribed region in imperial Russia where Jews were allowed to live. As soon as the railway came in, my family saw a chance of moving to a new life in South Africa, the destination for a lot of Jewish people at that time. They weren't fleeing because of any problems or persecution. They just saw an opportunity for a fresh start.

So they went to Cape Town, some of them moving on subsequently to Johannesburg and Durban. Most, though, stayed in Cape Town. During the filming of the programme, I learnt more about my paternal grandfather from a cousin based in Johannesburg. In one photograph, my grandfather looks just like Poirot, without the moustache. The parallels

are actually quite remarkable. A little man who walked with a cane, with his jacket done up tightly, *à la* Poirot, he earned the reputation of being one of the best-dressed men in Cape Town. He was very fastidious, too; used to constantly wash his hands and put cologne on them, apparently. But he could apply himself to anything and everything. He wasn't alone in that. I found out from the programme that my early relations in South Africa started a business importing and developing what they called 'Suchet Salt'. It was a family of entrepreneurs.

The family name got changed from Shocket to a more Jewish name: 'Suchedowitz'. It means 'son/child of' ('owitz') Suched. But when my father came to Britain, it became 'Suchet'. He was the one who changed it, I believe partly because Suchet sounded French, but mainly because he didn't want to be associated with a Jewish background, given the anti-Semitism that was around in those days. Funnily enough, my maternal grandfather Jimmy did something similar. His surname was originally Jarkov, which he changed to the French-sounding Jarché. There is, in fact, no French blood at all on either side of the family.

Jimmy's ancestors were also from Lithuania, which I discovered during the programme. In fact, his family was probably based not too far from my paternal relations. Because Jimmy married Elsie Jezzard, who was Church of England, and so a Christian, the Jewish line ended with him. The Jewish line follows the mother, the female line, because you always know who your mother is, but you can't always be sure who your dad is.

It was fascinating piecing together various aspects of our ancestry, right back to my great-great-grandfathers, on both sides. On my mother's side, my great-great-grandfather, George Jezzard, of Sandwich, Kent, was the captain of a sailing brig that took coals to and from Newcastle, along the east coast of England. I was able, on the programme, to meet

the great-great-grandson of the lifeboatman who saved my great-great-grandfather and his crew after he'd insisted on sailing through a terrible storm in 1860, despite everybody telling him to come into port. He got reprimanded for that and was stripped of his captaincy, for a short while, as a punishment. Perhaps it was through him that I inherited my love of boats.

Similarly, I learnt more about the roots of Jimmy and my love of photography. My great-grandfather, Jimmy's father, left Lithuania and went to Paris, ending up as a photographic developing assistant in a photographic studio. In the late 1880s, he came to England and set himself up as a studio photographer from Paris, despite having only been a studio assistant in the laboratory. He was a real opportunist, an exhibitionist too, and yes, a bit of a rogue. His studio was in Tower Bridge Road; I sometimes catch a glimpse of where it was. So, in many ways, living in London, I've come right back to my very early grassroots, which they do say often happens – we always walk in the footsteps of our ancestors.

Researching and filming *Who Do You Think You Are?* was an eye-opening journey for me, for there was so much I had not previously known about my family. In the wake of the programme, I went to the Jewish cemetery in Kretinga, looking for ancestors, but didn't find any. Just standing in that small village, though, was very moving. I saw where my ancestors' little dwelling used to be – just an empty building plot now. It was a very strange and emotional experience, to look at an empty space and think that there used to be a house there where my family lived.

I'm not led by my head, but by my gut. Not gutless: gut-led. I think part of that emotion within me, which is very strong, comes from my Jewish/Russian heritage. I'm fifty-fifty, from Russia and from Sandwich in Kent: a Russian Sandwich, in fact.

As Shylock

I've played a number of Jewish characters over the years, partly, I think, because I can relate to them. I never realised why my relationship with my Jewish background was so strong until I did *Who Do You Think You Are?*

I took on the role of Shylock as a very young actor, and, before that, I played Messerschmann, an Eastern Bloc Jew, in *Ring Around the Moon* at the Gateway Theatre, Chester. I also played Shylock again, for the RSC, in 1981, opposite Sinéad Cusack as Portia. I relate to the outsider because of being a Russian Sandwich. Fifty per cent of me is an outsider but the other half is quintessentially English. I mean, you can't get more English than Kent, can you?

I've played the outsider Blott, in *Blott on the Landscape*, Sigmund Freud and, of course, Hercule Poirot. I also played Robert Maxwell, another outsider, who came from the Eastern Bloc, and Verloc in a television adaptation of Joseph Conrad's *The Secret Agent*. It was really at this point, in 1992, playing Verloc, that I became very aware that my career was being built on playing outsiders.

To be frank, a great part of me feels a bit of an outsider in my own country, and even in my own profession. I'm not a great fan of theatricality, nor a great socialite. I tend to keep myself to myself and don't enjoy expansive theatrical parties. I'm a member of the Garrick Club rather than any of the big actors' clubs in London. I think it stems as much from my father's influence on me as anything. He didn't think acting was a worthy job. He wouldn't call it a profession. So I wonder if I've always, sort of, avoided the limelight because, subconsciously, I know he wouldn't approve. Who knows?

Being an actor, though, has taught me a great deal about myself, because one of the ways I've always studied for a role, especially in the early days, has been to make a list of similarities and differences between me and the character in question. The similarities I could ignore – I could simply

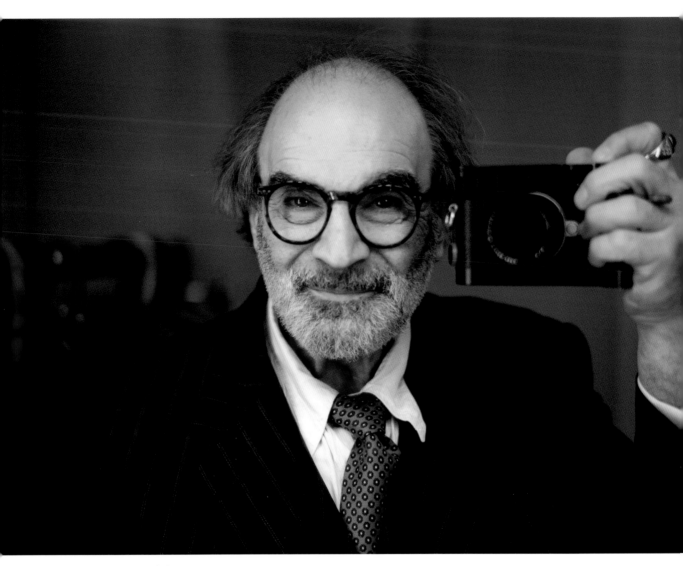

(Above) Gregory Solomon,
The Price: a self-portrait
and (overleaf) my family

embrace those – but I really had to work hard on the differences. As a young actor in rep, I would sometimes play fifty-year-olds or foreigners, and the differences were huge. As one grows older, of course, the differences become less, but, as a young man I often played elderly men. I once played an octogenarian when I was twenty-four! I was John Aubrey in *Brief Lives*, staged at the Gateway Theatre in 1971. Also, in 1972, when I was twenty-five, I played another octogenarian, Gregory Solomon in *The Price* for the first time.

I was able to fit into such character roles largely thanks to Jeremy Spencer, who taught me character work at LAMDA. He helped me to discover that I could change myself to become other people.

Despite having always felt a bit of an outsider, and this is often the conflict within me, I'm written up in the national press as firmly part of the Establishment. I'm an OBE and CBE, and apparently, sources tell me, I've even been considered for a knighthood. Whether that ever happens or not doesn't really worry me. When the other honours were offered to me, though, I was delighted to say yes. I was thrilled and flattered. When I consider my family's background, it astonishes me where I find myself today. I think that's down – in part at least – to my time at the Royal Shakespeare Company. I ended up playing huge characters for them, both in Stratford and London, which meant I became very well known as an English classical theatre actor.

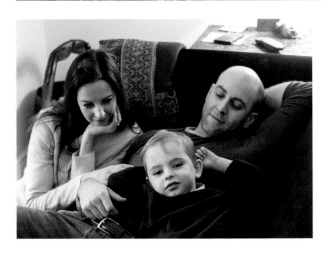

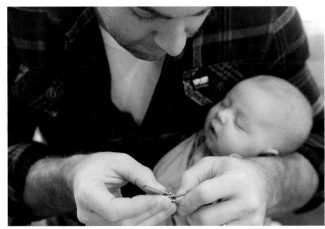

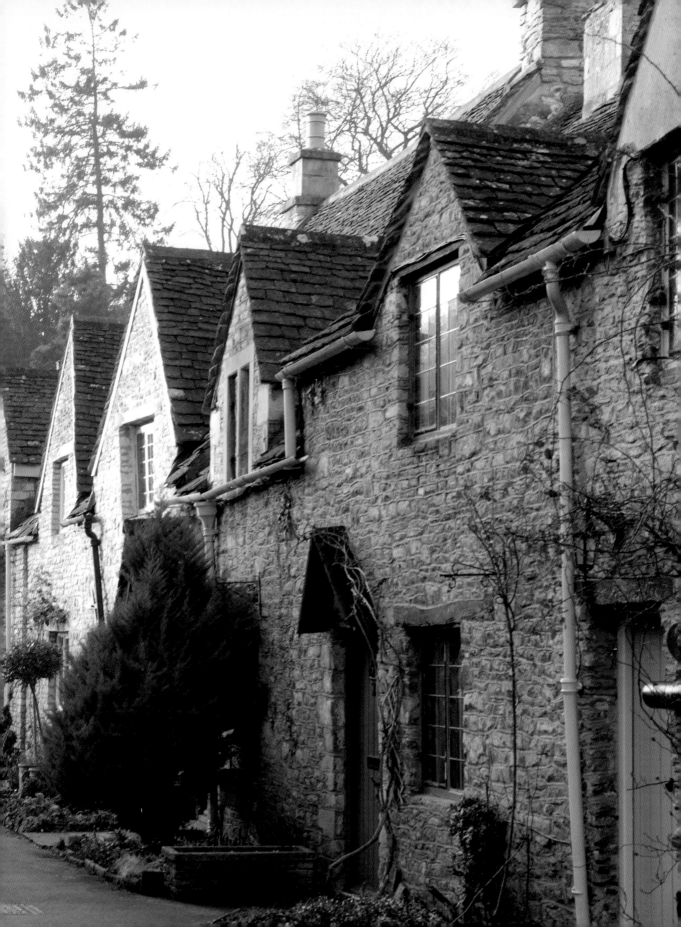

Three moments

Quite early on in my career, there were three key moments, which, looking back now, make me realise that I could have had a completely different life.

In the early 1970s, Moss Bros in Covent Garden used to advertise temporary sales jobs for unemployed actors in *The Stage* newspaper. The work meant you had to be there regularly, but you could leave for auditions, and stuff like that. Having spent nine months unemployed, I applied to join them in 1970, and was doing very well as a salesman. Then Monty Moss decided he wanted to bring in a whole new line of clothing, so he challenged us sales reps to sell off the store's stock of formal tailcoats, trousers, waistcoats, evening dress and so on. Well, it occurred to me that most major hotel restaurant staff wore tails and formal dress. So I had a card printed saying, 'Bargain tail suits to be had; contact the bearer of this card', and sent it round to all the big establishments: the Savoy, Cumberland, Dorchester, and so on. Before long, I had queues outside Moss Bros in Covent Garden (it's a Tesco store now). And the only person they wanted to deal with was me. The other salesmen were furious. I'd learnt some tricks of the trade from an elderly salesman, and ended up selling so many suits for Moss Bros that Monty wanted to meet me, to offer me a full-time job with the company. It was coming up to Christmas and we were very busy. The job, I was told, was that of junior manager in their Manchester branch, and, given that I'd recently been out of work for nine months, I seriously wondered if it might be worth changing career. *Maybe Dad's right*, I thought. *Maybe this isn't for me – perhaps I should go into the world of retail instead.* I considered it quite seriously.

Anyway, I went in a few mornings later for my meeting with Monty Moss, and Mr Warren – the hiring manager – stopped me at the door and said, 'Oh David, you've had a phone call.'

'What, where?' I answered.

'Here, you've had a phone call here. This is the number, and the name of the person you're to ring. It's urgent, apparently.'

'Well, I don't know,' I protested. 'I don't know this person, and I've got a meeting with Monty.'

'I know all about that,' said Mr Warren, 'but this person is very, very agitated. Make a quick call, and I'll tell Monty you'll be five minutes.'

So I go to the phone – a public phone, so I had to put money in – and a voice came on the other end: 'Hello?'

'Oh, hello, good morning. I've been given a message to ring this number; my name is David Suchet.'

'Ah, David.'

I still didn't have a clue who it was. 'Do, please, forgive me,' I started, 'but who am I talking to?'

'What do you mean, who are you talking to? I'm your agent, darling; your agent, Barry Ford.'

'My agent? But I haven't heard from you in such a long time.'

It turned out he had a walk-on role for me in a series of *The Professionals*, but, without even having a chance to look at a script, I needed to fly to Venice that weekend – it was now Thursday – and say yes or no to it. 'Well,' I thought, 'I'm an actor, aren't I? I've been offered this role.' So I said yes. I went to Mr Warren and said, 'I'm not going to the meeting with Monty Moss.' And that's how I ended up not going into retail, but continuing as an actor.

The second moment was a few years later when there was another job offer that could have stopped me pursuing my acting career. I went, in 1975, to the University of Nebraska in Omaha, to be a visiting professor of theatre, because the dean of the university, Jerome Birdman, had seen me teaching in New York; members of the RSC used

to deliver classes in New York universities, and various others, while we were performing our roles. I was there playing the king in *Love's Labour's Lost* and the Fool in *King Lear*. I taught at the university for a whole semester, from January right the way through until March or April, during which time, as well as taking classes, I directed a production of *A Streetcar Named Desire* and took part in one of the plays staged at the university, as a guest.

Jerome Birdman had Sheila and I over to dinner one night, and was so excited about what I'd achieved in the university that he offered me a full-time job there if I would come and live in Omaha, and become tenured – which meant that I would be the head of the English and theatre department. Just think of that: me as an academic! I remember being so taken aback at the idea that I fell on the floor. I just dropped off the settee in shock.

Sheila and I did talk about it. They would provide a house and a car, full education for any children we might have, and the assurance that, when they came of age, they would go to Omaha University. My whole life would be planned for me: I would become a teacher, a professor, in America, and I would stop acting. Jerome did say, 'Oh, if a role comes up in England you want to do, I'm sure we could find a way.' But, when I thought about it, I decided I couldn't do it. Despite the very tempting salary, I knew it wasn't for me.

The third key moment came in the early 1980s in Hollywood. The first major Hollywood movie I ever did was *The Falcon and the Snowman*, with John Schlesinger, the legendary director, who became a dear friend of mine. John loved theatre, and had seen me at the RSC. We'd often have dinner together, and got on so well. In the early 1980s, he began making this film with me, Sean Penn and Timothy Hutton. The film was about two disillusioned American guys, played by Sean and Timothy, passing on state

secrets to Russia through their handler, Alex – played by me – in the Soviet Embassy.

We had to go to Mexico to film, which meant I was away at Christmas, and my wife had just had our daughter, our second child, Katherine. I remember feeling terribly guilty about leaving them, but of course it's part of being an actor. It was the first big movie offer I'd ever had and a chance to work with this legendary film director. I enjoyed making the film hugely, and it was a moderate hit when it came out. As a result, I had an offer from ICM to go to America and be one of the English actors in Hollywood, with – if not precisely the promise of – the potential for many film scripts. They said they would find accommodation for me and my family and set me up to work in Hollywood as a film actor. I returned home and we talked about it, over and over again: were we prepared to leave England? Our children's education was the deciding factor – our first child, Robert, had already begun his early schooling; that, and the fact that I was really a theatre actor. My stable was the Royal Shakespeare Company. 'I don't just want to be in films,' I decided. 'That's not the sort of actor I want to be.' So we declined. And it turned out to be the wisest 'no' I've ever said. My career would have been very different indeed.

The offer of a professorship had been attractive in many ways. It offered stability, for one thing, and regular work. But I've never regretted my decision. I have personal regrets, but I don't have life regrets. Never do anything you're going to have a life regret about, because it will affect you in so many negative ways. I've made huge mistakes – that's life – but I've no major regrets. Why should I? I have had the most blessed life.

And it turned out to be the wisest 'no' I've ever said. My career would have been very different indeed.

I'd never want to abandon theatre. I've played in movies and great television series like *Freud*, *Oppenheimer*, *Blott on the Landscape*, but I first made my name as a classical actor in the theatre. And that's why, during my twenty-five years as Poirot, whenever I was offered the chance to do theatre in between the series, I would grab it. I don't want to turn my back on theatre. I want to embrace radio, film and television, yes, but no one thing to the exclusion of any other, least of all theatre. So, even to this day, you'll find me in the West End or many other theatres outside of London.

It has always amazed me that human beings are separated by the smallest amount of DNA from an ape. It may be only by the smallest amount on paper, I can understand that. But we're separated by something far, far greater. We are the only animals on this planet able to take a piece of paper, draw five lines on it, hear something in our head, and then, using black dots and so forth, write what we call 'music'. Some interpret music through dance. Others put words to it and create 'songs'. There are 'musicals' and 'operas'. Some create 'instruments' with which to play it. Then there are writers: some of novels, others of dialogue in what we call a 'play'. Yet others will stand on a stage and perform these works.

I don't know of any animal other than *Homo sapiens* that will pick up a piece of clay, or another material, and make figures, sculptures. I don't know of another animal that can shape images for people to assess, appreciate and enjoy; that express themselves through sculpture, painting, drawing, brass rubbing, and a host of other art forms.

We love to entertain and be entertained. It's got nothing to do with display, courtship, mating; it's about bringing pleasure to others. We don't need language to interpret music; it speaks to different people in different ways.

Likewise, we can be moved to tears sitting in a theatre and watching, being involved in, what's happening onstage. There

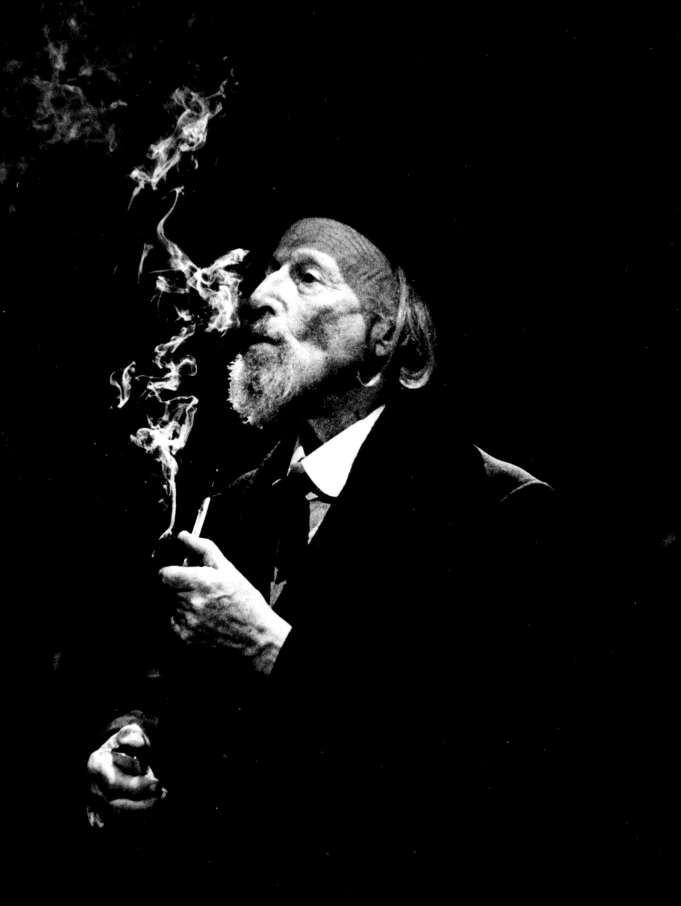

is no other animal on this planet that can do that: none – the gap is huge.

The performing arts are vital to being a human being; a huge part of who and what we are today, with music, pop videos, orchestras, theatres, dance, ballet, and all its other manifestations. They're all a key part of our society and, properly nurtured and encouraged, I believe they can significantly contribute to the wellbeing and harmony of all, a great healer for society and mankind, a bridge between nations. The conductor Daniel Barenboim had an orchestra of Palestinians and Israelis, and they performed together. How wonderful is that? Two nations in conflict, brought together through music. Sadly, support for the arts is too often neglected by ruling governments.

I consider myself privileged to be part of that world of the performing arts. It's given me a particular purpose in life: to serve my writers, who are my creators, rather than just serve myself. That was the whole basis of my interpretation of Poirot. I didn't want it to be David Suchet's Poirot. I didn't want to be an individual new Poirot. Because of the way I work, the only Poirot I could be, as soon as I started reading Agatha Christie's text, was the one that I believed she wanted him to be. The more I read, the more I encountered a character who had never been portrayed in this way, whether on stage, film or television. I was meeting a new person and I compiled a large dossier of notes, my only concern being what would have pleased Agatha Christie.

She wasn't alive, so I couldn't talk to her, but I knew she was famous for not liking any actors' interpretations. So when her daughter, Rosalind Hicks, approached me and said, 'I think I have to tell you that I believe my mother would have been very pleased,' that was a huge moment for me because, in that instance, in the eyes of the family of my creator, I had served them well.

All this is a long-winded way of saying that the reason I'm an actor and have stayed one is that I believe in the performing arts. I would go as far to say that we would be infinitely the poorer without them. We humans have a mind, body and spirit, and that makes up our soul. We can stimulate our minds through education. We can look after our bodies through going to the gym, playing sport, and so forth, by being as strong and healthy as we can. But our spirit is nourished by the arts. If we think of our souls as the three legs of a stool – mind, body and spirit – we need all three to be strong, in order to thrive and be at our best, in order for our stool to stand solidly on the ground. It's the arts and our creativity that separate us from the rest of the animal kingdom. Neglect that, and we will fail to realise our full potential, our capacity for existence.

Imagination is integral to our artistic side, because it leads to creativity. It can be summed up in one magic word we'd all do well to repeat time and again each day: the word 'if'. *'If* that tree could speak,' I might ask myself, 'what would its voice sound like?' Picture a 500-year-old oak tree. What has it witnessed and experienced during its life? What tales could it tell, if anybody were able to understand its language. Imagine if they could somehow communicate with each other, from the deepest corners of Cornwall to the top of Scotland, purely by rustling their leaves. Just think how much a story might become exaggerated by the time it reaches Edinburgh.

If I did such and such, what would happen? If someone does that, what might it lead to? 'If' is the magic word I use when I'm studying character. How should I do what they do? If my character does something in a play, how will I do it?

Children use their imagination all the time. 'Bang, bang, you're dead,' they cry when they play. 'What would happen if?' is the gateway to children's imagination and their world. Enter into that world; go there.

The question 'what if?' lies at the heart of extraordinary stories like *Alice Through the Looking Glass* and *Alice in Wonderland*. If I drank the liquid from that bottle and ended up two inches tall, what would my world be like, and how would I perceive normal life? How big would that chair be? How big would a human being seem, when I'm only the size of a tiny mouse? 'If' is the wonderful catalyst. Creativity, imagination, art. Those are what make us unique as *Homo sapiens*.

Serving my writer

During my time at the RSC, there was an occasion I will always remember, a moment of realisation about why I do what I do. When I first went to drama school in 1966, I was very keen to learn about acting techniques. I read the works of Konstantin Stanislavski, the seminal Russian character actor and theatre director, for example. Those, amongst many others, were very important to me in my early development.

But, by the mid-1980s, I was getting fairly bored with being an actor. I was sitting at my desk one day, studying a role, and I thought, 'I'm getting bored.' I'm simply not interested in me, and anyone who knows me well knows that. I'm not egocentric. I was getting very fed up with thinking about me, all the time, as an actor. How am *I* doing? How do *I* play this role? I, I, I, I, I. That's how I felt I had to approach all the roles I was being asked to play – how do I play this role? How boring. And then I tried to work out what it is that I do and why do I do it. Well, I become a different character, and so I looked up the Greek definition of 'character', and I got words like 'shape' and 'large object' – that's where 'caricature' comes from – and I thought, 'I don't do that.'

What interests me in acting is becoming a different character, yes, but also changing my person. When I act, I become a different person; I am developing a new personality. So I looked up the Greek definition of 'person' and I was fascinated to discover that the word *'persona'* derives from the mask Greek actors wore when they first moved from miming to spoken dialogue; one with a little hole in it for the mouth. It was called the *persona*. From which we get 'person', from the Latin 'per-son', meaning 'through sound'.

I suddenly got excited by this: 'through sound' – the voice makes me a person. So I would develop ways of working to find the voice of my character before I found anything else; seek him through his language. Was it emotional? Was it full of alliteration, onomatopoeia? That would guide me. Was

VICTOR: What?

ESTHER: You looked beautiful.

He laughs, surprised and half-embarrassed—when both of them are turned to the door by a loud, sustained coughing out in the corridor. The coughing increases.

Enter Gregory Solomon. In brief, a phenomenon; a man nearly ninety but still straight-backed and the air of his massiveness still with him. He has perfected a way of leaning on his cane without appearing weak.

He wears a worn fur-felt black fedora, its brim turned down on the right side like Jimmy Walker's—although much dustier—and a shapeless topcoat. His frayed tie has a thick knot, askew under a curled-up collar tab. His vest is wrinkled, his trousers baggy. A large diamond ring is on his left index finger. Tucked under his arm, a wrung-out leather portfolio. He hasn't shaved today.

Still coughing, catching his breath, trying to brush his cigar ashes off his lapel in a hopeless attempt at businesslike decorum, he is nodding at Esther and Victor and has one hand raised in a promise to speak quite soon. Nor has he failed to glance with some suspicion at the foil in Victor's hand.

Notice foil.

VICTOR: Can I get you a glass of water?

Solomon gestures an imperious negative, trying to stop coughing.

ESTHER: Why don't you sit down?

Solomon gestures thanks, sits in the center armchair, the cough subsiding.

the character completely intellectual? Look at Poirot. Is he a walking brain? Or is he down here, where I am, in my gut, in my emotions? That's why I prepare for voiceover roles in exactly the same depth as a physical role: the voice is so important.

But I also realised that if I was going to do this properly with the person I was to become, then it was no longer a question of, 'How do I play the role?' It was about what the writer wanted me to do. I understood, finally, how much we owe to those wonderful people out there, men and women, who write dialogue, and give it away to people like me and directors to interpret and perform. They could've written a novel, but they didn't; they wrote instead for performing arts, the theatre. So ever since that time, right until now, I've stopped saying, 'How do I play a role?' What I do is, I read the play, or material, without me in it, to find out what's missing, what qualities it lacks. It's like cooking: you're tasting your stew – what's missing?

So, when I took on the role of Iago for the RSC in 1985, I studied *Othello* for a couple of weeks at home, without thinking about my role in it, then wrote a long essay about the play without any reference to Iago, or any of his influence. Not for anyone else. Purely for myself and as a way of preparing for the role. If you read about Iago in textbooks, you'll come across phrases like 'motiveless malignity'. But how does one play 'motiveless malignity'? That's why I rewrote the story of *Othello* without Iago in it – because I needed to understand what his character brought to the play. I needed something more concrete than the textbooks' 'motiveless malignity'. I needed to go back to the play to see why Shakespeare had included Iago at all.

Basically, and very briefly, my retelling of Othello without Iago goes like this: Iago and Othello travel out to Cyprus to fight the Turks. But on their way, the whole fleet, the enemy fleet, is destroyed in a storm, and so we're left with Othello and Desdemona; no war to fight. They've just got married, which is why she's with him, and they end up having a wonderful honeymoon.

So, I learnt, sitting at my desk wondering about my purpose as an actor that day, that my purpose is to serve my writer, not to serve me.

Put Iago back, and what happens? Everybody gets caught by a particular disease, what Shakespeare expressly calls a disease: jealousy. Iago's first speech in the play shows him to be furious that Cassio has been chosen by Othello to be his lieutenant. He's jealous; so much so that he wants to hurt everybody around him, despite seeming to be the most popular, charming bloke in the world. Instead he ends up responsible for numerous deaths, including Othello's killing of Desdemona and then himself. If you play every scene for what it's worth as Iago, you end up as a complete erratic psychopath.

So, how do you play motiveless malignity? You can't really. You can't 'work out' evil; just focus on psychopathic behaviour.

Reflecting further on the play, it dawned on me that though most of its characters are Italian, including Othello and Desdemona, Iago is Spanish. He's an outsider, with a pretty low social standing. It would be perfectly permissible to play him with a Spanish accent. His name roughly corresponds to Jack, which fits well with his character of the nice guy down our street. 'Hi, Jack. Everything all right?' 'Yes, thank you.' 'How's your family, Jack?' 'Oh, they're well, thank you.' 'All right, Jack. See you, Jack.' Nice guy, Jack. Who ends up as one of the most prolific killers in Shakespeare.

So, I learnt, sitting at my desk wondering about my purpose as an actor that day, that my purpose is to serve my writer, not to serve me. And, from that moment on, that's how I've approached all my roles. I take them out of the play and work out what's missing. If I have a line and I don't know how to say it, I take it out of the scene. What does the line provide? What is missing from the scene if that line is not there? Then, at the very least, you can play what you provide. Your function will give you a clue as to where you are in that scene.

There have been three standout moments during the course of my career, when I have had the privilege of hearing that ultimate validation as an actor, that

I had served my writer well. The first I have told you about already – when Agatha Christie's daughter told me that she thought her mother would have been very pleased with my Poirot. It meant a great deal to me to hear her say that.

The second was when I played Blott in *Blott on the Landscape* in 1985 – an adaptation of Tom Sharpe's extraordinary and wonderful book of the same title. It was playing Blott, not Poirot, that first made me into a household name. Blott – an ex-prisoner of war of Italian/German extraction – is a handyman gardener in this majestic manor house, and he falls in lust with the lady of the house, played by Geraldine James. George Cole was the master of the house; it was a brilliant cast, and I had such fun playing this little outsider whom Tom Sharpe had created. Tom said he would write a sequel, but then he got writer's block, bless him.

Blott was an extraordinary character, and the whole thing was a fantastic adaptation of a wonderful novel, so unsurprisingly it became extremely popular. It was on BBC2. We only had three or four channels back then, and it became a sort of cult programme, especially because Tom Sharpe had a huge literary following; they really liked the adaptation. One of the most moving moments of my life, as an actor, was when I received a phone call late one night. It was Tom, and he said, 'I just want you to know that your creation of Blott is exactly what I had in mind when I was writing my book.'

Finally, appearing as George in *Who's Afraid of Virginia Woolf?* The story goes right back to 1975, in New York, when I saw Ben Gazzara – a genius of an actor – play the same role on Broadway. I was there with the Royal Shakespeare Company and I couldn't afford any of the posh seats, so I was sitting right up in the gods, but I was entranced by Ben's performance as George. 'One day,' I said to myself, 'that's a character I really want to play.'

Jump forward twenty years. In 1995, I'm filming in New York, and I hear that *Who's Afraid of Virginia Woolf?* is going to be put on at the Almeida Theatre in London, starring Diana Rigg and with Howard Davies directing. And I knew Howard, because he was an assistant director at the Royal Shakespeare Company when I took over all my understudy roles. He'd been hugely instrumental in helping me through that period, and we'd become very close. Anyway, I knew he was directing the play and I also knew Jonathan Kent, one of the directors at the Almeida Theatre in Islington, so I rang up my agent and said,

'Get me to see Howard or Jonathan. I want to play George. I have got to play George. I'm desperate to do it, especially with Diana Rigg.' Howard responded immediately, saying it would be a wonderful idea. Jonathan Kent agreed, but said, 'We have to convince Edward Albee in New York.' So they went to New York, and they convinced Edward – the playwright, who only knew me as Poirot – that I was first and foremost a classical theatre actor and that I would serve the play, and him, and George, extremely well.

But playing and rehearsing George was one of the most challenging roles I've ever undertaken. I didn't just want George to have a slanging-match relationship with Martha. I saw the play as a love story. I saw George wanting to kill the imaginary child that Martha dotes on, and propagates, and lives only for. I saw him wanting to kill that child in her mind, to save his marriage, rather than just shout and be angry, and everything. And I noticed, in the play, that he, during that whole evening of rowing, with the young couple coming in, would pour drinks and get everybody drunk, while he, himself, would only have one drink.

This surprised me because he usually is portrayed as getting very drunk. I played him cold sober. He gets everybody else drunk. He's the puppeteer. And he decides, 'This is the night to kill that child,' because he loves her so much. That's the way I played it. On the final run-through in the rehearsal room, Edward Albee was sitting there. He's a man of very few words, and at the end of the run-through, he just said, 'OK, thank you very much,' and Howard added, 'Yes, thank you all very much – I'll discuss things with Edward and give you notes tomorrow.'

I was last out of the rehearsal room, and Edward Albee suddenly said, 'Mr Suchet.' 'Yes,' I answered – for some reason, I almost called him sir. 'I want a word with you,' he said. 'Oh my God,' I thought, 'what does that mean?' If Edward Albee wanted a

word with me, it could only be negative. Well, he took me to the end of the rehearsal room, and said, 'Why the fuck are you playing it like that?' 'Like what?' I said. I was really frightened. 'The way you're playing him,' he continued. 'Tell me why.' He was quite animated. So I took a deep breath, and said, 'Well, Edward, if I may be allowed to say, I've seen what you've written for myself, and I discussed it with Howard' – here was me attempting to justify everything. 'I believe you've written a love story, rather than just a slanging match between two people, and I see that George is trying to save his marriage, because he loves Martha with all his heart and soul, and it's the only way he's going to keep her.' And he nodded, took off his glasses, looked at me, and said, 'That's what I wrote' – then turned on his heels and left.

Choosing a role

As Augustus Melmotte

How do I choose the roles I want to play? Well, I'm fortunate enough now to have the luxury of choice; the privilege of being offered a wide variety of roles. There are tiny roles that I will say yes to. I will also say yes to big roles, lead characters. And equally, I will occasionally say no to big roles. Why?

First of all, the film, radio, television or theatre production in question has to mean something to me. The message of the playwright or author is important. So when I'm offered a role – let's say a big one – my first job, after reading it and deciding it's something I wish to be involved in, is to speak to the director, and discover how they see the play, how they interpret it, because they're going to direct me in the production, so it's important we have a similar vision.

There are certain playwrights whom I'm particularly attracted to. Shakespeare, of course. I love Russian dramatists, particularly Chekhov. But above all others for me is Arthur Miller. I don't know what it is about the characters of his that I've played, or the language of his that I've had to taste, to chew, to digest, to speak. But his way of writing sits within my being and in my mouth in a way that I've not experienced with any other writer, even Shakespeare.

If I don't relate to the play in my gut, or to the character on offer, then I can't do it. I really can't. Also there are certain things I would not like to do in the theatre or on film. I don't want to be in explicit sex scenes, for example. I'm not that sort of person, nor am I much to look at, either; so I wouldn't be an immediate choice for such roles and, mercifully, I was not often asked to do them.

I have taken part in romantic scenes if the role called for it, though, and if the director requested it; when I was playing Verloc in *The Secret Agent*, for example. Verloc was hardly the most attractive character in the world, and when they filmed me making love to my screen wife, I was actually fully

clothed anyway, so I had no problem doing what the director asked in that case.

But then there was another incident, after which I really did have to put my foot down for good. I was playing a character called Mesterbein in *The Little Drummer Girl*. Directed by George Roy Hill, it was a 1984 adaptation of John le Carré's novel of the same title. I was playing a character who got killed, his throat cut from behind while making love to a woman. I remember talking to the director about this. 'I'm not happy doing sex scenes,' I said. 'I get embarrassed.' 'Oh, no, don't worry,' he said, 'don't worry; the girl that you're with, she'll be wearing a bathing costume, and you'll be wearing swimming trunks or your underwear. I just need your back to be naked so that we see your head being pulled back. We'll cut the scene there, and then return to see the knife going across your throat.' And that's what you see on the film, to this very day.

What you don't see is that I'm sitting beforehand in a dressing gown, getting ready to go on set, and in walks this most gorgeous Russian model, who takes off her dressing gown, wearing a G-string and nothing else . . . and I said to myself, 'Is that the woman I'm going to have to pretend to make love with?' My heart started beating with fear and embarrassment. So I went to the director and said, 'She's got nothing on. You told me she'd be wearing a bathing suit. I can't get into bed with her.' 'I'm sorry,' he said, 'you're going to have to. It's OK, just get on with it; it's not going to last long.' So, for the only time in my life, I got into the bed, and rolled, as I was told to, on top of this girl, who looked at me, and we both sort of gently smiled at each other, and I said, 'Hello, my name's David,' and, in her Russian accent, she told me what her name was. She was naked from the waist up, so it was very difficult for me; this is not what I do. But being a gentleman, I took the weight on my elbows. Then the director said, 'OK. On "action", I want you to go for it. You hump away there, and I will shout when

'I'm not happy doing sex scenes,' I said. 'I get embarrassed.'

(Overleaf) Peter Capaldi

your head has to be moved back, but we won't actually see that happen. When I say "cut", you stop.'

There I was, on top of this girl, and when we heard the word 'action'; well, let me put it this way: she was going for an Oscar. I leave the rest to your imagination. I didn't know what was going on but I was so mortified and uncomfortable with the whole thing that I just completely froze; I didn't even hear the word 'cut'. I remember it finally being over and hearing the director shouting at us: 'I said, "cut"!' He did actually apologise to me later. 'I'm sorry about that,' he said, 'but, you know, we have to keep going, we've got a schedule here.' It was the most embarrassing moment of my fifty-year career. I'll never, ever put myself through something like that again, and luckily I wouldn't be asked to now, unless it was a scene in a geriatric home!

The biggest role I turned down on moral grounds was a 1989 film called *Scandal*. I was offered the role of John Profumo, British Conservative Secretary of State for War; the plot covered his affair in 1961 with the nineteen-year-old showgirl and model, Christine Keeler, and the political fallout that followed. It was the first major film role I had ever been offered, with a very nice salary attached. But when I read the script, instead of thinking, 'Oh, great,' I remember thinking, 'If I were John Profumo, would I like a film like this being made about me?' Having thought long and hard about this, I said no to the role.

In fact, having turned the role down, I was offered it again, with extra carrots attached, only for me to turn it down a second time. Then I was offered it once more, with further incentives. When I turned it down the final time, those in control of the production were clearly very angry, very upset. That's probably why I didn't receive any more film offers for quite a long time afterwards. Who knows? I did often wonder.

I remember going to see the film, thinking, 'I wonder whether I should have done it.' When I talked to friends about it, several

of them said to me, 'Why didn't you find out through your agent if Profumo would've minded?' What an idiot I was. If I'd asked that, and he'd told me he wouldn't mind, I would have taken the role. But it never crossed my mind and, well, that's part of life's rich tapestry, isn't it?

Occasionally, of course, I'm offered something I don't even need to consider! That happened in 2016 when Gilly Sanguinetti, my agent at the time, rang me, and said, 'I have an offer for you.' It's always nice to get offered parts, and I always get terribly excited, until I find out it's two lines in something, and I don't want to do it. But this offer was to play in an episode of *Doctor Who*, with the wonderful actor, Peter Capaldi, in the title role, so I said to Gilly, 'Yes, please, I'll do it.' 'But you haven't read it,' she said. 'I don't care,' I answered, 'I want to do it.' 'But you never take a role without reading it,' she protested. 'Well, I am this time. I'm going to play in an episode of *Doctor Who*; I want that on my CV.' The episode was called 'Knock Knock' and I played a weird character called the Landlord. People loved it, though; and it was a thrill for me to appear in *Doctor Who*. I loved every single minute, and wouldn't have turned it down for all the tea in China. Regardless of what the role was! People often used to say to me, 'I'd like so much to be in a *Poirot*' – that's how I felt about *Doctor Who*. I was chuffed to bits.

Two very recent examples of roles I chose to play are in *Press* and *Decline and Fall*, both BBC television dramas. In *Press*, I played newspaper magnate George Emmerson, a very topical role. I read the scripts and the role wasn't that large, but I related to the character and wanted to play him. I also wanted to work with Ben Chaplin, who I really admire.

Decline and Fall, based on the book by Evelyn Waugh, is a satirical exploration of English society and public schools in the 1920s. It's a comedy, and I was asked to play the headmaster, Dr Fagan. I wanted to play him in a certain way, so I met with the director, Guillem Morales. It was a joy for me to be playing

It was a thrill for me to appear in *Doctor Who*. I loved every single minute, and wouldn't have turned it down for all the tea in China.

comedy, and a great personal pleasure to work with Jack Whitehall – *Decline and Fall* was something of a departure for him, but he was brilliant in it. Back in 2005, when I was in Terence Rattigan's *Man and Boy*, Jack's father, Michael, had been one of the play's producers. I remember him asking me if his son Jack, who was just a young boy at the time, could come and sit in on rehearsals. 'Of course,' I said. And Jack became my gopher, getting me cups of coffee and so on, while learning how the theatre worked. He came to see me in *The Price* when it was on in the West End and we remembered how we had first met. My goodness, what a meteoric rise to success Jack has experienced, and quite rightly so. He's such a clever comedian.

There are some roles, of course, I want to play more than others. As mentioned, I have a tendency to play outsiders, often fighting for acceptance. That's always held a great attraction for me. Take the life story of Robert Maxwell; it was an enormous opportunity for me. His actions – the way he behaved – was terrible. But I don't believe that anybody is 100 per cent evil or 100 per cent good. Human beings are complicated, that's what makes them real. So I wasn't put off by his actions, but, in order to play him, I had to understand him, I had to empathise with him. So I went back to look at the story of his life. He came from a very poor background in Czechoslovakia, never having shoes on his feet as a young boy, escaped Nazi occupation and then came to Britain, eventually building up a hugely successful publishing company in the UK. The fact that he had something to prove, as an outsider, really attracted me. And if you look at his background and tied that in with the sort of person he became, he was never going to be anything other than a bully. So I didn't play him as an evil character, even though I knew that he'd taken his company's pension money. I didn't play him as a criminal, but as somebody who had genuinely intended to put the money back, as he claimed. I didn't want to point the finger and judge him; if I was going to play him, I had to believe what he'd

Ben Chaplin

said. My performance in that drama got me an Emmy Award, an international Emmy; I never anticipated that in a million years. But it was an attractive role for me.

Another reason I was drawn to that role was because Maxwell had been one of my inspirations for the way I played the character of Augustus Melmotte in *The Way We Live Now*, the 2001 television adaptation of Anthony Trollope's novel. In the novel, Melmotte has a mysterious past, but has moved

Paul Kaye (left) and
Noel Fielding

to London and wants to be considered an Englishman. A
shrewd and aggressive businessman, he is finally exposed as
a conman, and poisons himself. There is a portrait of me as
Melmotte that was used as a prop during the series and, when
filming was over, the producer asked if I would like it. I keep
it now in my home, and I enjoy having it there, because when
people see it, they assume it's a relation of mine. It makes me
laugh; them, too, when I tell them, 'Well, actually, it's me.'

So, when I was asked to play Robert Maxwell in the 2007 feature-
length television drama *Maxwell*, it was as if *The Way We Live*

Now, and my in-depth study of Maxwell for the role of Augustus Melmotte, had become like a dress rehearsal for that moment. I was able to speak to Maxwell's widow, Elisabeth, and she talked to me about her husband. So when I played Robert Maxwell, although I knew I wasn't his height, his size, I knew his power, his voice, and before I went on to the film set, I would hear him speaking in my head. I'd rehearse my lines with his voice, and take his voice, his persona, with me on to the set; and while I was on that set, I would sound like Robert Maxwell, absolutely.

One of the more challenging things about taking on certain roles is learning how to inhabit the very darkest of characters. One of the most extraordinary roles I've been offered, and had to grapple with personally, was that of Gregor Antonescu, in a Terence Rattigan play called *Man and Boy*. I was first offered the role in 1993 when I was doing *Oleanna* at the Royal Court. So I read the play, and discovered in Antonescu a character so evil, so dark, that I knew, however much I might try to stretch my imagination, I was not prepared to go there. I didn't know how to touch that evil within myself. I couldn't access it. I wasn't ready.

Strangely, the same role was offered to me twice more in my career, and both times I reread it and said, 'No, I'm not ready. I can't go there.' Finally – in 2005 – I heard it was going to be staged again, produced by Michael Whitehall – Jack's father – and directed by Maria Aitken. I knew that age was catching up on me, and that if I didn't do the play then, I'd probably never get the chance again. So my agent contacted Michael Whitehall, and over lunch together I told him I would love to play the role, if he'd consider me. 'I'd love you to play it,' he responded, and that was the beginning of it.

So I started studying the play, in the way that I do, and it soon became something of a mission for me, for I discovered that *Man and Boy* was written in response to some criticism Terence Rattigan received when the so-called kitchen-sink

dramatists – John Osborne and his contemporaries – became *de rigueur*, deeming Terence Rattigan old-fashioned. He was terribly upset, and his attempted comeback, as a playwright, was this play, *Man and Boy*. Only it didn't work. It didn't work in London. It didn't work when it went to New York. In fact, it was considered such a flop that it hadn't been staged since, and the play was out of print. I had a mission, as an admirer of Rattigan's work. I wanted it to be back in print, and for it to be accessible to anybody who might want to put it on. I think he was an extraordinary writer, and ironically, whenever his plays are performed now, they get more notice than all the kitchen-sink dramatists put together. He will be the one people remember.

So, back to the performance. I was able, with the help of Maria, to go to those dark places; to really touch the character of that man who was able to pimp his son to another man. Terence Rattigan, a homosexual himself, was writing at a time when homosexuality was illegal.

At the end of the play, Antonescu commits suicide, because he goes bust and money is his god; he doesn't give a damn about anything else. He's an absolutely irredeemable character.

Accessing that kind of darkness isn't easy. I have to 'unzip myself'. Unzip anybody and there will be darkness within. There will be pain. I have to access that darkness from within myself, rather than paint it on. I don't like watching acting that is painted on. I'm drawn in when I watch musicians play and I feel that same way about actors. I used to watch Paul Scofield and other actors who I admired and, when they were really in the zone, I would be mesmerised and completely drawn in. The worst word anyone could use about any performance of mine is 'impressive'. I don't want to be impressive; that doesn't mean anything to me. I'd rather someone was unable to speak because they were so drawn into the character and what they experienced.

Take Iago and his jealousy. Within us all is the potential to be jealous. There's jealousy in me. There's jealousy in you. There's jealousy in everybody. I can tap into my own jealousy if I go into my past and access those emotions, how they affected me. And if I meditate on that, and recreate those emotions within myself, then I can develop that for my character. Even darker: I believe that most people have, within them, the capacity to commit murder, *if* the right buttons are pushed. Whether it be defending their child or avenging a betrayal. So, again, it's about accessing that seed within myself and building on it.

If I can't understand a character using my own experience then I will often talk to people who can help me understand them. Back in 1972, when I was at the Belgrade Theatre in Coventry, I played Renfield in a production of *Dracula*. It was really only a very small part but I took it very seriously. Renfield is an inmate at a lunatic asylum and becomes a sort of servant of Dracula. He eats flies, which Dracula sends him, and then he starts to feed the flies to spiders, before eating the spiders. And then he feeds the spiders to birds before eating the birds – all as a scheme to accumulate more and more life. This was beyond any kind of personal experience I could tap into, so I sought advice from a local psychiatrist.

This psychiatrist was extremely helpful, and invited me to visit one of his patients. This lady used to steal things but, crucially, she'd always start with the small – so, first, she'd take crumbs which would lead to slices of bread which would lead to her grabbing whole loaves of bread and hiding them under her jumper. I immediately saw the similarity with Renfield and leapt at the opportunity to meet her. And I did meet her, and she very calmly and sanely explained to me the compulsion she felt to start with the small before working her way up. So I was able to use that knowledge to play Renfield; there was some form of reality there which I could use as a platform. That's why I go into it so deeply, because I need a

The things that attract me to roles are usually emotional; gut reactions rather than intellectual analysis.

foundation, a platform to stand on, so that I know what I'm doing is real. I can't just accept that – say – Renfield eats flies and then spiders and that Robert Maxwell is an evil criminal, I have to know more.

I am often asked if my Christian faith affects my choice of roles. Sometimes, yes.

On faith

Hugh Dickinson

When it comes to talking about faith, I never quite know how to start, because I don't ever want to sound 'holier than thou'. I'm not interested in trying to convert anybody. Although I started life in Church of England schools, I was a confirmed agnostic for much of my life, though never a complete atheist. Equally, I've never been somebody who automatically denies what we cannot see. I've always thought that there's something 'out there', and always been willing to accept that.

Neither me nor my brothers were christened. Dad put C of E on our forms for schools because he thought it would look good, but he became an atheist, despite having been brought up a fairly Orthodox Jew, a path he rejected for good when he married my mother, a baptised Christian. Emotionally, when he was into his eighties, he began to embrace his Jewish roots again; that often seems to happen with age.

Now, I have a very strong Christian faith and I'm equally fascinated by theology. I have several religious items that have been given to me – I have a *yad*, a pointing tool used by Jewish scribes when they read the Torah, the Jewish law. They don't actually touch the book, but hold the pointer and follow the words with it. I also have some shards of clay, given to me by an archaeologist and Poirot fan, which date right back to the biblical era. They are over two thousand years old.

When I met Sheila in 1972, we were both very interested in New Age stuff. We'd witnessed the sixties, the Beatles going off to India, gurus and all that. I used to read books by the American author Carlos Castaneda, who chronicled his training in shamanism, and saw how people were affected by magic mushrooms and other hallucinogenics, but I never experimented with drugs myself. I must be one of the very few to have grown up in the sixties not to have done so. I don't know why, it just doesn't interest me in any way at all.

I was, however, always interested in Christianity, and the afterlife, but I didn't really accept any of it until my conversion in 1986, when I was forty. I was lying in a hotel bath, in America, thinking about my grandfather Jimmy. He'd always been a kind of spiritual guide for me. I would say to myself sometimes, 'What do you think, Jimmy?' I tried to imagine, I suppose, what he would have said, how he would have acted. He was a kind of lens, through which I tried to view the world. But lying in that bath, I thought to myself, 'Why the devil am I thinking like this, when I don't even believe in an afterlife? Jimmy's not there. So why do I try to tap into him?'

That got me thinking more about the subject of afterlife and resurrection. I wanted to find out more so looked for the Bible that is normally found in hotel rooms. Unusually, there wasn't a copy, and so the next morning I rang a bookshop, having decided to buy a Bible. There were thousands of religious bookshops in the telephone directory; I was in America, remember. And when my call was answered, I whispered down the phone, as though I were asking for pornography, 'You don't sell Bibles, do you?'

'Yeah, that's what we do here,' came the reply.

Having bought a New Testament, I didn't really know where to start with it. We must have touched on it at school, but it was clear that not much had stuck. I knew about Jesus, obviously, but not whether he had really existed or not. I did know that a guy called Paul was responsible for the spread of Christianity across much of the ancient world, and I knew that his letters were preserved in the New Testament, some fragments of the originals existing to this very day.

I decided to read one of those. I've always been fascinated by the Roman Empire, so I chose Paul's letter to early Christians in Rome called 'Romans'. I didn't understand much of it, but halfway through I came across a passage that spoke of a way

of life I wanted to be part of: about how people should respond to others; how one should behave and think, and how to look at the world. It was a world view I'd been searching for ever since the 1960s. Suddenly, I'd found something that really spoke to me; something I felt I'd been looking for perhaps most of my adult life. A way of being, if you like. Up until then, I had just been living from moment to moment. I wanted a career and a family, but I didn't have a coherent philosophy that I could really relate to. Christianity offered me that. The Christian world view is love.

That's why Jesus – who was Jewish, remember – responded as he did when he was asked which of the Ten Commandments – indeed, of all the countless Mosaic laws that characterised legalistic Jewish faith at that time – was the most important. He answered that all those laws and regulations were summed up in just two commandments: 'Love God with all your heart, with all your strength, with all your soul and with all your mind'; and 'Love your neighbour as yourself'.

What unifies those two statements is, of course, the word 'love'. And suddenly, it was a light, a beacon guiding my way. So then I turned my attention to the Apostle Paul, to see what he had to say about Jesus. I read of how he encountered what he understood to be the resurrected Jesus on the road to Damascus, and the dramatic conversion – the Damascene moment – he underwent. He believed he'd actually met the risen Christ, spoken to him, and that he'd been commissioned to take the message of Jesus – what later became known as Christianity – around the world. That's how it ended up in Rome.

Unlike Paul, I wasn't immediately converted. The light had gone on, I believed this was what I'd been looking for, but I was a cynic; I refused simply to have blind faith. I needed to find out more about it. There's a clear parallel here with the way I treat my work as an actor – when preparing for a role,

I always start with in-depth analysis, before I unlock the door to let it all out and freewheel, to let the role embody me.

So, if I was going to take on a faith, and to release myself into that world, I couldn't do so without finding out more about it. I didn't eventually profess total faith in Christianity until 2007, over twenty years later. That's how long it took me. It involved many, many years of investigating the claims of Christian belief, wrestling with problems such as the wars, persecution, cruelty and bloodshed perpetrated in the name of religion. People who have never even read the Bible too easily blame religion for all the problems in the world; that's much too simplistic. But I had to tackle such questions, because I shared them at the time.

So I read all around the subject; I still do today: my study is full of books on theology, the early church, Christian faith

going right back to the beginning of Christianity, including books from other faiths such as the Qur'an. I wrestled, above all, with belief in the resurrection. Paul, in his letter to the Corinthians, says: 'Without the resurrection, there is no faith.' So the whole of Christianity is based not only on the death, the crucifixion, of Jesus, but also on the resurrection. The early Christians believed he was divine *because of the resurrection* and, for me, without the resurrection, there is no faith. You cannot separate the cross from the resurrection, which is the greatest miracle justifying Christian belief in Jesus's divinity.

It's not always easy to be a Christian, especially in today's secular society. Many people are very sceptical about faith and

regard anyone who professes it to be an oddball, weird. I hope I'm not. I'd hate to come across as a zealot. I don't talk about my faith in public, unless I'm asked to; in fact it took me many years to have the courage to mention it at all; it doesn't come easily to me. And I'd never, ever bash somebody over the head with my beliefs and try and convert them – never. But I am extremely grateful for the Christian world view of love that I now have, even though I fail daily to live up to it. To love others, especially people you don't like, can be a challenge. The test is to look at the world, in all its ugliness and cruelty, and still try to show love, empathy and understanding to those of other faiths and persuasions.

I even started studying for a theological degree, but I found that too much intellectualising turned me away from reacting with my emotions and my heart. For me, faith always comes back down to what Jesus said about the law and commandments being summed up in the command to love: love God and one another. That's what I've discovered, why I converted, and why I have a Christian faith. I could've easily opened the Bible at the Old Testament and embraced Judaism, because of my family background. It's very attractive to me – but now I'm glad I'm a mixture of both Jew and Christian.

When my conversion experience started in 1986, I knew that if I was to continue or develop as a Christian, I had to be baptised. That's one of the things written in the Bible; I knew this. During 1986, I was in Portland, Oregon and met a Reverend Philip Newell, who taught me more about Christianity. Before I left America, he baptised me, as a Christian. Looking back, I pray and hope I wasn't too dogmatic when I was coming to terms with this new-found faith I had.

I want to take a moment here to pay tribute to the Very Reverend Hugh Dickinson. I owe a lot to this wonderful gentleman. He's been extremely valuable to me in my walk as a Christian. I got to know him when he was just leaving the

position of dean of Salisbury Cathedral. We've become very close friends, as we were of his late wife, Jean. He's something of a mystic; quite extraordinary: a wise and, I would say, very liberal-thinking human being. He's held my hand in my journey as a Christian, and guided me along the way. It's not easy to walk in faith, especially as an actor, and he's been extremely helpful in that. A very dear and valued friend.

It's stood me in good stead, my Christianity, in my profession, my private life, my personal life. I wouldn't claim for a moment that I've succeeded in following the way of love. I always feel I should have done better, but at least I know – or I think I do – what's right and what's wrong.

I think it's important that I relate my faith to my whole philosophy, my feelings concerning who we are; mind, body and spirit – or mind, body and soul. I'm very aware that people of faith, any faith, are now greatly in the minority. In the end, I have to believe that God is in control and knows what's going on. In the medieval world, and centuries before that, faith was a huge part of people's lives. You only have to look at how many churches there are in the City of London, in the wider UK, indeed all over the world, to realise that faith, for better or for worse, was a part of people's lives. But today it's cool to be an atheist. It's sort of fashionable to be an atheist or an agnostic, and it's certainly out of fashion to believe in something you can't prove. Faith is mystical. It doesn't offer clear answers. It doesn't necessarily sit happily in a world where logic and data seem to reign supreme.

Strangely enough, though, spiritual retreats get booked up incredibly quickly. I believe – hopefully not naïvely – that underlying this whole secular society is a need, a longing, to discover more to life than just what's there on the surface. There's a spiritual hunger; I really believe that. Sadly, people are probably embarrassed to tap into it, because it's not cool.

Such things as honouring your father and mother; not killing, stealing, committing adultery, lying or coveting others' belongings – these fundamentals of moral and behavioural law are enshrined in our legal system, to this very day. And they come from the Bible; our legal system is based on Judeo-Christianity. Much of our moral code – and this will surprise a lot of people – stems from the biblical book of Matthew: Jesus's Sermon on the Mount found in chapters 5, 6 and 7, and the Ten Commandments. Jesus talked to ordinary people, telling them: 'You don't have to be rich to be loved.' Or, 'Those who seek after being righteous will be satisfied in their search. Blessed are those who make peace and not war', and so on. It's no accident that many who don't believe he was the Son of God still say, 'He's the greatest moral teacher there's ever been.'

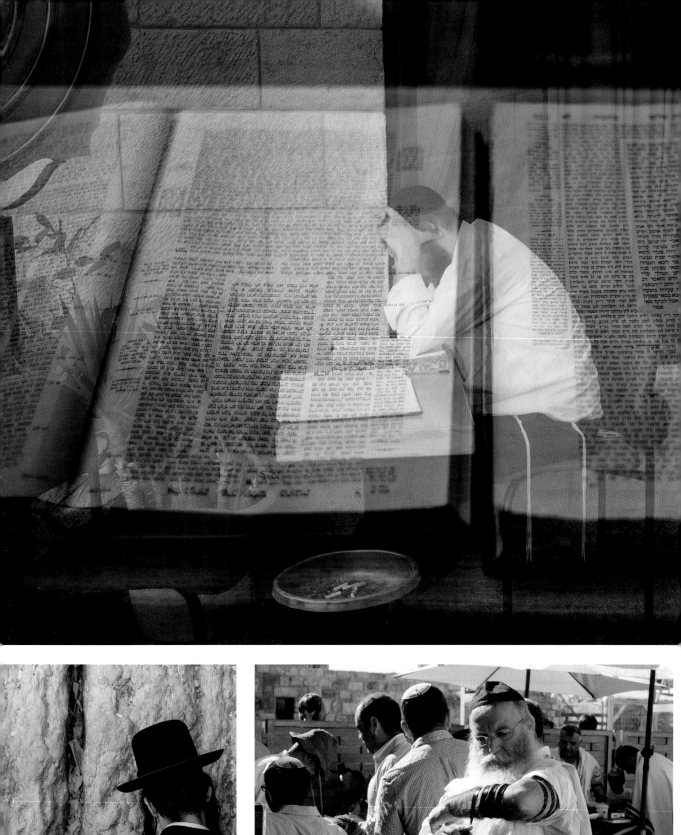

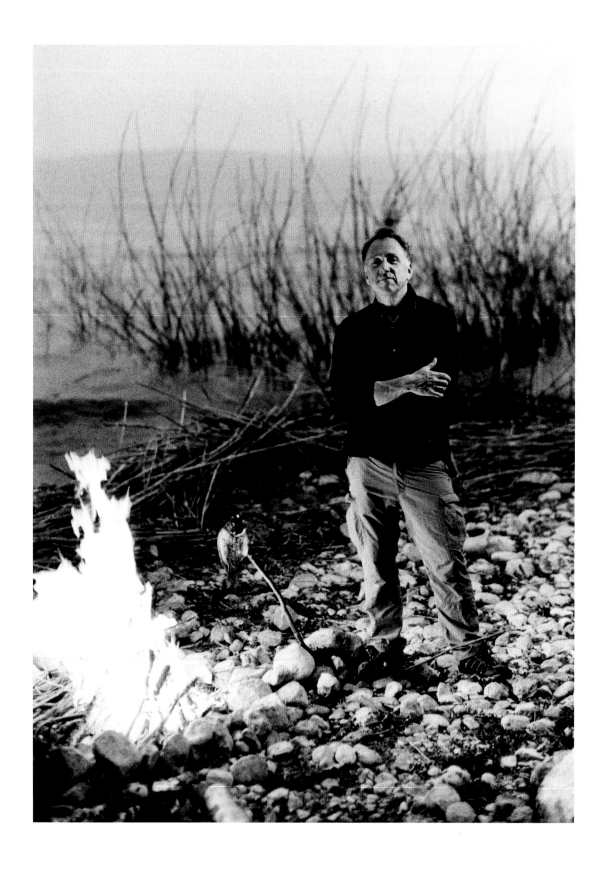

Faith and work

Martin Kemp, director of *In the
Footsteps of St Peter*

It has been a great pleasure for me to explore my faith through my work and, in recent years, I've done quite a few projects in this vein.

A project very dear to me has been my recording of the whole Bible as an audiobook. There are many recordings of the Bible, but somehow they're either adorned with music, or seem to lack a deep knowledge of what's being read. And there are very few versions in English by one voice. So I decided I would like to do this, and I approached CTVC, the comapny which had produced the 2014 documentary, *In the Footsteps of St Peter*, which I did for the BBC. They had a studio not too far from where I lived, which was convenient for me. It took around 250 hours to record with retakes and so forth. And about another 500 hours in research. What I used to do was take a book, chapter or verse, and if I didn't fully understand the message being communicated, I would talk to priests, scholars, people in Bible colleges and so forth, until I found a way to read aloud every single word from beginning to end in a way that meant something to me. As an actor, I didn't feel I could do it any other way. I wouldn't have skimped on research had it been an acting role, and I couldn't do so here either.

The words themselves were a challenge sometimes. Those long lists of family names go on and on at times, and the names are almost impossible to pronounce; I almost got to a stage once or twice when I couldn't believe I was going to carry on and do this. Until, three-quarters of the way through the books chronicling the people's laws and history, I suddenly realised that this was a roll call; a bit like when they do a roll call to mark the D-Day landings, or those killed in the Great War, to remember those who died; names of the deceased are still read aloud to this day in some of the war cemeteries in France and Belgium. It dawned on me that anyone distantly related to any of those people would be thrilled to hear their family name read out. So I said, 'I'm going to start again,' and the producer behind the glass in the recording studio went,

'Ohhhh no. No, you're not going to start that again.' I said, 'I've got to, because each name represents a family. And somebody might hear me read their family name and go, "Whoa, we were there." So the second time round, I made every name mean something. I would stop and say, 'What's the origin of that name? I must find the origin of it.' It didn't make the names any easier to read, but they took on a whole new meaning.

The Bible is an extraordinary collection of books put together by the early church. The most important thing for me, with every book of the Bible I read, was to think: who was it written for, and therefore, why was it written? Who were the people the writer intended their work to be read by? Once I was happy with that in my own mind, I could bring that out in the reading.

Many of the Old Testament books, the Jewish Bible, date from a time when a lot of people wouldn't necessarily have been able to read. So the scriptures would have been read out loud to people. That's extraordinary, isn't it? Numerous passages begin 'Hear the word of the Lord', and for them that would have applied literally.

During recording, I would wear headphones, which meant I could hear what I was reading. Very, very intensely, because headphones block out all other sound. So, in a sense, it was almost as if someone were reading it to me, and the words really affected me. Some moments in the New Testament, such as when Jesus spoke to his disciples at the Last Supper, are intimate, gentle, warm and reassuring, and I found I was hearing the words in a different way.

I've since had the honour of reading Mark's Gospel, in St Paul's Cathedral in 2017, at the beginning of Lent. I was overwhelmed to see that the cathedral was packed, absolutely packed, and I read the whole thing without stopping, from beginning to end. I think it took nearly two hours. You can see it, if you want, on YouTube if you type in 'David Suchet, Mark's Gospel

at St Paul's'. That, and the audiobook of the Bible, are a help, I hope, for anybody who wants to get to know more about this collection of religious writings from the Middle East. The Bible is not a Western book; it derives from the Middle East. Christianity is an Eastern religion.

Another great privilege for me was being invited to make an Audible podcast, *Questions of Faith – Can There Be Peace?*, which gave me the opportunity to explore one of my great passions, different faiths. It wasn't just about Christianity; we focused on the relationship between religion and conflict within the three Abrahamic faiths, thus I was able to talk to Jews, Christians and Muslims all over the world. In 2017, I went to the Holy Land while I was researching an episode of *Questions of Faith*. I was glad I had my camera – it's a very evocative country. It's hard to believe how much blood has been spilt on its soil, especially in Jerusalem. I pray for peace, I really do; for peace between Israel and Palestine.

We saw the Dome of the Rock, formerly known as David's Temple, a Jewish temple, but now an Islamic shrine. We saw some of the famous Banksy drawings, including the image of the Dove of Peace, wearing a bulletproof vest. I found that so evocative, so emblematic of all the tensions and conflict between Israel and Palestine.

But the reason we were really there was so that I could interview a lady called Robi Damelin, and a man called Bassam Aramin. These two extraordinary people, both of whom lost children in the Palestinian/Israeli conflict, have formed something called the Forgiveness Project. They do talks and stage events together, aimed at showing that even parents bereaved due to the conflict can forgive and work together for peace. I interviewed them in the garden of the Austrian Hospice in Jerusalem for the podcast.

What they are doing is a great example of what can be achieved. Bassam became involved in the Palestinian struggle

as a boy, growing up in Hebron. As a teenager, he was caught planning an attack on Israeli troops, and spent the next seven years in prison.

On 16 January 2007, his ten-year-old daughter, Abir, was shot with a rubber bullet, and killed, by a member of the Israeli Border Police, while standing outside her school with some classmates.

In March 2002, Robi Damelin's son, David, was shot by a Palestinian sniper while he was serving in the Israeli Army. He was twenty-eight years old. The sniper, as a child, had seen his uncle violently killed, and, Robi says, 'This man went on a path of revenge and, unfortunately, my son David was in the way, along with nine other people.'

I found these two people, an Israeli and a Palestinian who had both lost a child to their so-called 'enemy', yet who had now come together, hugely powerful.

(Overleaf) Robi Damelin and
Bassam Aramin

How to Stop Acting

About fifteen or sixteen years ago, I received the greatest professional gift I ever could have received. Enter Harold Guskin. He was such a huge influence on my life, and reinvigorated and rediscovered me as an actor. He was a terrific human being and a most gifted, unique teacher. He's recently died, and I miss him deeply. Harold was instrumental in a huge change in my theatre work, my radio work, everything. He was an absolute gift to me, as a person and as an actor, and I know he's been likewise to countless other actors. I don't know whether this is true, but Harold told me once that Robert De Niro used to ring him up asking, 'Man, tell me what the fuck to do with this role.' De Niro actually ran through the lines with Harold, over the phone!

I first got to know Harold while we were working on the sci-fi movie *Wing Commander* in 1999. He was a drama coach for Tchéky Karyo, who was playing a commodore, and we got talking; we soon became fast friends, really communicating with each other about acting and so forth. He was an admirer of my work and a huge Poirot fan, especially.

Anyway, cut to 2004. Harold wanted to publish a book in the UK called *How to Stop Acting*. It'd been a great success in America, and he wanted me to write the foreword for the British edition, which I did.

Around the same time, I was cast in the Terence Rattigan play *Man and Boy*, having finally felt ready for the role. I thought how wonderful it would be to prepare for that role with Harold. So I got on a plane, went to New York, and worked with him, and it was the turning point of my whole acting style. I'll never forget our first day.

I arrived at his basement flat in SoHo, New York. He and his wife greeted me, and then we started on the text. He said one line, and I the next, then vice versa, but we were still on the first page when he suddenly said, 'Do you mind if I stop?'

'No, no, not at all,' I said.

'Er, Mr Suche …' He trailed off. 'Can I call you David?'

'Yes, yes of course you can,' I answered.

'Right. Now listen, David, I'm honoured to be teaching you, the two of us working on a text together. I think you're the most fantastic actor, I really do. But what the fuck are you doing?'

I looked at him in surprise. 'What do you mean?'

And that's when he laid into me. 'Why the fuck are you trying to impress me? I know you're a good actor, but why have you already decided on how you're going to play the role? Fuck it. I'm not interested in that. I just want to see you react to the language, so let's start again.'

That, I came to learn, was the way he taught: whatever the text represented to me, I was to react to it. It's called 'lifting off the page'. But it took a while for that to sink in.

We continued for most of the day, and we didn't even get past page one, and over the next two or three weeks that I was in New York, he broke me down. 'What you're doing is just shtick,' he complained. 'I'm not interested in your shtick. I want to find out about you, how you react to language. Come on now. Be free, be open, and don't be frightened of failing.' That's the best advice I ever had as an actor: 'Don't be scared of failing.' In that moment, I felt released. Suddenly, whatever the words spoke to me, I just went with it, saying to myself, 'Fuck it, I don't care.'

It was quite late in my career. I knew what I had been doing had been working but now I came home with a completely new way of working, a completely new way of being on stage. It wasn't logical Stanislavski: how to present a character, what my objectives were, and so forth. It was just reacting in the moment.

Hans-Michael Rehberg

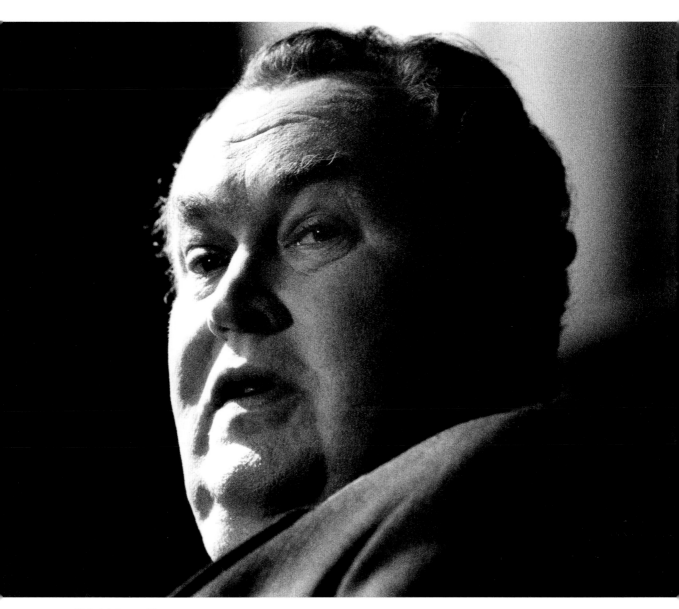

Friedrich von Thun

And don't forget, it's now fifteen years ago; I've worked on many other things in that time. That lesson has taken me to a place where, even when I'm on stage, I'm sometimes not sure what's going to happen next. I feel so released when I'm in that state; almost dangerously so. I don't want to know how I'm going to be. I don't want to know what objectives I have as a character any more. Because I *am* the character, and I'm reacting as I do in life. Who knows what's going to happen next, what I'm going to say next?

Acting styles have changed over the years. They're more naturalistic, less theatrical. I'd been at a certain stage where I felt I was stuck, and Harold unstuck me. He got rid of my acting glue, got rid of my shtick, and I was able to challenge myself and, in rehearsal, not be frightened of failing.

If you are an actor, you will hear the word 'no', but don't let that worry you. The rehearsal place is the place to open up. Children learn to walk by falling over, not by immediately standing on their feet and striding off. They hurt; they fall over; they lose confidence. And I do much the same as an actor in rehearsal. But I no longer care, because it's all part of the process, and actually, it's part of life.

Harold changed me at the ripe old age of fifty-seven. He took me to that next level, and I would regularly go back to him with every role – even, sometimes, when I didn't have a role – just to work on text.

I've got him to thank for ripping me apart, getting rid of my old theatrical shtick, and helping me to develop the courage to be free and in the moment. I owe him everything in terms of my career over these last fifteen years, not least my portrayal of Poirot. Harold changed the way I approached my work in 2003 – I had been doing *Poirot* since 1989 and would continue to do so until 2013. I worked from Christie's books for every *Poirot*, every single episode, and those who have read *Poirot and Me* will know that I study all the little gestures Christie mentions.

I put them into the TV script. But doing what Harold taught me allowed me to be far more spontaneous as Poirot. When I look back, I can see the change. I don't know if other people picked up on it, but I can see it very clearly.

With Harold Guskin and the spider's web

1929 (Oct) (Wreat crash)

1903, 24 yrs of age —

(Educated in Russia)
(Pale of Settlement)
Lithuania
Litvak.

Lower East Side

1932 4th yr of Gt. Depression

1878
53 yrs old

1923 Okay BUT Hyperinflation

Panic of 1904 (1907) Stock Market fell 50%)
San Francisco Earthquake.

1898 America Declares War on Spain USS MAIN

hit a Mine in Spanish Waters.

= Cuba became part of USA.

Ceded Puerto Rico + Guam to USA.

Daughter Committed suicide 1916

Born 1879 89 yrs
Left Russia 1903 - 24yrs

I was 36 yrs of age.

May daughter was 15 yrs of age in UK.

Married 1st time 19 yrs in lithuania 1898 Died in childbirth
First World War.

2nd time 22 yrs " 1901
1914 - 1918

3rd time 5 1yrs USA ~~1917~~ 1930

4th time 75 yrs. USA 1954 (14 yrs now)

1879
54
1930

Appraisers Association of America founded 1949. 70 yrs

Russia Revolution 1917.
March 8th
7th Nov

Gallagher + Stean 1923.

14 yrs old.

The spider's web

Gregory Solomon's spider's web

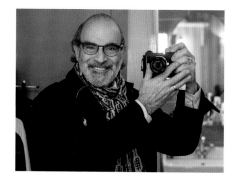

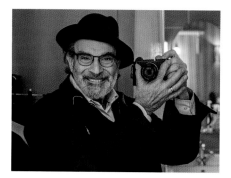

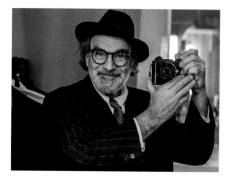

Becoming Gregory
Solomon

Harold Guskin gave me another gift of great value during our time together: the spider's web. Harold and I used to philosophise together about life, nature, art and acting, about how the web of our lives is bound together. He gave me a plate once, to illustrate this and to remind me of our discussions: a plate emblazoned with a spider. We human beings are rather like spiders. They spin their web from behind, and it's only when they get to the end of a particular line of silk that they turn around and can see the shape of what they've been building. Similarly, we humans don't know what we're spinning as we go through life, but every now and again we will turn round and look at our life web, and notice how this led to that, which led to that, and so forth, without us realising it at the time.

It's the same with characters in a play. They don't know what they're spinning. A play is just a slice of life in that character's world, that character's development. It's simply a snapshot. They had a life before that's led to the events portrayed, and unless they die, they'll have a life after. So you're spinning as you go. You're spinning your web, at every moment, but you don't know what you're spinning, until you turn around and look back.

This is an absolutely crucial thing to remember when preparing for a role and is something I always hold at the forefront of my mind. So, let me talk a bit about how I prepare for a role, specifically a play, but I use similar techniques for every role I take.

Let's take *The Price* by Arthur Miller. So, I get the play, and, irrespective of whether I've played the part before, I start afresh with it, as if it's a brand-new published play which has just come through my door. That was the case here. I'd played the eighty-nine-year-old Gregory Solomon in *The Price* when I was twenty-five. But I wanted to do it again, because I hadn't really had much idea how to play him at that age.

So I read *The Price* again, and got an idea of the whole story. It's very difficult for an actor to read a play without dwelling on the character they're going to play. You need to read the complete thing again and again, until you can do so without focusing on that one character. Then I really start analysing. I begin with the text, with the facts. What do I know about the character, only from the text; not from my imagination. Is he married, for example? Does he have children? What was his background? What was his education? Where was he brought up? Where does he live now? I aim to glean as much of that information as possible. If it's not there in the text, I don't let imagination take over. Imagination comes in later. Just get what you're given. Start with the facts.

I used to write copious notes. I still make a lot now, but I've learnt to do so more quickly and succinctly. I make a note, in the text probably, of things I want to use or do.

My aim throughout, with every character I play, is to speak meaningfully for them. So I consider how other people would view me as that character, and what I would say about them. I reflect on my relationships, or attitude, to the people in the play. It doesn't matter whether they're telling truths, or if I'm telling truths, at this point. It's just the facts.

I look at my personal history, and at where the character starts and finishes in the play. Any play affords just a small window on the life of a character; there was a life before and there's a life beyond. At what stage in their life does the playwright introduce them? When does my character come in? When does he leave? I research, too, what he is wearing, the actions he performs, the emotional content of his language – all sorts. And it all comes from the text. The main thing for me, in producing a character, is voice. The authentic voice of the character, and where that voice is placed.

Incidentally, I'm fortunate in that accents come very easily to me. A lot of my career has been with accents, including

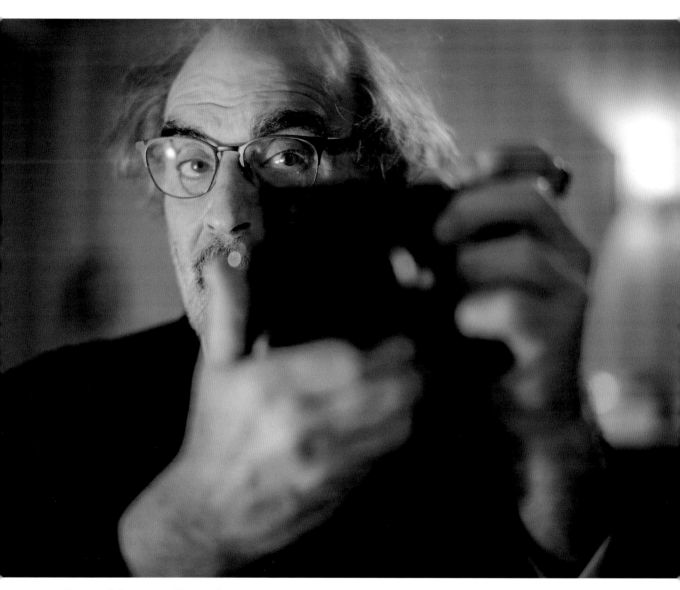

Gregory Solomon: a self-portrait

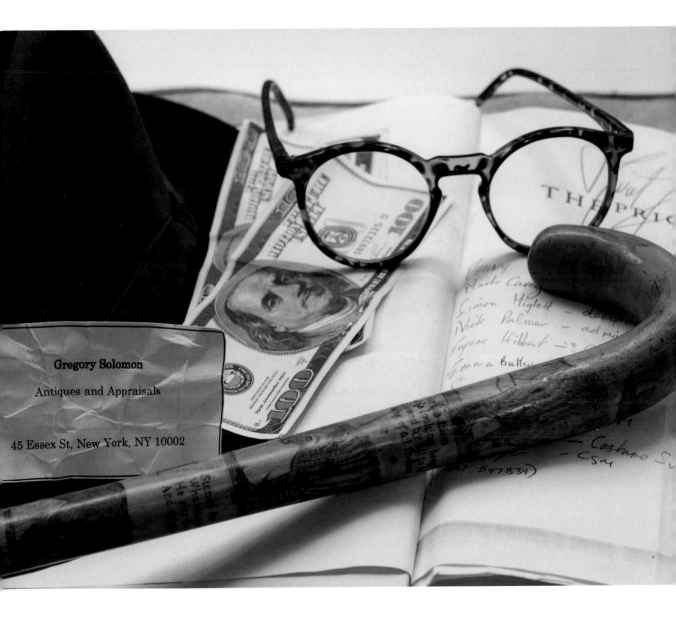

twenty-five years as a Belgian! I find it funny that people often tend to assume that the Poirot accent is my own. So they're surprised when I speak and they hear what I really sound like.

That's not the only time an accent I've put on for a role has been mistaken for my own. In 1998 I played Detective Karaman in a film called *A Perfect Murder*, a modern remake of Hitchcock's *Dial M for Murder*. My fellow cast members included Michael Douglas and Gwyneth Paltrow and it was a great treat to play against actors of their stature.

However, the reason why I was offered the role is something of a catalogue of errors. I had appeared in a film called *Executive Decision* in 1996, playing an Arab terrorist. The director of *A Perfect Murder* had seen this performance and offered me the role in *A Perfect Murder* on the strengh of that. I flew to New York for the start of shooting, where I met the director for the first time the following morning. Unlike in the theatre, there's rarely an opportunity to meet a director before agreeing to take on a film role. As we were talking, I couldn't help noticing he was looking at me in a very strange way. Then he suddenly said, 'You're not an Arab,' and I said, 'No. No, I'm not.' He said, 'Do you speak Arabic?' 'No,' I said. And he just looked at me, and went, 'Oh fuck.' He'd obviously assumed, because I'd spoken in Arabic and with an Arabic accent in *Executive Decision*, that I actually was an Arab. I ended up having to have a dialogue coach and accent coach for *A Perfect Murder*. Hours of hard work, and costly for the film. I felt very insecure in my role at first, because I was clearly working with a director who'd made a big mistake. But happily it all worked out very well eventually.

Poirot said, 'I listen to what you say, but I hear what you mean.' He was into voice, and he would understand people, not necessarily through what they said, but, behind that, through how it was said, what words were used. Similarly, in my research for a part, I look at onomatopoeia, alliteration. I look at lengths of sentences. Are they long? Do they flow?

Where are the commas? Where would they breathe? Are they logical? Is the language emotional or intellectual?

It's essentially a total interrogation of my script. Obviously, the date of the play, where and when it was written and so forth, is also very important. Each play is set in its time. Yes, Shakespeare is sometimes adapted for the present, actors putting on modern-day dress and the like, which can be very exciting if done properly. But, usually, the play belongs to a certain time and place.

I say I'm not an academic or an intellectual, and that I was a bit of a dunce at school, but it has been pointed out to me that my approach to my roles is not dissimilar to the analysis that goes on in an English Literature degree! I hadn't thought about it like that before, but I suppose one could say that I am now something of an academic in the way I approach my roles. I think it started because the first ever role I was really successful in at school was Macbeth. So my love of acting started with Shakespeare. And I was also studying Shakespeare at school, as everyone does, but in the classroom I couldn't understand it at all; the theory of it in the classroom, the iambic pentameter all baffled me. But, as soon as I took on the role of Macbeth, and started speaking the words, something clicked. I became terribly excited by the language. And that's why I think schools should always encourage students to read these plays out loud, and treat them as drama – they're plays; they were written to be performed, not read. Because, for me, I needed the practical element to awaken the theoretical element. I suppose I developed an ear for it – take *Timon of Athens*, for example. It's well known that a huge amount of that play was not written by Shakespeare and, when I came to perform that role, I could actually taste the difference in writing within the play.

I didn't just stop at the language – I then had to know everything about the playwright himself, their personal and historical context. I can't be in a Miller play without learning

everything I can about Miller himself. That's just me: I'm all or nothing, and that's how I approach every part of my life.

Take Gregory Solomon in *The Price*. Yes, he's Jewish, but that's not why he's called Solomon. The name also relates to Solomon, the biblical king of Israel who came after David and who was famed for being wise. Arthur Miller named the character deliberately. Gregory is the only older man in the play born in another century. He's twice the age of the younger people in the play, who themselves are middle aged. Take him out of the play and there's no old-world survivor. At the end of the play you can say, 'Yes, well, Victor survives and Walter survives and their marriages go on.' But Gregory Solomon is *the* survivor. It's not whether he's going to survive. He brings knowledge of all the pain that he's experienced, far greater than anything experienced by any of the other characters.

He can see the futility of the family splitting themselves up over talking about their parents' past and getting rid of their furniture. He comes in, for example, in a strange scene in Act Two, almost like a seer, a wise man, saying, 'Stop it. Stop your arguing, it's not worth it.' He can't order them, but he can advise them: stop it, stop it. Then he leaves the stage, and they continue. They don't listen to what he said, and as a result they break up. If you read the play without that scene, the significance of the scene is immediately clear as you realise what it brings – so that gives me a clue on how to play it.

Once I've grasped what I believe to be the reasons behind what Arthur Miller has written, I've given myself a reason to be there too. It's up for debate, for collaboration, for disagreement, but at least I can bring something to every rehearsal. The other thing I like to do, which a lot of actors find very strange, is to work in the rehearsal room as much as possible in the costume that I'm going to be wearing. Aside from rehearsing, when I put a costume on for the first time, I'll then spend a lot of time in it on my own. How does it make me feel?

I'm a firm believer
that everybody,
every day of
their lives, puts
on a costume,
according to what
they're doing, who
they're meeting.

As an actor, one of my great joys is going to the theatrical costumiers and choosing what I am to wear. I get very involved in that part of the process. It took me ages to find the right suit for Gregory, because I wanted something that spoke of his age and experience, but also had a vaudeville quality to it, something that was quite jaunty despite being a bit shabby. And, of course, then his hat, and his coat, and his shoes; everything about it had to match. And, as Poirot, I used to drive the poor tailors in the costume department bananas because I was obsessed by detail. I would notice things like one sleeve of my jacket being a millimetre shorter than the other. They were so patient with me and so supportive. Even living with myself can be difficult! But the detail is so important because that's what makes something real.

Because I'm a firm believer that everybody, every day of their lives, puts on a costume, according to what they're doing, who they're meeting. When I travel on the Tube, or see people going to work in the City, there are often people dressed very smartly for work. But perhaps they'll also be wearing trainers, because those are more comfortable than formal shoes, which they'll change into afterwards, or carrying a rucksack. I try to observe people in real life wearing similar clothes to my character.

For example, I was on the Tube one day and an elderly man, with a briefcase, a walking stick and a newspaper got on to a very crowded train. He was in a three-piece, pretty crumpled old suit, and I thought, 'Woo, that's like Gregory Solomon.' He had a walking stick, too, and I'd been finding, during rehearsals, that I had to do so much with my hands that I kept having to put my walking stick down. I didn't know what to do with it. I watched this man carefully. He put the briefcase down by his feet, and then, unable to hold the stick and open his newspaper at the same time, he hooked the handle of the stick into his waistcoat.

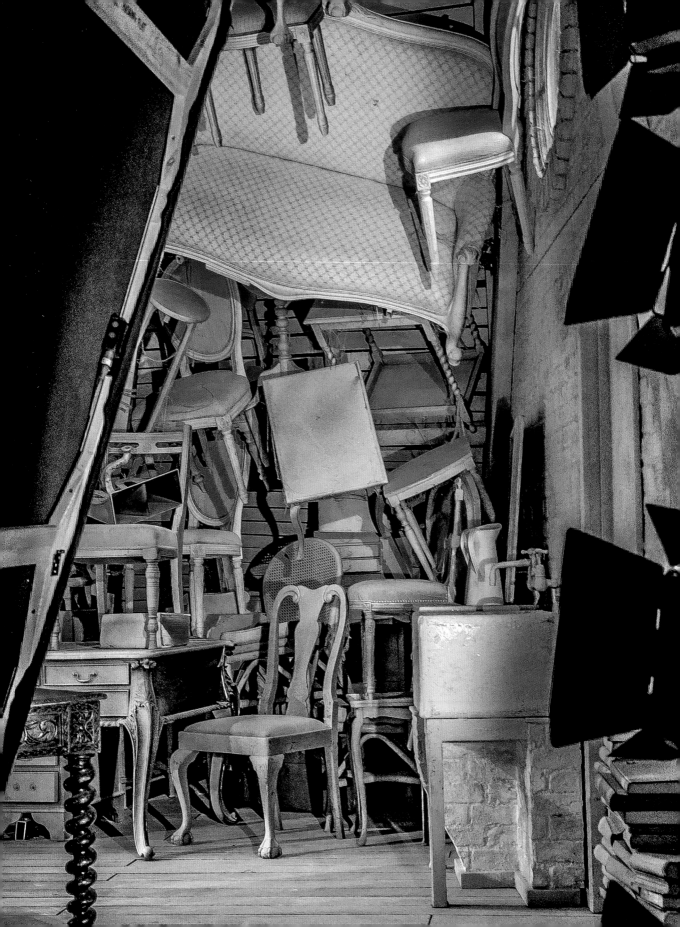

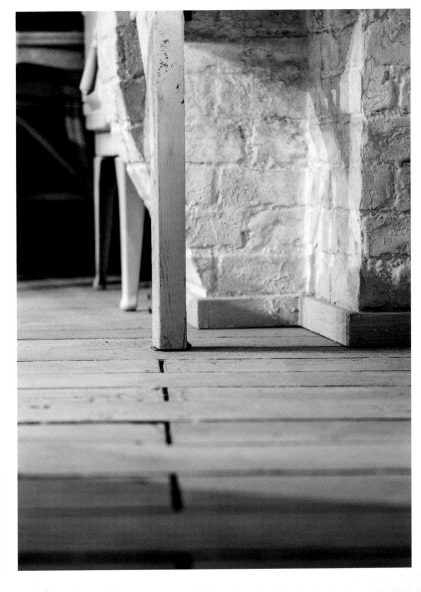

So that's what I did as Gregory Solomon. Every time, I would put my cane in my waistcoat, and that enabled me to have my hands free. I didn't need to put it down anywhere on the set after that.

As for playing an old man, I needed to study ageing and what that involves. Given that Solomon had a walking stick, he probably had arthritis, or at least stiffness of the hip. He wasn't necessarily going to be in pain; there's nothing in the play to suggest that he was. But he had a cane. 'In walks this phenomenon,' Miller writes.

I consider the body language of an ageing person. I look at Solomon's past, at his health; I glean that he smokes cigars, that he's a man of the world and that he's suffered much. But I note also that he doesn't dwell on it; he suffers, yet he makes jokes about it. I then forget everything about how to do gestures, how to use my hands and so forth. Once I've found that inner voice, that inner core; once I've found a character's reason for being at every moment in the play, and how the lines I have to say are part of his personality – once that's there, I trust my body to express itself in the right way. And if it's not believable, then I rely on my director to say, 'The way you did that doesn't work for me. Can you think about it again?' I study age and health, but not gesture or movement – not any more. That all comes naturally from within. Weird, isn't it?

I am constantly observing. It's my lifeblood as an actor. When I'm rehearsing, I will go in search of somebody like me, my character. I'll go out into the world and see those people for real. That old man and his cane on the Tube was a gift to me and a gift to Gregory. I am fascinated by people, by whoever I'm with. I like one-to-one conversation; I don't really enjoy being in crowds or attending big dinner parties. I am analytical but, first and foremost, I am an observer.

I used to work at things like body language as a younger actor, but now I've learnt just to let it come. It's one of the most

important things in acting, and something I try to teach my own students. I always learn my lines, by the way, a long time ahead of rehearsals, so that I don't waste weeks at that stage trying to remember what I've got to say. I've prepared like that ever since I was around forty, ever since Iago actually, in 1985. I pre-learn them, without deciding necessarily how I will deliver them.

People sometimes ask, 'How do you learn your lines?' Well, invariably I do so by talking to myself, in a mirror. Rather than just listening to myself on tape or silently learning lines, I have to talk to somebody, get those lines out. Then I can hear the voice, the person, the sound. I can't do anything until I've found that. And that can take quite some time.

As a young actor, I soon discovered that when I try to learn something, if I don't speak out loud, directing my words to somebody, I just don't remember what I've been reading. It goes out of my head, because the energy has stopped, trying to remember. But trying to contact another person with the words, above all with their meaning, is different.

I can hear myself talking out loud, to somebody else, and that's how I learn my lines. It's odd, I know. But it makes sense. I find by learning in my head and then speaking the lines out loud for the first time in a rehearsal room, I forget what I'm going to say. Because I'm distracted by hearing the lines spoken aloud for the first time. But, if I speak the lines out loud whilst learning them, then I've already overcome that obstacle.

The more you say the lines, the more they will sink to the back of the head. And then you can simply be the character, without also trying to remember the lines. It's like you don't have to think about how to sing the national anthem. You don't have to remember it. It's just there, already in your head: 'God save our gracious Queen, long live our . . .' – you could say or sing those lines at any speed you like, but when you've just learnt something, you can't do that.

Let's pause for a moment to think about Poirot. It's one thing to play a character in one film, an eight-part television series, for the run of a play. But to play a character for twenty-five years? To keep the character fresh and believable, before every series I would watch about ten hours of my own performance from previous series, and would make sure, as much as possible, that he was the same person. Obviously, he aged. Twenty-five years in total. His energy levels changed too, but the actual man, I hope, stayed the same. That was what I wanted, more than anything. I didn't want him to change, because Agatha Christie never wanted him to change. He never aged for Agatha Christie until the very last story, *Curtain*, in which she describes him as a very old man in a home, but apart from that he never changed.

To help me get into character as Poirot again at the beginning of each new series, I developed various techniques. I would get out my cane, in my house, walk around the garden like him, speak out loud like him, attempt to look at the world through his eyes, reflecting his conviction that God had put him on this earth to rid it of crime – he saw that as his God-given mission. I tried to become more observant before we started shooting. I'd look at picture frames at home, for example, making sure they were straight – through his eyes, in other words. And if I had two boiled eggs at home, even though I'd never insist on them being the same size, I'd notice if they weren't.

The most important thing for every actor, myself included, is the moment in rehearsal, whenever it occurs, when you decide, 'I'm going to jump out the plane without a parachute.' That's how Harold Guskin described it. Forget everything; there is no right or wrong way of doing things. I will add this: nobody in the rehearsal room must ever, ever be allowed to feel they have failed. That word doesn't exist in my vocabulary. No artist fails. They may experiment, and that experiment may not be acceptable at a particular time, but there is no failure. Such talk is so

Pure art is about taking risks, daring, going beyond logic.

negative, and makes one feel inhibited, because you feel, 'I've done something wrong. I've failed.' An artist, whatever they're doing, whether it's photography, painting, writing, dancing, music and so on – above all, I would say, as an actor – they've got to be free. Freefall, take risks, dare, forget all the planning, forget whether this is logical, forget everything. Start rehearsing released from such worries, without thinking about it, and just see what comes out.

Just let it happen, and fly. Because it's only by going through that barrier that you've created for yourself, that safety net, that acting becomes real – a part of art. Pure art is about taking risks, daring, going beyond logic.

Listen to music – Mozart or Beethoven. They weren't careful. They splayed everything out on paper. The same with painters such as the impressionists. It's not precise; they were trying to get away from photographic portraiture, or photographic landscape; they wanted to create just an impression, to be free. That's what I want to do not only with my acting but also with my camera. I don't want to just take what you see and represent it. Yes, there'll be occasions for that, like when I go on holiday and take snaps of the family, but to make photography into art, you have to release everything that you know about technicalities, and just let go. That's what I try to do equally, as early as possible, in rehearsal.

Being willing to do that involves having the courage to make a fool of yourself, and that's terribly important for me, as an actor, in the rehearsal room. To make an idiot of yourself and not give a damn. Don't care about what other people think of you. Don't try to be impressive, to be good, to get nice things said to you by the director. Just zone in on your character, and live in that moment. And then, when you come out of the zone, people can talk to you about it. They may not like what you did – but you haven't failed, even if what you just did is never used again.

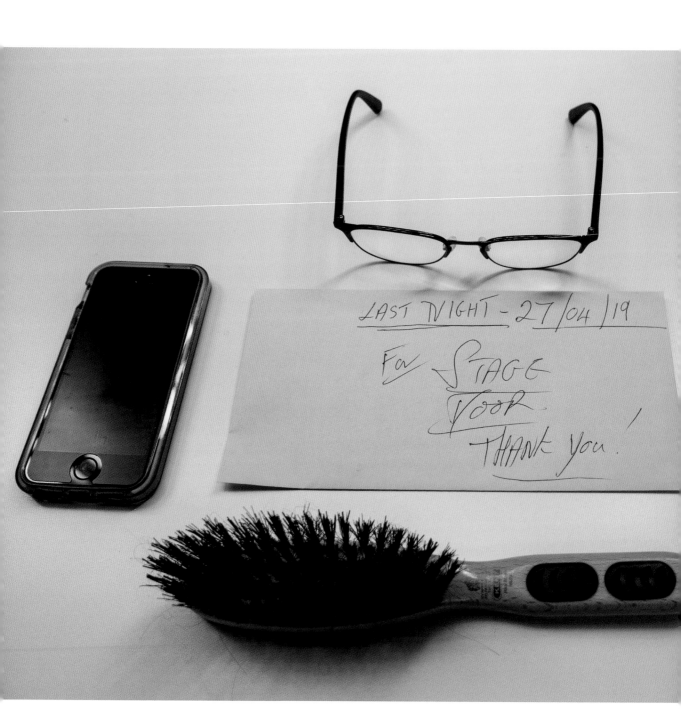

The great directors know this. People I've worked with, like Harold Pinter, Trevor Nunn, the late Howard Davies, Peter Hall, Jamie Lloyd and Jonathan Church, just to name a few, will sit and watch you, and when you've dared to do something, the first thing that such wonderful, sensitive directors will say is, 'Thank you. Thank you for that.' It may not be acceptable, but they all say thank you.

I wish sometimes I could be more laissez-faire about my acting, but I just can't. I don't know how other actors work, though I believe for some – Judi Dench, for example – it's just totally instinctive. She's a very creative actor. I, by contrast, have to spend hours and hours in preparation, and then let it become instinctive. It's completely individual to the actor in question. If you get to the same result, there's no right and no wrong.

A NIGHT IN SUPPORT OF AMNESTY INTERNATIONAL AND CHANCE TO SHINE

THE JAMIE LLOYD COMPANY
PRESENTS

PINTER AND PINTER

happy birthday, harold

WEDNESDAY, 10TH OCTOBER 2018
A CELEBRATION OF HAROLD PINTER'S LIFE AND WORK

CHANCE TO SHINE
Spreading the power of cricket

AMNESTY
INTERNATIONAL

HAROLD PINTER THEATRE

DAVID SUCHET /
SHEILA SUCHET

happy
birthday,
harold

On directors

I've worked with some fantastic directors in my time. Adrian Noble for one. Harold Pinter. Trevor Nunn. Terry Hands. Peter Hall, of course. An actor must react within character, truthfully, emotionally, to the given situation of the scene, with the guidance of a director. I want to be as faithful as possible to what the author has written, with the director's help. My first duty, as I've already said, is towards my writer.

We had actor managers into the Edwardian era. They would put together their play as an actor and be in it. The role of a separate director is a fairly recent invention. Good directors are an actor's gift. I've only worked with a few very bad ones, who will not be named; the sort who will say, 'I want you to play it this way.' Well, the worst word they can use, to me, is the word 'I'. I'm not interested in that. I want a director who will work with me for the sake of my playwright, exploring together what we think that means.

The most important thing, for me, in an actor/director relationship is a *collaboration* of ideas and words. They're not a *dictator*, but a *director*; the word 'direct' means to lead in a direction, to guide. You go into Google Maps: you don't have to take one particular route, but it advises you as to what looks to be the best way. So it is with the best directors.

As I've explained, I will always study a script, and a part, before meeting a director, to get an idea, a flavour, of what it involves. I always want to meet the director before finally accepting a role, and if I feel it's just not going to work, or s/he and I are at loggerheads, then it's simply not worth accepting the part. If the director is totally directorial (we call it director's theatre, or designer's theatre, where the design is so strong that it takes over the whole play), then it's clear to me that it's not the sort of theatre I want to be involved in. If the director's concept is at odds with the writer's, I can't do it. That's resulted in me sometimes turning down jobs that I would otherwise love to have done, but so be it.

For *The Price* we had a wonderful director, Jonathan Church, who I've got to know well over the years. He was formerly director of Chichester Festival Theatre. You just feel with him that you're with a friend and sharing ideas. It's collaboration, and he was a great help to me playing Gregory Solomon, because he also used to do one thing that is totally necessary for every actor: he encouraged.

Literally, he filled me with courage, and if an artist is given courage to do what they do, extraordinary creativity will result. Conversely, tell them all the time, 'You're wrong,' or 'I don't like that,' or 'No,' and they will feel a failure or discouraged. That's the most negative barrier to creativity in the world.

Working with Harold Pinter was extraordinary. If you look at our personalities, we probably shouldn't have got on. I remember him saying to me, 'Do you like cricket?' And I said, 'Yes, I like cricket; I used to play it at school.' 'Will you play in a team that I've put together?' he asked. 'No,' I answered, 'I don't like playing cricket now.' To which he responded, 'Good God!' He didn't speak to me for a bit after that, because cricket was a religion to Harold Pinter.

But we got on. We worked together on *Oleanna* in 1993, an extraordinary play written by David Mamet. Incidentally, David also uses a Leica camera. That's what we talked about when he came into my dressing room one evening. We didn't talk much about my performance; we talked about Leica cameras. *Oleanna* is about this young student, Carol, brilliantly played by Lia Williams, who in the first half of the play seems to be very vulnerable – being comforted and looked after by John, her university professor: that's me. It's only in the second half that you realise she's manipulating me, attempting to get me sacked for raping her.

John doesn't rape her; she's talking about psychological rape. Harold, as the director, somehow captured that ambivalence in the lack of physical proximity between the two characters.

(Left to right) John Macmillan, Russell Tovey, Hayley Squires

This was one of the many ways in which Harold was so wonderful, in the way he guided us, movement wise.

When Lia and I were rehearsing – it was just a two-character play – Harold would tune into my way of working, instinctively understanding what I was trying to do, and then helping me towards it, with an economy of words. He said to me once, for example: 'You know that part of the scene, beginning here? It needs to be darker.'

'Darker' – isn't that a wonderful note to give a flavour, a tone, of what's required? Directing as a route, rather than a dictatorship.

> I was so angry, so tense, that I could hardly move. You know, not just angry but seething.

One time, towards the end of the rehearsal period, I remember feeling the anger in the relationship between Lia's character and mine, and what was going on between us. I was so angry, so tense, that I could hardly move. You know, not just angry but seething. Do you ever experience that: being so furious that you can hardly move, and the words almost won't come out? For some reason, over the whole of Act Two, once I felt that anger, I couldn't let go of it. I hardly moved until the end of the play, when I sat down. And Harold said, 'What happened?' For a moment I thought, 'Oh my goodness, it was wrong, out of place.' You know, the insecurity thing. I said, 'I just felt so angry inside,' and he looked at me and said, 'I couldn't take my eyes off you. Get that anger, if you can, inside you, every performance, and don't move.' He came to a performance of the play while it was running, and the note I got from him afterwards said simply, 'You moved.' Wonderful little touches.

The production got the most extraordinary reaction when it opened. It was the play of the moment, eliciting the same response as it had when it was first put on in New York. It was the talking point in the world of theatre. After playing, time after time, to a packed house at the Royal Court, where we first staged it, it was once again sold out after we transferred to the West End. People used to go home afterwards arguing

about which of the two characters was in the right. It created such unbelievable arguments – between men and women – at dinner, after the show. Was Carol right in accusing John of being too forward with her, psychologically anyway? It's fascinating, because we're still talking about the same issues today.

We became very close, Harold and I, after *Oleanna*. I got to know his wife, Antonia Fraser, well too. Harold was famous for not being very loquacious, but I remember, after he saw me in *Man and Boy*, the Rattigan play, we went out to dinner, and we talked at length about the play, and about Terence Rattigan. I was thrilled to read recently that he and Arthur Miller were also close. They had an excellent relationship.

When I did Harold Pinter's play, *The Collection*, in London recently, I dedicated it, in my heart, to Harold. I just love his writing. He's a poet. He's not there to be understood, to be logical. Just receive the language, and accept it on so many different levels, rather than as logical theatre. He's extraordinary. The director Jamie Lloyd, together with the Ambassador Theatre Group, put on – at the Comedy Theatre, now called the Harold Pinter Theatre, because most of his plays were done there – a season of Harold's short, one-act plays. It was a fantastic season, and you really got to know Harold through his work. I was so honoured to be asked to be in *The Collection*. It was lovely, at my age and stage in my career, to suddenly be working with a generation of actors – John Macmillan and Russell Tovey among them – in a Pinter play.

I've known Adrian Noble for a very long time – from before he became director of the Royal Shakespeare Company, when he was at Stratford as an assistant director. We got on extremely well there. Disappointingly, though, I never got to be in a play he directed while I was with the RSC. I very much wanted to be, but I'd left the company by the time he took over the full directorship.

Subsequently, however, he asked me to be Lady Bracknell in *The Importance of Being Earnest*, but I was unsure about taking on the role. It was only when the producer of the play, Kim Poster, with whom I'd worked on a number of productions and got on very well, came to dinner, that I seriously considered it. 'Have you thought about *The Importance of Being Earnest*?' she said. 'Well,' I responded, 'given my age, there aren't many characters I could play in that. I can't play the two young men. There's the old butler, I suppose. The old priest, Chasuble, too, but I don't want to play him. There's nothing for me in the play.'

'What?' I said. 'No way! Lady Bracknell? You are joking?' 'I'm not,' Kim said . . . 'I think,' she concluded, 'that it would be astonishing; not just a gimmick.'

'Think carefully,' said Kim. 'What do you mean?' I asked. She said, 'You like comedy?' And I said, 'Yes, I don't do enough comedy; I would love to do more.' 'I know that,' said Kim. 'So think: who's got the best lines in the play?' I answered, 'Well, the best ones are obviously the boys', the wonderful scenes with the girls, and of course, the legendary Lady Bracknell.' At that, she looked at me and said, 'Well?' 'What?' I said. 'No way! Lady Bracknell? You are joking?' 'I'm not,' she said, 'because I believe you will play it not like a pantomime dame, but bring to that character the things you bring to every character you take on.' 'I think,' she concluded, 'that it would be astonishing; not just a gimmick.' So, having said no, I said, 'I'll reread it.' I had to do so a number of times before I actually felt able to say yes, but I'm so glad I did: it was extraordinary working with Adrian.

Collaborative; always a director rather than a dictator. He encouraged me in that production throughout. As soon as the corset was made for me, I was working in it, together with all the underwear, the hoops, the heels – everything. I was trying to find out how Lady Bracknell would move, how a woman moves, and how to become a lady of that stature and figure. I learnt how I might change myself into a woman – and you can't, of course, you can only go so far – and it was me becoming Lady Bracknell. Anyway, once I'd got that and found her voice, her persona, her personality, and felt that was coming through, I really started to enjoy it, and had the most wonderful time. It was glorious. Numerous reviews observed, 'David Suchet's having such fun.' And I genuinely was.

Lady Bracknell: a portrait

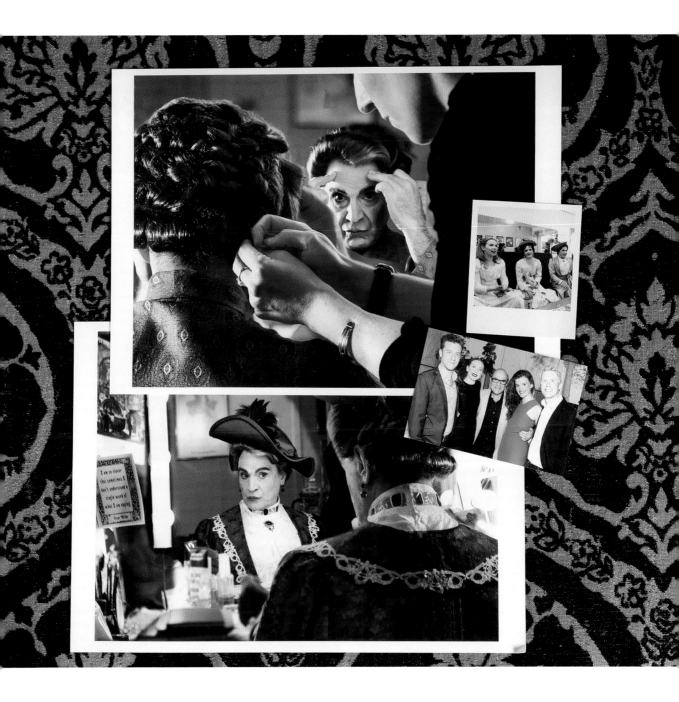

An actor's life

L ife is not always easy for an actor, on or off stage. As I said in response to a question I was asked at LAMDA the other day – about dealing with times when you have no work: 'You've got to remember that unemployment, and what people call "resting", are actually part of the job. Part of your job description is unemployment, because at the end of every job, it's the end of a contract, and if you haven't got another job to go to, there will be a break between the end of the present one, and whatever opportunity may present itself next. It's part of your job description, and if you can't deal with that hanging in the air, not knowing what's going to happen next, then never become an actor. Unemployment is an inevitability that must be treated with positivity; you mustn't feel you have failed.' That word again.

Being unemployed is not pleasant. I've not really experienced it much for many years, but when I was a younger actor, there were numerous times when I was unemployed. I used to do Tube journeys, and watch people, observe them; also try to keep up with politics. And I would visit art galleries, or, if I couldn't afford those, find free-entry places instead. I'd take out my camera, and keep experimenting. And, of course, I'd still do my voice exercises at home, still limber up and keep as fit as possible. My body is my instrument. There's no point in suddenly, after a period of, say, three months, four months, getting a job if your instrument isn't ready, because it's going to take a long time to retune it. You have to be in tune and as flexible as possible. You have to know how to use your voice; keep doing your voice exercises, tongue exercises, lip exercises, in order to maintain the quality of your instrument, so that it's ready when you're asked to use it. In short then, I would approach unemployment positively, rather than negatively, as much as I was able.

The biggest difficulty with being an actor, or any performing artist, whatever medium you find yourself in, is rejection. That word 'rejection' leads to a sense of failure, and what I

constantly try to instil in young actors is an understanding that rejection is also part of the job. You won't hear many good things about yourself. In rehearsals, you only get what they call notes; very rarely are you told, 'Oh, that's good.' You'll be informed about what's not working. You'll go up for jobs that you won't get, and it can lead to feelings of 'I'm no good. Nobody wants me.' That's, sadly, the ego of the wounded artist, and we have to have ego. We wouldn't even want to be an actor if we didn't have it, but that ego must be put in its right place and must never turn into egotism. There's a big difference. There's an accepted egoism, but don't let that be so wounded by rejection that it can destroy you, because rejection is more common than acceptance. We have to deal with it. It's part of who we are. I've been rejected for more things than I've been accepted for, because that's the life of being an actor.

For actors fortunate enough to secure a role in a long run, there then comes the business of appearing on stage every evening for however many weeks. Once the rehearsal period is over, you move to the stage, and that involves a number of challenging processes. In a sense, it's like helping a baby to leave a womb. You're giving birth, or at least are starting in labour, as soon as you leave the rehearsal room and move into the performance space, where you will meet the furniture on stage, the lighting rigs and so forth; we refer to these moments as technical rehearsals. Then comes the first production with an audience watching, and that is the birth of the play. There is no play without an audience, however wonderful it may have been in the rehearsal room. I remember, at the RSC, Terry Hands saying, 'That final run-through of *Troilus and Cressida* was one of the finest run-throughs I've ever witnessed. Congratulations everybody!' We were slated on the opening night. It happens.

Developing the relationship between the play and the audience is the next huge step. I think it's very important,

> That word 'rejection' leads to a sense of failure, and what I constantly try to instil in young actors is an understanding that rejection is also part of the job.

because it can take a few weeks before we've got everything right on stage. I'm always upset when a director leaves after the press night and doesn't come back, because we're left on our own then while we're still trying to nurture this baby, with an audience, and wrestling with, 'Well, this doesn't work, that doesn't work.' You need a third eye to help answer your questions. 'Why didn't I get that laugh tonight?' Or 'why didn't that work as well this evening?' It's that third eye, when you're on stage, and the audience's reaction to your piece, your character and so forth, that helps so much.

On a typical day for me during the run of a play, I go to bed late at night after a performance; actors are inevitably night owls. When I wake up, I do my physical workout as soon as I get out of bed, because – especially at my age now – it's important to stay as physically flexible as possible. During the day, I often have time to do whatever I want, like putting together this book, for example, at the same time as appearing in *The Price*. But when I'm appearing in a show, say at 7.30 in the evening, I generally feel the character I'm playing starting to kick in at about two o'clock in the afternoon. I begin to think in the way

that character does. Other people might not notice it, but I do. I try and keep that character down as much as possible, but it's very difficult. If you're playing Iago, you start seeing the world through his point of view, his glasses. You don't want it, but the character kicks in; it's like a gear change in your day. If you're doing a matinee, it's harder still, because the character starts kicking in at about 11.30 in the morning.

Once on stage, it's all about routine. The trick is to keep a performance fresh. How do you do that, night after night, matinee after matinee? I have a little trick; well, several actually. I mentally place an actor, or director, or somebody I greatly respect, in my audience, to make sure that the performance is kept up. And if ever I'm feeling so tired that I start thinking to myself, 'I really don't want to do this today' – that happens sometimes, you know – I say to myself, 'Well, there is no guarantee of tomorrow, for any of us, in this world. I could be run over tomorrow. This could be my last performance, ever, as an actor, and whoever sees this performance might be watching my last performance on earth.' By God, that makes a difference to your attitude. You go out there and just give it everything.

It's totally different being in a film or television production. You read the script first of all, which will be half as thick as a play, because there's far less dialogue in films. Then you shoot, according to where the location is, which means scenes are often shot out of sequence. You don't get much preparation time for a role; not many rehearsals, if any. You just arrive on the set and meet the people you're going to be working with that day, some of whom may have only been employed for that one scene. It's not like a theatre company, where you spend a lot of time together in rehearsals; in film or television you may do three or four takes of the scene from different angles, taking maybe three or four hours for a big Hollywood movie. The final cut may be only one and a half, two minutes, on screen, that representing a whole day's work.

Despite that, you must be in costume for hours at a time, which is sometimes very uncomfortable! The armadillo padding I always had to wear as Poirot was extremely hot, especially because we were filming in Morocco – I actually passed out on the film set. Got out the car and collapsed. We had to have air-conditioning units on set, because, of course, Poirot was not allowed to perspire. Unthinkable.

In *Reilly, Ace of Spies*, I played a Chinese man, Inspector Tsientsin. Obviously that wouldn't be allowed today, but back then, in the early 1980s, that is what I had to do. I found that role very hard, very challenging, but I loved it. It was what I do. I'm a character actor. I had to learn how to speak English with a Chinese accent, and wear what they call fish skins over my eyes, to try and make me look like a Far Eastern person with that slanting of the eye. The fish skins were dreadfully uncomfortable. They were actually a layer of latex that would be moulded for me and stuck around my eyes, and I remember it got so sore, every day taking them off, putting them on, taking them off. It wasn't like a theatre production; you're wearing the makeup all day, every day. It was very uncomfortable.

The bittiness of film and television work can make it very hard to maintain character. That's why I got the reputation, when playing Poirot, for always being in character. One of the drama students at LAMDA asked, 'Is it true that you're always in character when you're off stage – off set as well as on set?' 'I'm afraid it is,' I said. On set and off set, I tried to speak like Poirot, walk like him. I even used to speak to my wife like him, and to my agent, when he rang. I would still be Poirot, because he was such an extreme character. It's very difficult just to switch from being yourself to the character you're playing on set. I had to maintain a level of performance over many weeks. I would even speak like Poirot while doing press interviews, so my reputation for staying in character all the way through a production – it's true.

DOCTOR WHO

SERIES 10

EPISODE 4

"Knock Knock"

Mike Bartlett

SHOOTING SCRIPT

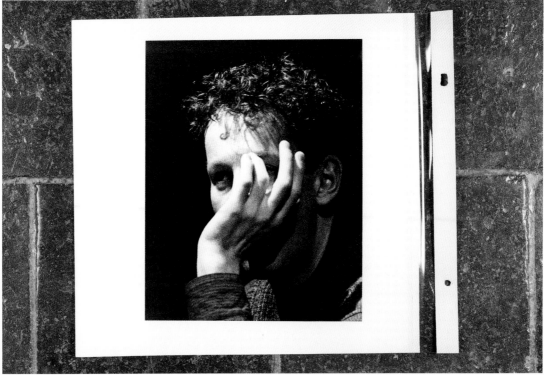

Now, I want to talk about *Freud*, and about *Timon of Athens*. They're connected, for me, in a way. When I was cast as Freud back in 1982, I did my usual thing of researching the role carefully. I read everything Freud ever wrote. Then I went to Vienna, to the Berggasse, the street where his house was; and after that to Maresfield Gardens in Hampstead, just off Fitzjohn's Avenue, where he fled after getting out of Vienna to escape the Germans, because he was Jewish. He was long dead when I went there, of course, his daughter Anna too, but his house was just as he left it. It's a museum now, but it wasn't then. I used to tip the caretaker and study, as Freud, at Freud's desk.

In front of me was Freud's famous couch, and on the desk were all his Egyptian antiquities. I absorbed so much about him – probably too much, looking back. I wore his coat; it fitted me like a glove. I remembered reading in a biography that Freud was a compulsive cigar smoker, and that even after several operations to treat cancer of the upper jaw, which involved cutting up the mandible of the soft palate, he still couldn't stop smoking. Apparently, he cut off the end of a clothes peg so that he could use it to prop open his mouth wide enough to put in the cigar, and let go. I found that clothes peg in his desk. I used it in the series. And I died as Freud, on the daybed that he died on. I fear that I may have even taken him into my personal life. Maybe I went too far.

The same thing with *Timon of Athens*. A dear psychiatrist friend of mine, who's now no longer with us, called Antonio Montanez, came to see the play and visited me backstage afterwards. This was at the Young Vic Theatre, the play directed by Trevor Nunn. Over a glass of wine in the dressing room, Antonio told me how much he'd enjoyed the play, which was good to hear. Then he said, 'The way you play it, you must still be in character now.' 'No I'm not,' I answered. 'Don't be silly, Antonio.' 'I think you are,' he said. 'You can't do what you did on stage and just drop it.' 'Well, I'm not,' I protested. 'Let

me ask you some questions,' Antonio continued. 'What's your name?' I said, 'Don't be silly.' 'What's your name?' 'David Suchet.' 'What's your date of birth?' 'Second of May 1946.' 'What's your telephone number?' I hesitated for a moment. 'Why are you pausing?' Antonio asked. 'You know your telephone number. When was the birth of your daughter? Of your son? What schools do they go to? Who teaches them? What's the birth date of your wife, Sheila?' And I genuinely found I had to think hard to remember them. 'You've got to learn to come back to yourself,' said Antonio, and he gave me a method, which I use to this very day. Before I leave the theatre, I will look in the mirror, after a show, and I will go through all my personal details as quickly as I possibly can. I can do that now very, very quickly, and it brings me back to myself.

As I've said before, it's terribly important for an actor not just to paint on a character but to *be* the character. I don't want to just paint on a character, go out on stage, be impressive and win plaudits. If you watch someone like Daniel Barenboim at the piano, or a fantastic virtuoso violinist, they're so zoned in they're not aware of anything else – not their hand or bow movements. They're at one with their instrument, so much a part of it that the audience are drawn into the performance. I try to do the same as an actor; to zone in on the role, just be there, so that I'm able to say to the audience, metaphorically, 'This is me,' rather than, 'Look at me.'

Inhabiting so many roles, and going to the depths that I do to reach my characters, it is important to anchor myself firmly in reality. Family, faith, photography, the canals, nature: they all anchor me.

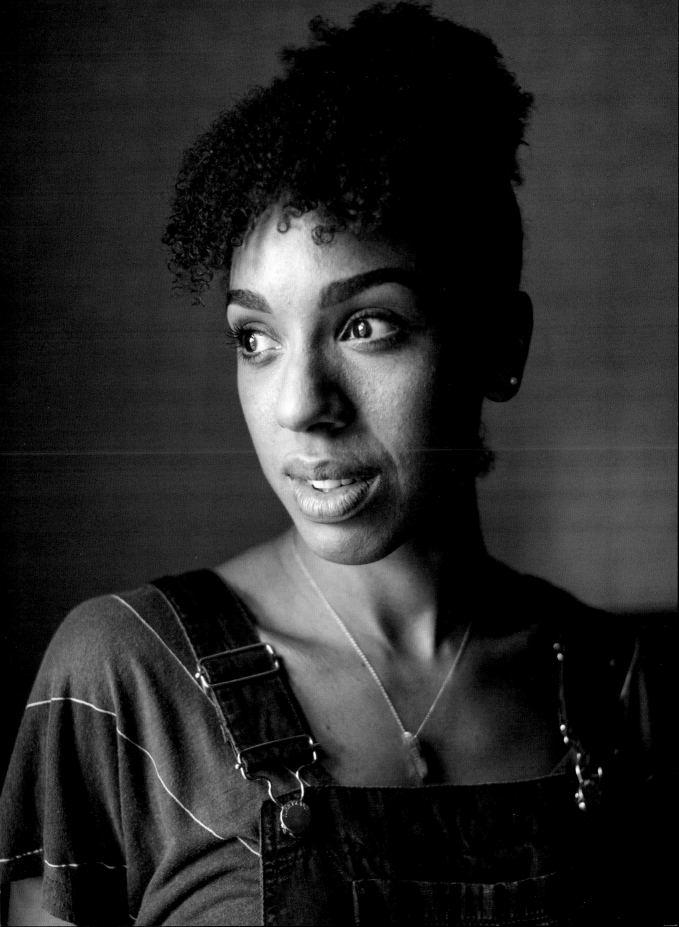

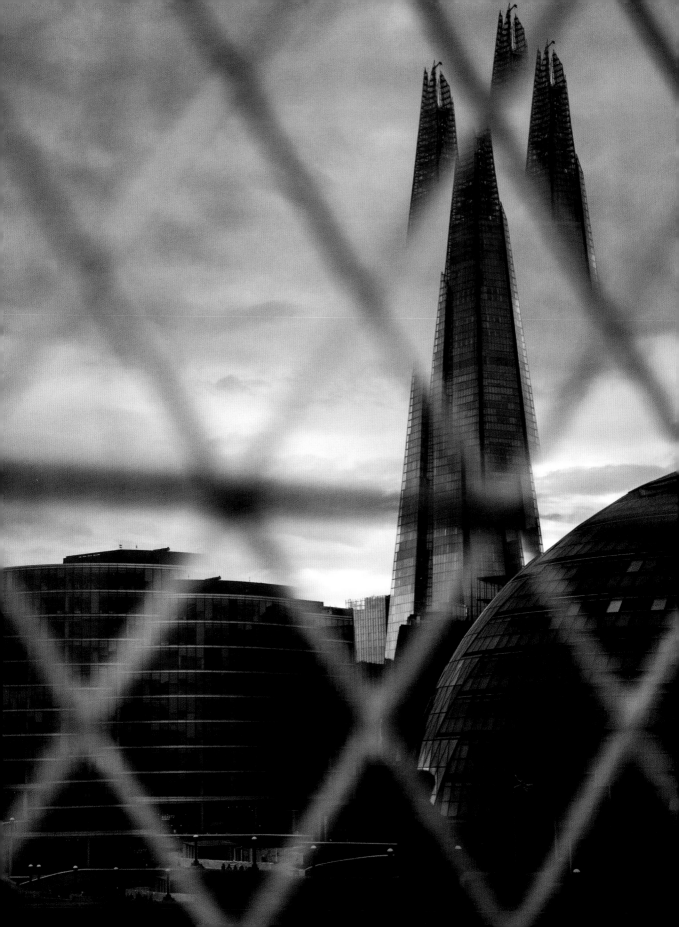

Looking back: part i

A huge difference from when I started out acting is that theatre is now no longer the only entertainment. When I started, fifty years ago, in 1969, you had repertory theatre throughout the whole of Great Britain. There were theatres in every major industrial town, and when you left drama school, that's what you did: you went to repertory theatre.

We only had three channels on television: BBC1, BBC2 and ITV – that was it. You didn't really think about going into television; you did theatre and then, hopefully, you might get the odd TV role; film was another world – way, way beyond. So, the emphasis has changed enormously.

Television now has taken over from theatre as the main drama people watch, because they don't have to leave their homes to enjoy it. There's a huge theatre audience, yes, but it doesn't compare with the TV audience. My Poirot was seen by 750 million people. Each performance of *The Price* was seen by about 750 people a night, which, assuming a full house, eight performances a week, works out at about 6,000 per week.

An actor's life today encompasses theatre, television, film and radio. As soon as I realised that, I wanted to be an actor who could embrace all the media. I can recall several great actors in those days, especially at the RSC, who said, 'Right, I'm leaving now because I want to do film and television,' only to find they couldn't. They didn't know how to speak normally, without being theatrical, and many an accomplished actor fell by the wayside as far as film and television were concerned.

There's also the fact that many movies, increasingly influenced by America, are now so ultra-naturalistic that the text is really not important. You go to do a scene in a Hollywood movie and the star of the show with whom you're working doesn't say the lines you're expecting – my cues, and so forth; they ad lib instead. To me, for whom text, text, text is everything, that's anathema. It's all very freewheeling nowadays, people

mumble so much you often can't hear what they're saying. I'm of an age now that often when I watch an American movie on television, I can't understand them. I do watch a lot of films, though, because I'm one of BAFTA's judges now, even if I do have to watch some of them with the subtitles on!

Things in film have changed. If you watch a film from the 1930s, it's so slow compared to the films of today. In the thirties, the camera would rest on someone's face, pause while we took in what they'd said. Now, the cutting is so fast. What's changed all that is advertising. In a TV advert, an image is typically shown for half a second or so before it changes to something else. People simply do not have the same attention span they used to. It's hugely different; the world of entertainment has changed almost unrecognisably over the past fifty years.

Portrait by Sacha Newley (now hanging in the Garrick Club).
Note Poirot's cane . . .

Henry Goodman

So when actors today come to do Shakespeare and the classics – Chekhov and so forth – they have to find a way to respect the text, respect language – to understand once more the way people like Shakespeare spoke. They need to almost relearn that, whereas for me it was part of my training.

Mind you, drama schools today, such as LAMDA, are fantastic. They have film studios where students learn how to do film work; TV studios in which they're taught how to work in close-up; radio studios, where actors practise doing plays on radio. In my day, we didn't have any of the latter; all we were told about performing on radio was, 'Practise speaking while sitting on your hands', so that you can't gesticulate. Because on radio, nobody can see you indicating 'Go out that door.' They can't see you pointing. That, pretty much, was my radio technique at drama school. It's all changed now; much for the better.

We're also seeing the most extraordinary new plays being created by young writers. I would like to see more of them. I want to encourage modern plays as much as possible. We need new writers; playwrights who are not simply producing what they think can be made afterwards into movies or adapted for television, but writing first and foremost for the theatre: genuine new plays, in which they can express themselves for our time. There are constantly new television programmes. But we need to encourage more new plays for the theatre.

I've performed in very few modern plays during my career, so I find it exciting when I have the opportunity to do so. I've spent most of my life as a classical actor, whether performing works by Shakespeare, Pinter or Arthur Miller. But they're all revivals. They've been done before, and the directors are thinking, 'Well, how's it going to be done now? What new take can I put on it?' Which often leaves me conflicted, because I will work from the author's, or the playwright's, point of view. Frequently, in a modern interpretation of a classical play, I have to find a way in which I can still remain faithful to the playwright. Mercifully, when I was in Miller's *The Price*, Jonathan Church, the director, really studied the play, and we placed it in its time. That's where I feel most comfortable.

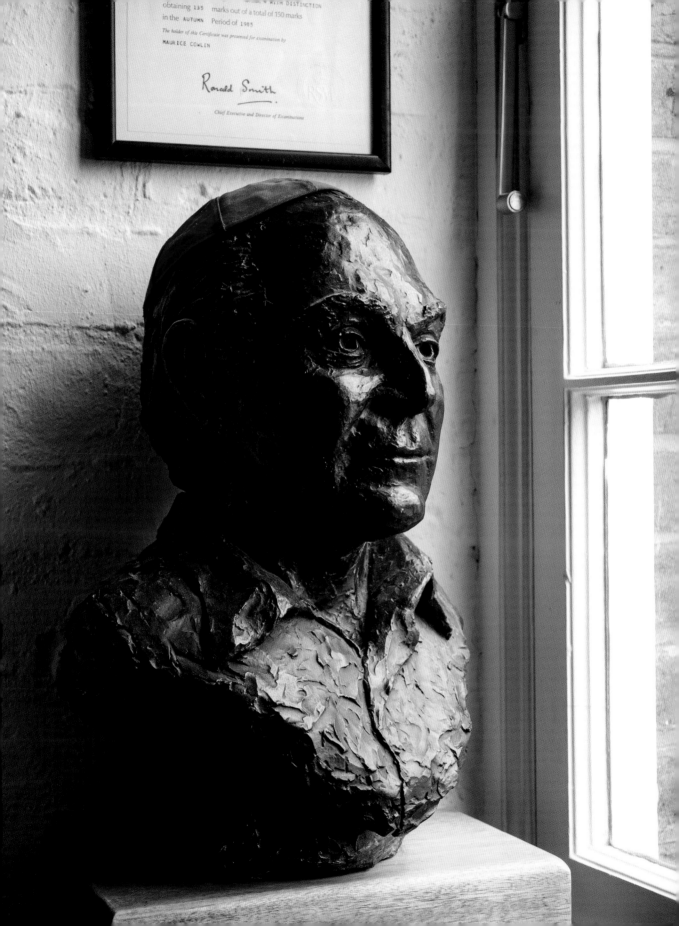

On fame

Not only has the world of acting changed but, for want of a better term, the world of 'fame' – our whole understanding of it – has fundamentally changed during my fifty years as an actor. How has that affected me?

Well, let me start off by saying that we, *Homo sapiens*, of course, have always needed heroes. Look at the Trojan Wars and Shakespeare's depiction of them in *Troilus and Cressida*, for example. It swiftly dawns on you, when you read the play, that Hector was the pin-up boy of the Elizabethans. It must have been horrifying for Elizabethan audiences to see their hero murdered by the evil Achilles – who I have played, incidentally.

We've always had heroes, not least sporting ones, and that goes right back to the Greeks and the Olympic Games. There's something about human beings that needs to create mini-gods. So, when film and television started, especially in Hollywood, people looked up to actors and actresses as demigods, stars became hugely wealthy and had huge Hollywood homes built. We didn't have quite the same in England. But, certainly, we had a star-struck public, idolising celebrities like Errol Flynn, John Wayne, Doris Day, Elizabeth Taylor. The names of countless Hollywood actors and actresses roll off the tongue. And then came television.

It was in the 1950s and 1960s when it really took off. I remember watching the Queen's Coronation on a tiny screen on a black-and-white television. Next came colour TV, then bigger screens, then digital, satellite, HD – you name it. And then reality TV burst on to the scene. All of a sudden, a 'celeb' society began.

Today, fame can come to anybody and everybody. Reality TV offers just that: instant stardom. There are talent shows in which singers and performers compete for celebrity status, where young chefs try to out-cook each other, and other reality vehicles where simply being young and beautiful

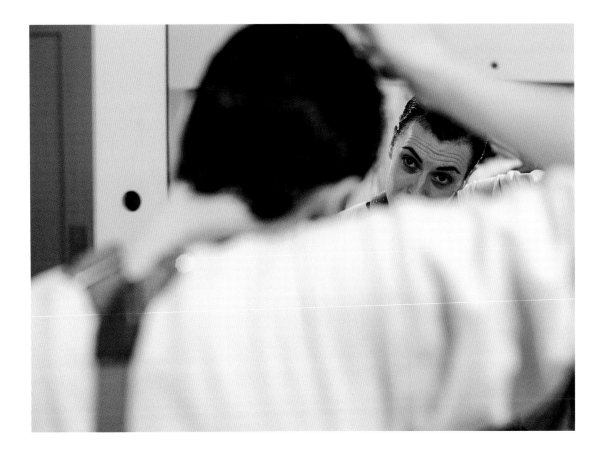

seems to be the be-all and end-all. It's a dangerous society in which we live. One has to be very careful not to live life purely for other people's opinions and praise, or simply to gain fame and money.

I go into LAMDA sometimes, to give talks to current students. And I always say to them, 'If any of you want to be a star, become a model or something like that; if you're going into this business for the sake of stardom, then you really should question your goal as an actor.'

Everything's changed, and the world of fame and celebrity culture is not one in which I feel comfortable, but I'm speaking as a man who started his life as an actor in 1969, when things were very different.

Ruth Wilson

'Mr Poirot? I'd know the back of that head anywhere,' she cries . . . she rushed up to me from behind and gave me a great smacker on my cheek, with my wife sitting right there next to me!

For me, it was playing Blott in *Blott on the Landscape* that really got me noticed for the first time in the UK. Suddenly, according to the media and press, I was a household name. And when *Poirot* came along, and went international, I began receiving fan mail from around the world. I still do: Germany, Hungary, Japan – wherever. I always know where it's being shown, because I'll get fan letters from that country, even now. As a result of *Poirot*, I can't go anywhere in the world without being recognised.

And it doesn't have to be my face that calls to mind that tubby little man with the moustache. There was one instance when just the back of my head sufficed. I was doing a film called *Diverted* in Newfoundland, Canada, in a little place where planes that were originally headed for New York were diverted in the wake of the horrific events of 9/11. My wife was with me, and we went into this coffee bar, and, as was my custom, I sat facing away from the room.

So that's what I was doing in this coffee bar. I was gazing out of the window in front of me – normally I'm stuck facing a wall! – but here I was actually enjoying looking out at the world, when suddenly we hear a yell from a lady somewhere towards the bar. 'Mr Poirot? I'd know the back of that head anywhere,' she cries, and next thing we knew, she rushed up to me from behind and gave me a great smacker on my cheek, with my wife sitting right there next to me!

But, I have to say, whether it's because of the character, or my age, I always get treated with huge kindness, and a great deal of respect. Nobody mobs me.

In 2010 I played Joe Keller in *All My Sons* by Arthur Miller, directed by Howard Davies with Zoë Wanamaker playing my wife. When I think of that play I still find it moves me now. People flew in from countries across the world. Elaine De Saulles, the stage manager, got hold of a map of the world and we stuck pins in it together, one for each country represented there.

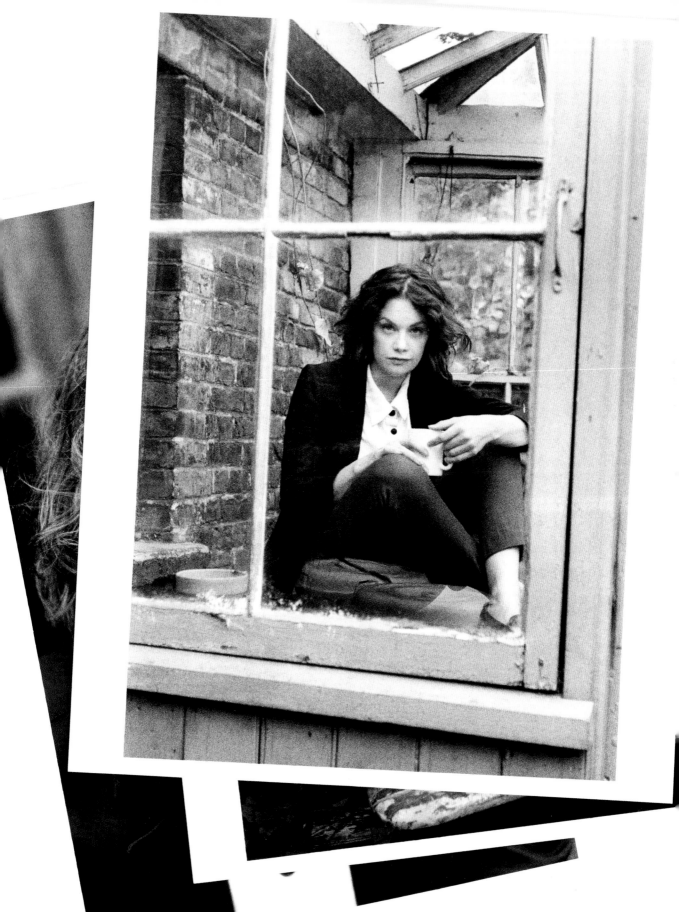

Many asked for my autograph after the show. That's usual; there will typically be twenty, thirty, or even more people outside the stage door every night wanting me to sign something. It's the way the world has become.

After a performance of *The Price*, three actors who had flown in from Moscow turned up outside the stage door to see me, due to fly back the very next day. People come in from Johannesburg, Hong Kong, Tokyo, New York – all over – to see the play. They'd only seen me on television, never on the stage. But the name would've meant nothing to them without *Poirot*.

When I played Lady Bracknell on stage, and took a curtain call, members of the audience would come and give me a bouquet of flowers. And some of those would speak to me in a foreign language; they've held on to those flowers all through the play, probably not understanding a word of English.

I don't court it. Quite the contrary. I made the conscious decision a long time back to keep my personal and public life as separate as possible. I can't keep away from the recognition, of course, but I can deal with it.

Lindsay Duncan

My handling of fame stems from an encounter I had with a famous comedian, when I was a boy. I was very young, on holiday from school, out buying some Christmas presents with pocket money from my parents, and I found myself in Whiteleys, in Kensington – it's no longer there. Anyway, I suddenly spotted this famous entertainer and comedian, and I thought, 'Oh, my God!' I was determined to get an autograph, so I picked up a bit of paper from the floor – a receipt or something – and followed him until he paused at the glove counter. Then I went up to him, and said, 'Excuse me, sir. I love your programme so very, very much; would you give me your autograph?' and he looked at me and went, 'Yes.' I was so nervous, though, that I must have dropped that scrap of paper. I didn't know where it had gone, so just stood there stupidly. And after a moment he said,

'Piss off, sonny,' as rude as that, and I went away and cried, feeling such a fool.

Cut to me as an actor. Nowadays, autograph hunters and the like are made to stand in line, behind a barrier, outside the stage door, but in the early days of *Poirot*, for example, I would come out of the stage door and there'd be thirty people all crowded round, all holding out their autograph books, and I would always search for the person whose hand was shaking the most. I'd call them forward and make sure I signed their book first, and talk to them, make them feel better. That's something I learnt from Laurence Olivier when we were talking together at the bar of the Old Vic. He said, 'I think you're going to make a success of your career and, if you do, remember to make sure that everybody who approaches you for an autograph goes away feeling better for having had the courage to do so.'

(Opposite) Donald Douglas

That's stayed with me all my life. I try to interact with people in a natural way and never make anyone feel uncomfortable. Celebrity culture is not something I find easy – I don't fit into it and I don't want to. I'm not interested in pushing myself forward for fame's sake. It just doesn't fit in with my values, and I find what fame does to people frightening. I think that there's a danger of losing sight of who you are. As far as I'm concerned, I simply do a job. I'm an actor. That's what I do. Who I really am is very different.

I'm very happy to be ordinary. When I meet fans at the stage door, they tend to put me on a pedestal, because of *Poirot*. But I'd like to be remembered as an ordinary person. Not as a remote star, but someone who can talk to anybody. Like my grandfather Jimmy.

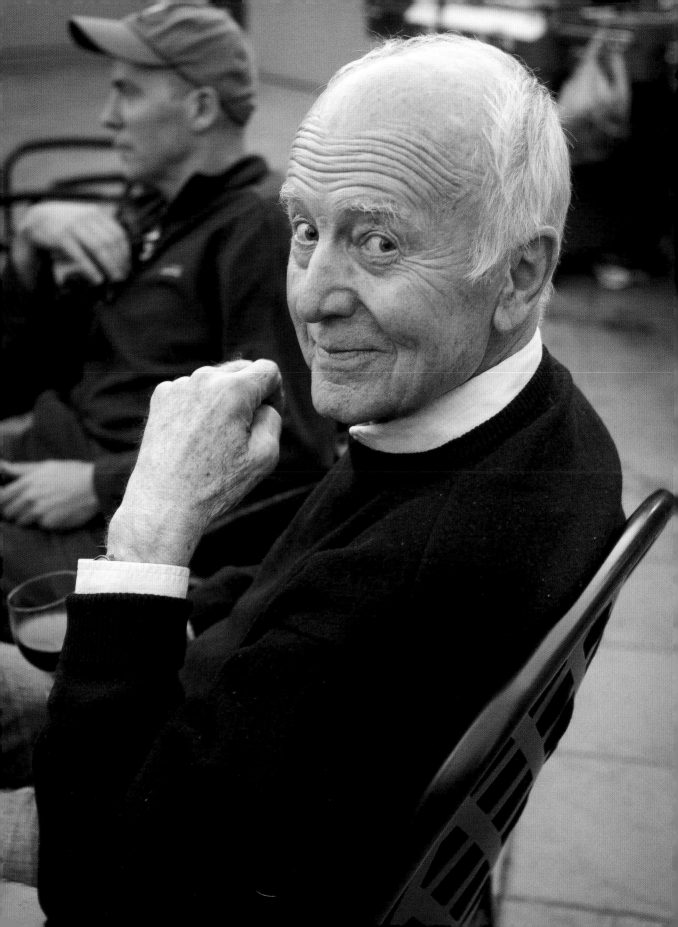

Poirot: reflections

The story of my time as Poirot actually begins in 1985, when I played Inspector Japp in the film *Thirteen at Dinner*.

I was asked to play Inspector Japp, and didn't really want to do it. I have to be honest here: I was not a huge fan of Agatha Christie or her works at that time. But I had just accepted the role of Iago at the RSC, and I was being paid more to do this film than I would be paid at the RSC, and I thought, 'Well, yes, I'll have a go.' The way I played Inspector Japp has to be one of the worst performances of my whole career, but the film gave me the opportunity to work with the wonderful Peter Ustinov, who was starring as Poirot. I became friendly with him, and I remember saying to Peter one day as we chatted in his trailer, 'I'd love to play Poirot one day.' He looked at me, and said, 'You'd be very good, I think.'

I didn't keep in touch with him. I felt rather bad when I played Poirot, given that comparisons – not very favourable towards Peter – were made between my performances and his. I was the new boy on the block, and everybody said, 'They've found a Poirot who matches the character in the books.' I appeared with Peter on Michael Aspel's chat programme, and he was asked about my interpretation. His response was so generous. He said, 'Well, look at David; he can be the Poirot from the books. Look at me: it's impossible. I could never look like the Poirot from the books, so I played the character my way, and made him funny. David's done it as the books were written.'

Cut to 1987. The producer Brian Eastman took me out to an Indian restaurant when we were living in Acton, and he said, 'We'd like to do this series: ten one-hour short stories of *Poirot*. Would you be interested in playing Hercule Poirot?' It was a direct offer and I said, 'Well, I'd love to read it, the stories, the books, because I haven't read much of Agatha Christie.'

I knew Poirot from films, mainly with Peter Ustinov. I'd also seen Albert Finney in *Murder on the Orient Express*, and

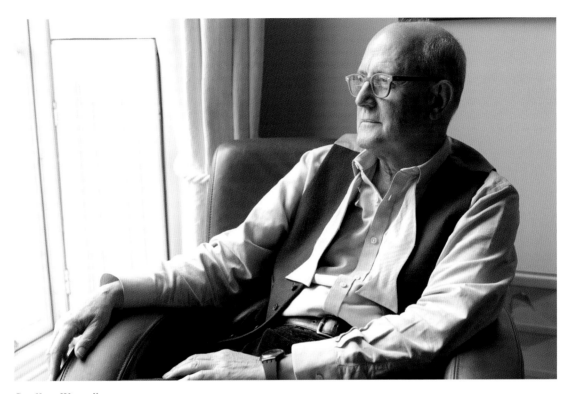

Geoffrey Wansell

'Hercule Poirot?'
my brother said.
'Do you really want
to do that, David?' . . .
'You want my advice?'
he continued.
'Don't touch it
with a bargepole.'

Ian Holm playing Poirot on British television. But I hadn't read the books at all. When the scripts came in, I read them and felt that Poirot could be a wonderful character to play, but I still wasn't sure whether I should do it or not. So I rang up my brother, confident he would give me good advice, and I told him about the role I'd been offered. 'Hercule Poirot?' he said. 'Do you really want to do that, David?' 'Well, I don't know,' I answered. 'You want my advice?' he continued. 'Don't touch it with a bargepole.' The message of this story, of course, is never listen to any elder sibling! The wonderful success of *Poirot* obviously changed my life beyond recognition. Interestingly, my close friend, and co-writer of *Poirot and Me*, Geoffrey Wansell, saw the potential. He told me, 'You know, I think that playing Poirot is going to change your life, and your career.'

So I read the first story that Agatha Christie ever wrote, *The Mysterious Affair at Styles*. That spurred me to read some of

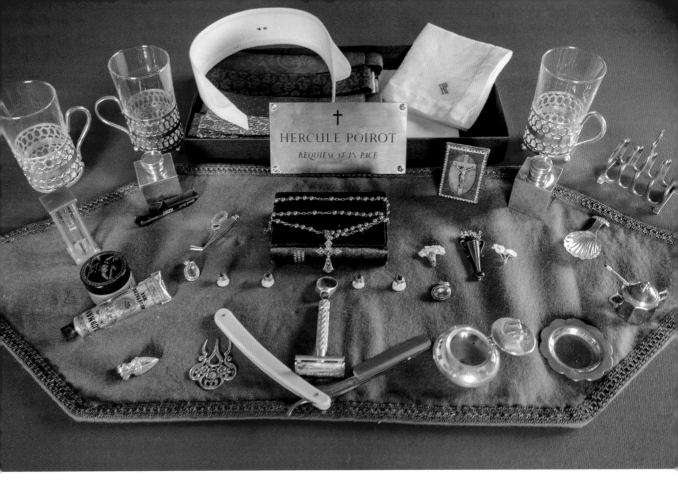

Hercule Poirot: a portrait

After I'd shot my final scenes in 2013, the company kindly gave me some mementos of my time as Poirot, which I will always treasure.

her other Poirot stories as well, and as I did so I couldn't help wondering why the character I found there had never been portrayed accurately on screen. I said to myself, 'I'm going to play Poirot, I'm going to say yes to this, because I'm going to play him as she wrote him.' It was a challenge, a professional challenge. And then I found out that the Agatha Christie Estate wanted me to play Poirot, because they had seen me in *Blott on the Landscape* and felt that, as a character actor, I could do Poirot justice. When Brian Eastman put me forward to them, they said straightaway, 'We would like him to do it.' They really chose me – they had total control. Had they said no, I wouldn't have been cast.

Once chosen, I read every book and made a dossier of all Poirot's characteristics: his clothes; his move from wearing a pocket watch to a wristwatch, and how he couldn't deal with that; the stripe of his trousers; his likes and dislikes; his putting

lavender water on his hands; how he refused to eat two boiled eggs that were not the same size; how his pictures had to be straight in his rooms; how he would always be immaculately turned out, and so forth. Especially how he spoke.

It was all those little details that were so important to me. After I'd shot my final scenes in 2013, the company kindly gave me some mementos of my time as Poirot, which I will always treasure. They include a beautiful green-baize cloth, on which, in the series, I used to lay down all my toiletries; my famous wing collar, with a rounded tip; not a straight tip with a point – no, Poirot had a rounded tip; my bow-ties; my tisane glasses, from which I drank my tisane. Then there's a personalised handkerchief, a coffin plate, two inkpots, a little egg timer, a moustache comb, moustache wax, black colouring that I put on the moustache, and a tiny moustache trimmer somewhere as well as a small silver serviette holder. A prayer book with a rosary on it, only of course the prayer book is in French, because Poirot was Belgian and spoke French. There's a little leather crucifix; that was always by my bed in the series. And a tiny toast rack; not an ordinary toast rack – it wouldn't be, would it, for Poirot? Everything, for Poirot, had to be miniature, and very precise, very detailed, very neat, and that's why it's a tiny toast rack. A shell ashtray, a round ashtray, a portable ashtray with a lid; and there's a small mustard pot with a minute spoon, cufflinks, dress-shirt studs, the famous silver lapel flower vase with dried flowers, my razors, and a three-pronged fork for eating oysters.

The series was called *Agatha Christie's Poirot*, and I was her Poirot, but I didn't know, at the end of the first year of filming, whether we'd ever make any more. We'd filmed for six months, and I remember making a speech at the end thanking everybody at the wrap party, saying, 'I don't know if we'll make any more, but thanks to everybody who's supported me in this role.' Hugh Massingberd, a journalist with the *Daily Telegraph* – sadly no longer with us – asked me in an interview

before the first series went out how I felt about playing Poirot, the new kid on the block. I said, 'Well I'm frightened of being a bit boring, really, because all I've done is try to be the Poirot from the books. I won't be as entertaining as Peter Ustinov or Albert Finney, I know that. I don't know how I'll be received.' The rest is history.

I never once regretted my decision to play Poirot, or felt I wanted to stop playing him. There was a point, though, when ITV decided they wouldn't make any more. It may surprise you to know that I was never given any long-term contract; I was contracted year by year throughout the twenty-five years of the series, never guaranteed a next season. That sounds extraordinary now, doesn't it? So, I never knew whether I would ever play him again.

Anyway, in 1997, my agent got a telephone call saying that ITV were no longer going to make *Poirot*, and I received a letter from the company, thanking me for my work. There was quite a gap after that, but apparently public demand for it to return was so strong that ITV decided to reintroduce it four years later, with a new producer and new look. We would do Christie's main stories, as they were written, staying as faithful as possible to the books.

To my regret, that included only featuring Hastings, Japp and Miss Lemon in the stories in which they originally appeared. I missed them in the later productions, and I think the audience did too. I'd like to say a special thank you to them now – Hugh Fraser, Philip Jackson and Pauline Moran. When we were together in those early series, we were almost like a family, and I felt their absence. I think that's when Poirot became more serious, in the big stories. But, of course, that's what Agatha Christie intended. In the short stories, she could have much more fun with him, and make him more eccentric. That was something I noticed in the writing, when I was preparing: he was far more eccentric and humorous in the short stories

(Opposite) Philip Jackson
as Inspector Japp and
(right) Hugh Fraser as
Captain Hastings

than he ever was in the long ones. Anyway, I will always
remember Pauline, Philip and Hugh with immense gratitude.
I don't know how they felt supporting a lead actor for so long
– whether they found it difficult in any way – but they were
always encouraging and immensely generous.

I'd also like to pay tribute here to my driver and now dear
friend Sean O'Connor, who has been with me throughout the
whole of the Poirot journey – in fact, even earlier than that.
I first met Sean in the early 1980s when he drove me in his
taxi from my then home in Acton to where I was rehearsing
in Hampstead. At this point I had no money and certainly
couldn't afford taxis. But, on this occasion, I was terribly ill

with the flu. So ill that I couldn't get the Tube but I had to get to rehearsal because I was the lead role – they couldn't rehearse without me. Sheila had scraped together the money for the taxi journey there, and that was the first time I met Sean, but I was going to have to get the Tube back. But there, when I came out of rehearsal at 5.30 that afternoon, was Sean waiting for me. He took me home and never charged me a penny. From that day on, whenever I could afford a taxi, I would call the minicab company and ask for Sean O' Connor.

Later, when I was offered the role of Poirot, the contract included a driver of my choice. I immediately thought of Sean. At that point I was only contracted to play Poirot for a year. Little did Sean and I know that, twenty-five years later, he'd still be with me for the final episode. He was indispensable to me during that time and an enormously important part of my time as Poirot. To this day, we're great friends, and Sean is now one of the great film and television chauffeurs.

I think it's that people feel safe when they watch him. Poirot offers, perhaps, the greatest moral compass.

What are my thoughts on Poirot now, you may wonder, after it's been some years since I last played him? Presumably because I did for so many years, I can remember him more vividly than any other character I've played, and yet, when I look at photographs of myself as Poirot, it's another life. It's in the past.

I'll never forget how I felt on the last day of shooting, knowing it was the end of *Poirot* for me. In certain stills of my last episode – not the one when I died, but the last episode I filmed – you can see the sadness in Poirot's eyes: well, my eyes really. I'll never forget the whole experience as long as I live and, when I look back on it, I can't believe it actually happened. I ask myself, 'How is that possible? What was it about that little man that prompted the public to watch stories about him for a quarter of a century?' Even now – and, remember, I finished filming six years ago – people as young as seventeen or eighteen, born not that many years before I finished in the role, will stand outside

Rosalie Crutchley

my stage door, and they tell me they have begun to watch the series from the beginning. My former trainer, who now lives in Australia, sent me a photograph recently of his four-year-old, sitting in front of a television watching me as Poirot.

I'm beginning to realise that, just possibly, *Poirot*, or at least my Poirot, may never date. Parents pass on complete sets of the series to their children, who perhaps in turn will pass them on to their children's children. I still receive the most amazing letters; I got one today, in fact; a woman telling me, as so many people seem to do, how watching *Poirot* has made her feel better when she's not been well. I don't know why it does that, but it seems to happen.

Poirot has gone for me; not banished from my memory, but I'm moving on in life, yet I still get these fan letters from people who are watching the series now, and saying the same things that people did when writing to me nearly thirty years ago.

I think it's that people feel safe when they watch him. Poirot offers, perhaps, the greatest moral compass. It's difficult for me to know for sure because I don't share their experience of sitting down and watching *Poirot* on television. But clearly the series touched many people very powerfully.

What is it about Poirot they like, I wonder? He's quite opinionated, arrogant. He has an enormous ego. He doesn't like the English upper classes, and frequently has a go at them. He's nice to servants and the lower classes; maybe that appeals. Or is it that he's on the side of right; that he wants to rid the world of evil, of people who commit murder and hurt other people. I think viewers also see him as lonely. You know, he needs a bit of love in his life. Maybe they feel that; perhaps that's what endears him to them.

There's nothing about Poirot that's salacious. I remember how a reporter once – a woman – was very sceptical about *Poirot*. 'Oh well,' she told me, 'you know, nowadays, women don't

After I finished filming the last episode, there was a sort of grieving process. I'm still grieving now. Because Poirot was my best friend; my alter ego.

react to that sort of man any more.' So, as Poirot, I walked her around the set, attentive to her in the way he would have been. And her cynicism ceased immediately, because he, not me, had made her feel like a real lady, even though she was quite a hardened feminist. Isn't that strange?

I don't know why. Perhaps it was simply old-fashioned good manners, which are really not PC any more. You're not supposed to open doors; you might get told off for offering to carry a woman's heavy suitcase. Young women today don't want it, and maybe that's a good thing. But that wouldn't appeal to Poirot, and he couldn't behave otherwise; it's in his very bones: his politeness, his manners, his courtesy, his respect. One of the things I love about the character is that he never undermines anybody's dignity, even that of criminals. He'll be angry about them, and believe they deserve to be punished, but he never makes them feel little.

'True civilization,' wrote the American lawyer, politician and orator Robert Ingersoll, 'is where every man gives to every other every right that he claims for himself.' That's a sentiment Poirot would agree with as do I.

Because I played Poirot for such a long time, I think there's inevitably a degree of overlap between his values and mine. To an extent, that was always going to happen. Of course, I was bound by my scripts but, more and more, over time, I became aware of his loneliness. That's not something I share with him – I'm the opposite of lonely – but my own sensibilities would certainly become more attuned to the character.

After I finished filming the last episode, there was a sort of grieving process. I'm still grieving now. Because Poirot was my best friend; my alter ego, in many ways. I knew him better than anybody I know. I knew what he'd like to look at. I knew what he'd choose for breakfast. I knew everything about him. I grieve for him in a different way than I grieve for other characters I've finished playing, because he was so much a

part of my life, and affected it in so many deep and personal ways. But there was nowhere else I could take the character.

Looking back, it was a gloriously happy time. Not without its fraught moments, of course. I had to fight sometimes for the character, and there were always some directors who wanted to do things differently, or got fed up with the way Poirot was so prissy, such as the time when I wanted to wipe a park bench with my handkerchief and then sit down on the handkerchief, which was a description drawn directly from Agatha Christie's book. 'I don't want you to do that,' said the director. 'Well, that's what Poirot does,' I responded. 'I'm sorry, but that's what he does,' and there was a huge argument about it. So, I became the defender of *Agatha Christie's Poirot*; what she said he would do, I would fight for. In the end I got my way about the handkerchief but it was cut in the final edit!

Even today, six years after I finished as Poirot, people still identify me with him. I've just been in the south of France, and a waitress came up to me and said, '*Vous êtes l'acteur, de cinéma et de télévision?*' I said, 'Yes,' and she told me that she'd seen me in many films, but liked me particularly as Hercule Poirot. They see me as Poirot, yet they don't see him. I don't have his forty-six-inch waist, or speak with a funny accent, or have his moustache. I'm not this odd, strange-looking little man. And yet they recognise me as Poirot. They always say, 'It's your eyes.' They always come back to my eyes. Or, occasionally, my voice. Even without the accent, they recognise my voice. To an extent, there has always been a blurring of fiction and reality when it comes to my Poirot. I find it fascinating, and, I suppose, as an actor, there's no greater validation.

There's one wonderful story I always like to tell people. I was in Hastings, and one day there was a bit of a break in filming, so I'd gone for a walk. I was in full costume but I just wanted to get off the set for a bit. So I find myself standing in

Poirot 03
'In De Nile'

an ordinary street, in Hastings – all was quiet – when I saw a little old lady pulling her shopping trolley up the hill towards me. I didn't move. When she got close, she stopped and said, 'Ooohh. Ohhhh. Hello, Mr Poirot.' Now, I didn't quite know how to answer because I'm fully dressed as Poirot, complete with moustache, so I didn't feel I could say 'Hello' as me. So I said 'Hello, madame' as Poirot. 'Oooohh, ooohh,' she went. 'I watch you all the time, Mr Poirot. What you doing here, though? There ain't been a murder, has there?' I replied, 'No, madame. There has been no murder, not here in Hastings.' 'What are you doing here then?' she asked. 'I am on holiday,' I replied, 'I am *en vacances*.' 'Oh, that's nice. Lovely. You're looking very well and it's very nice you're here,' she said. As she started to move away, she said, 'By the way, Mr Poirot.' '*Oui, madame?*' I replied. 'Thank you for choosing Hastings for your holiday.'

The reason for relating this story is that I was so astonished that someone could actually believe that Poirot was a real, living person. I'll always be very proud to be associated with the character and I don't mind the attention it brings me at all, for me, but I am very aware that it is hard for the people closest to me especially my children. But Poirot has become something beyond my control; it's something which has successfully travelled the world and is still being discovered by new audiences today. It's simply a part of the spider's web of my life and I must embrace it.

Professionally, too, there's always going to be that association. During and after. A lot of people who considered working with me in the 1990s or the 2000s, Americans or otherwise, would have known only *Poirot*. That's just the nature of the beast. I accepted that; I knew it would happen. At its highest point, *Poirot* was being watched by 750 million people worldwide, so that's obviously what people are going to mainly notice you for. But I made sure I played a theatre play, in England, pretty

much every eighteen months, during the twenty-five years of *Poirot*. I kept coming back to the theatre.

In fact, since finishing Poirot, I've actually been offered some of the most interesting and most enjoyable roles of my career, such as *Press* and *Decline and Fall*, none of them anything like him at all. And that was not a conscious decision, or because of anything I've deliberately sought out – these roles are simply what I've been offered and have been delighted to accept.

I hope I can be as generous to other Poirots in time, as Peter Ustinov was to me. So far, though, I've chosen not to see other portrayals, because I'm the only actor to have played the role for twenty-five years, doing every single story; I really believe that it's not fair or right for me to judge. I haven't watched Kenneth Branagh's *Murder on the Orient Express*, nor John Malkovich's *ABC Murders* (incidentally, my favourite of all the Poirot stories). I will, one day, when there are many other Poirots. But for now, I'm truthfully able to say, 'No comment, I haven't seen them.' I wish all of them luck, though, because, don't forget, I played Inspector Japp wanting to play Poirot. I've got nothing but feelings of goodwill towards those who play him.

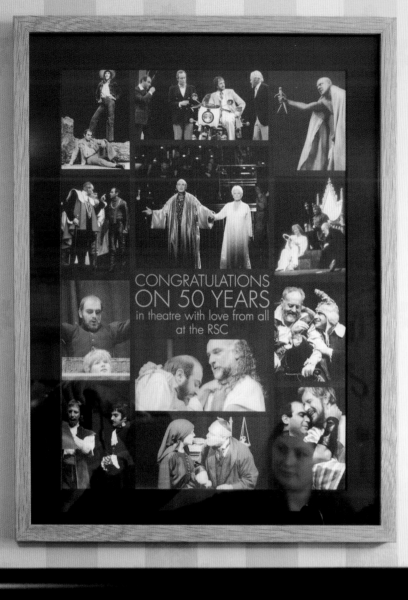

CONGRATULATIONS
ON 50 YEARS
in theatre with love from all
at the RSC

Looking back: part ii

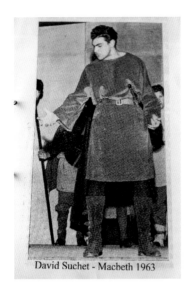

David Suchet - Macbeth 1963

People sometimes ask me if my career has turned out as I thought it would. To answer that, I have to return to my spider, my web. At my age now, I can look back and see that where I began as an actor was about a quarter of the way through my web. I can see how one thing led to another, one opportunity to another opportunity – how the things I said yes to, or no to, are all linked.

A taxi driver the other day said to me, 'My goodness, so many young actors would love to have had your career. How did you do it?' I told him I didn't feel it was down to me; that I consider myself to be lucky; to which he replied, 'Oh, I don't agree with that, Mr Suchet. You make your own luck.' Well, do you know what? I've known many actors – hugely talented people who I genuinely looked up to – that never got the opportunities I did. They were never asked to take on a role that would change their life; never given the opportunity fully to express themselves. I often think, 'Ah, if only they'd been given the chance' – that's where luck comes in. And that's where I believe I was so lucky. Yes, OK, maybe people will say, 'But you used your talent, which led to other things,' but if I hadn't been given opportunities – especially at the Gateway Theatre, Chester, in those early days when nobody knew me – I wouldn't be where I am today. That's luck.

In the early days of my career, I didn't think I stood a hope in hell. Look at me: I'm short, stocky, slightly overweight, with a deep voice, passionate, dark haired, olive skinned; hardly your typical Englishman. What chance did *I* have, going into the world of British theatre? It's fascinating to look back at my web and see how one thing led to another. For instance, performing in *Brief Lives* in Chester, which led to me going to the Belgrade Theatre, Coventry, where I met Sheila, which led to me being interviewed in London, which led to my first film work and, most importantly, in 1973, to my joining the Royal Shakespeare Company, which was to prove the springboard for the rest of my career. I'll be thankful to that company until

my dying day, because without the opportunity it gave me, things might have been so different.

Sadly, an opportunity for one can mean tragedy for another, and so it was here. It was when Bernard Lloyd, a wonderful talent and leading light at the company, injured himself in my first year that I took over all his roles. Suddenly, just two years after joining, I was a leading actor in the Royal Shakespeare Company and going on tour to Broadway with them. That, of course, got me seen even more, which led to *Oppenheimer*, playing Edward Teller, then to *Freud*, then to *Blott on the Landscape*, and eventually on to the career opportunity that changed my whole life: *Poirot*.

I'm so grateful for the way things have turned out, and count myself very fortunate. I vividly remember one of my teachers at LAMDA – a great character actor called Ronald Lacey, who became a dear friend of mine – saying to me, 'If you can last ten years in the profession, you'll maybe have a chance to spend your life as a professional actor; whether you will ever do well or not is another thing.' But this is my fiftieth year as an actor. I can't explain it.

I've so many marvellous memories looking back over my career. It's almost impossible to pick out highlights, but here are a few of them.

One was playing Edward Teller in *Oppenheimer*, a BBC television mini-series in 1980, and the chance to work with the great American actor Sam Waterston – a most wonderful character actor, and a man with humility in spades. I was playing a Hungarian-American scientist who wanted to create the atom bomb and get rid of the whole of Germany, all those who hated Jews. Edward Teller was a Jew, you see, and a very angry man. It was a fantastic role for me to play. That was a great personal highlight for me. An unforgettable thing happened to me at the very end: the director of *Oppenheimer*, Barry Davis, who'd given me the role of

Teller after seeing my performance as Shylock in the RSC, came up to me and said, 'I want you to do that scene again, and I want you to do it as though you're going for the Oscar. We've got what you've done,' he said, 'and it's terrific, thank you. But I really want you to go for the Oscar on this one.' Well, I went back on, ready to give my all, and next thing I knew, Sam Waterston threw a custard pie in my face! It's on camera, to this very day.

Many other moments, of course, not least becoming a professional actor at the Gateway Theatre, Chester. And hugely special to me is the memory of my appearing with my wife-to-be at the Belgrade Theatre, Coventry, thinking, 'My God, I'll never get this wonderful woman.' She was something else. I was playing Renfield in *Dracula* and she was the ingénue whose neck Dracula would bite to make her his slave. I was in rehearsal, thinking, 'Here I am playing this mad, stupid fellow; she's never going to look at me.' Well, thank you, she did, and so that's a huge highlight.

Then there were the early big roles at the RSC. I was briefly cast as Tybalt and Oliver, but after just a few weeks, I suddenly found myself playing Mercutio and Orlando. I became a fairly major leading actor very quickly. Even the small roles I was given in rep, when I first began, were often meaty roles in their way. Because I'm rather stocky with a deep voice, I typically got to play middle-aged men, and those tended to be the best roles, really.

Oppenheimer opened the door to lots of things on television. Being cast as Freud was a huge moment for me. It was one of the very few times in my life I've ever written to a director saying, 'Will you please see me for this role, I want to play it?' It bowled me over when she, the director, Moira Armstrong, said, 'Yes.' I remember driving home, thinking the heavens had smiled down on me.

This was in 1982. And then came *Blott on the Landscape*, being offered that and working with so many magnificent directors and actors. I've had so many highs in my life and career.

There have been lows too, of course. One was thinking that I'd never work again as an actor when I went to Moss Bros and was lined up for that interview with the manager. 'That's it,' I thought. 'This is the end of my dreams. I'll become a junior manager in Moss Bros in Manchester.' But then, that telephone call. My goodness, the timing of that moment. I often return to it in my head and remember that moment when Mr Warren said, 'Oh David, you've had a phone call.' I'll never forget that.

Confidence-wise, I've had a few really big knocks. In my profession, you have to expect to be knocked as well as feted. And one of the biggest knocks I had – though the play turned out, in the end, to be a huge success – was when I was in London playing Salieri in *Amadeus* in 1982, with Michael Sheen as Mozart. It was directed by Peter Hall, a dear man who was a great influence on me through the way he worked.

I was nominated for an Olivier Award for my role in that. Then I went to Los Angeles with the play, and received accolades such as I'd never have believed. When I walked on for the second act, at the Ahmanson Theatre in Los Angeles, the audience applauded, which was extraordinary. It created such a furore that people flocked from all Los Angeles to the Ahmanson to see *Amadeus*, and there were radio interviews, TV and so forth. We flew next to New York and all the papers gave us rave reviews, except one, *The New York Times*, probably the most influential newspaper in America. The reviewer, who shall remain nameless, compared me to Ian McKellen, and wished that I had played my role more like him. He claimed my interpretation wasn't interesting. That really knocked the confidence completely out of me. I'm one of those actors who

actually does read reviews. I don't judge my performance by them, but I do want to know what's been said, good and bad. But it's not always easy to take the bad, and I remember having to return for the second performance, having read those reviews, and dealing with it. Yes, a big knock. Or at least it was until I was nominated for a Tony!

I remember thinking how extraordinary it was: that you can be enjoying an amazing career one minute, and be knocked down so hard the next that you struggle with your confidence, only then to be nominated for a Tony Award for Best Actor. Eventually, you get those ups and downs in perspective and you realise they're two extremes of the same life that you're experiencing. You learn not to place too much importance on approval or disapproval. You have to rise above that; that's part of maturing as a human being. If you depend, in life, on being liked, constantly seeking validation, you're heading for disaster and disappointment. There comes a stage when you learn to be who you are; not who you want to be or think you are, but who you really are. And people will either accept or reject you. That's part of life.

There are a few other characters I'd still love to have a go at, given the opportunity. I'm a little old for it now, but I would love to play Napoleon in his final exile. I have actually played Napoleon already in the 2000 comedic film *Sabotage!*, opposite Stephen Fry as Wellington. That was great fun, but I'd really like to sink my teeth into Napoleon in his later years. Napoleon wasn't just a romantic, I believe he suffered from a huge inferiority complex. I think he had what's called narcissistic personality disorder, which is usually the result of insecurity.

I remember reading about a meeting he had with his generals in which he launched a vicious tirade against them, but then afterwards cried on Josephine's shoulder. Weak; bullies are weak. When you realise that someone bullying you is acting from a sense of insecurity and weakness, you're far more able to deal with it.

Napoleon fascinates me, all the complex facets of his character. He was the Hitler of his generation. He killed prisoners, for example, because he didn't have enough food to feed his troops. But the way we treated him was questionable. We promised him asylum, only to ship him off, on the *Bellerophon*, without him

knowing that he was being sent into exile. I'm not exonerating him. But he's somebody I want to get under the skin of. He died at a much younger age than I'm at now so, in a sense, I'm too old to play him, but I'd really like to do it still. Not in the theatre, but on screen, so that I could draw the camera into his thinking more, which you can't express so well in the theatre.

What I'd really like to do in the future is try my hand at directing. More than anything, that's the way I'd like to go now. Also, directing is a lot about teaching and I've always really enjoyed teaching. The question is: what do I want to direct? As an actor, I am for hire, so I wait to be offered roles. I rarely know what I want to play before I'm offered it. But with directing, the impetus would have to come from me. So, watch this space! But I'd love to have a go.

Like most people, away from acting, I do have some personal regrets: times when I let people down, behaved badly, caused hurt. We've all done it in our lives and, looking back as an older man, I wish I hadn't, and I'm truly sorry for any upset I may have caused. I'm sorry, too, that I didn't give my children more summer holidays, but work had to come first, and that's life, isn't it? We're all fallible. Apart from that, no major regrets. I still, in spirit, get on my knees every night and say thank you for everything. I've been so very fortunate.

Someone asked me recently how I've managed to sustain a fifty-year career amidst the fundamental change the acting world has undergone, and indeed the wider world, in that time. And I said, 'Yes, I've somehow managed to do that but I've also managed to maintain a marriage, which is far more important.'

My marriage is now forty-three years old, and counting. I'd known Sheila four years before we tied the knot, so we got together forty-seven years ago. Without being stupidly romantic, I owe my career to her; she gave up a career for

herself, a very successful career, to look after the children, while I was forging ahead. She made that decision selflessly, and has supported me in every decision I've made. I don't know whether she agreed with me on all of them, but she's always said yes to what I wanted to do. She's guided me, advised me, been my confidante. I can say anything to her, and know there will be no finger pointing. I have been blessed beyond measure through the wife I've been given. She said yes when I asked her to marry me. God bless her.

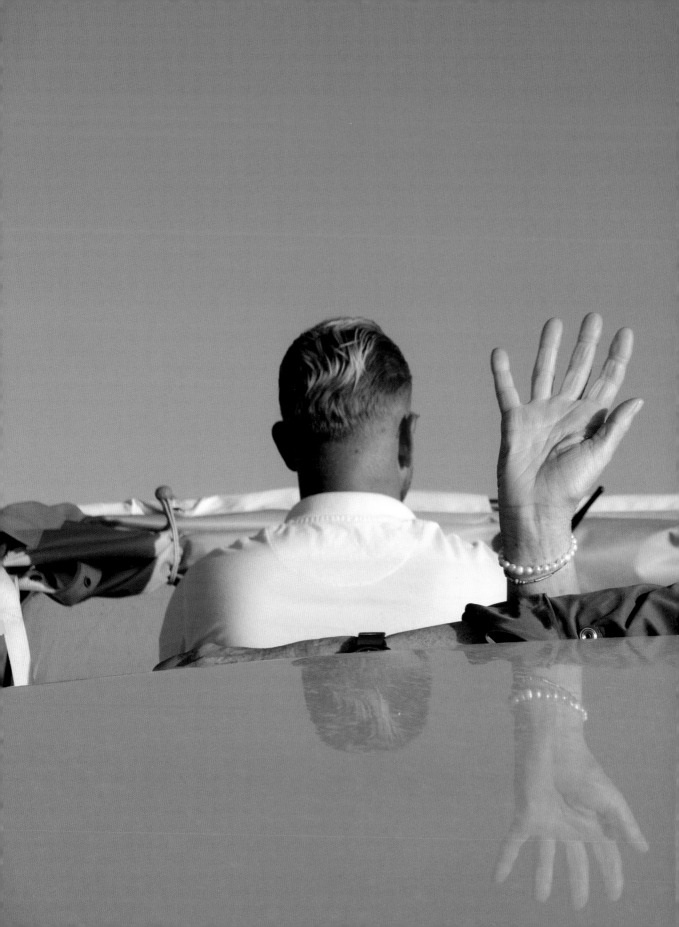

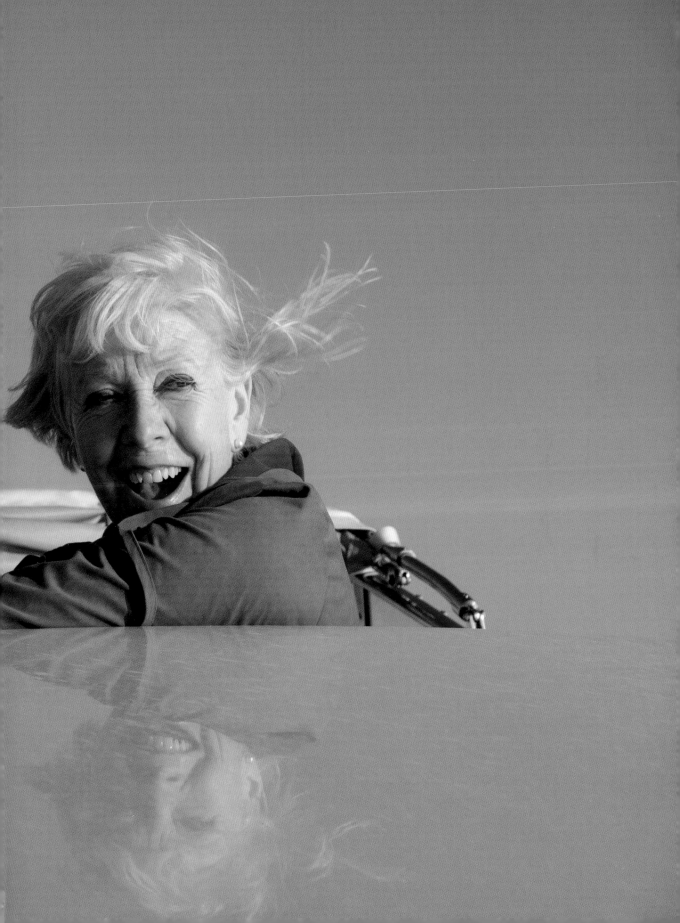

Final thoughts

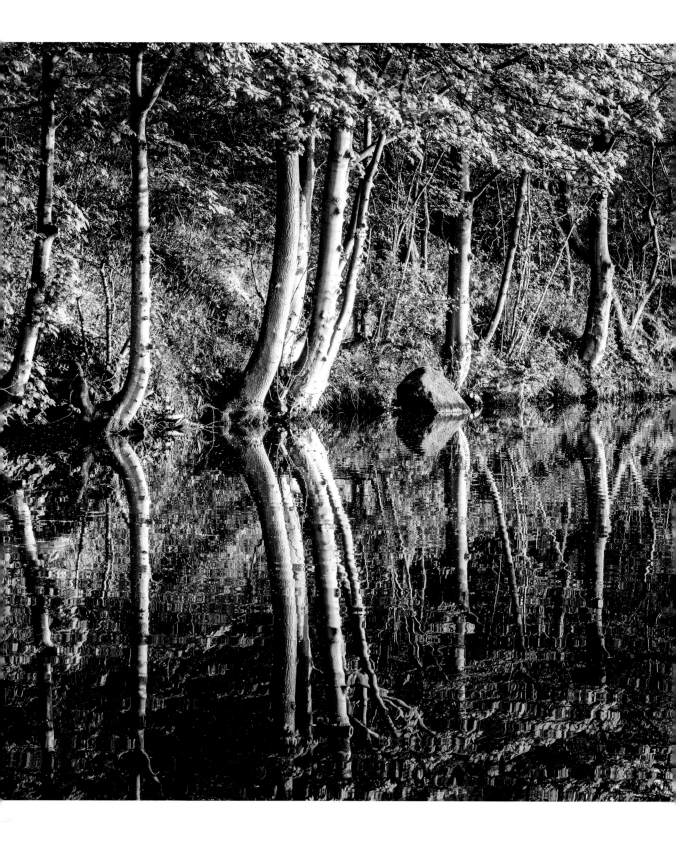

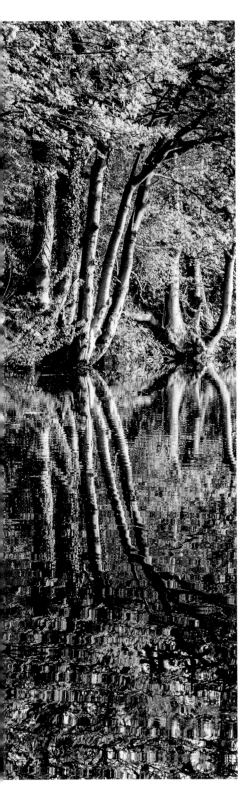

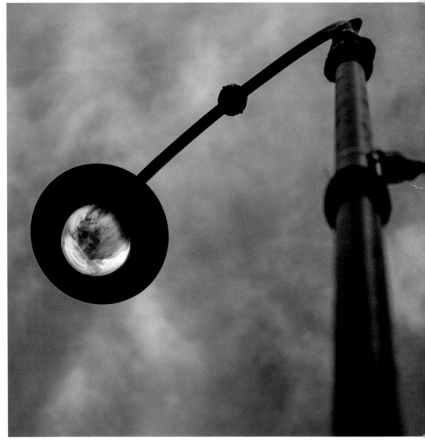

So, here we are at the end of the book. I hope that, by looking at the photographs and reading the words, you've seen, through my eyes, how I approach my life and work.

How would I sum myself up? Family is the most important thing in the world to me. I love people. Photography is my dearest hobby. Trees, light, canals, music, literature are all things that move me. My faith is an integral part of my life. I enjoy my work and I take great pleasure in fully immersing myself in a role. But I don't enjoy the celebrity culture that encompasses my job as an actor. When people look back at my career, I want to be remembered as a character actor. I'm not really interested in me as a person. I'm interested in the characters I play, the works I perform in. Of course, serving my writer. Perhaps I do take myself too seriously sometimes but I take my work seriously. I'm not afraid to admit that.

2019 marks my fiftieth year as an actor and, when looking back over those fifty years, I feel very lucky. Lucky to have enjoyed so many opportunities. As I said at the beginning of this book, I've always been reluctant to write my autobiography and that's not what I originally wanted this to be. But, maybe this is my autobiography after all. It's the only one you're going to get!

Thank you for reading it.

Harry, *The Collection*

Acknowledgements

I would like to thank, first and foremost, Robin Sinha. Robin is the Leica UK Akademie tutor and a freelance photographer. He is also my personal photographic tutor. Without his help and professional expertise in sorting out and organising these photographs (there were over eight thousand from which to choose), this book would not have been possible.

My grateful thanks to all at Leica UK.

I would also like to thank and acknowledge Ivor Cooper (and all the staff at Red Dot Cameras) who supplies me with my Leica equipment and gives me invaluable advice.

Thanks also to all those who appear in this book.

Very special thanks to Claire Chesser, my editor, for her support, encouragement, enthusiasm and patience.

Finally, my list of people to thank would be incomplete without my dearest wife Sheila to whom this book is dedicated and, of course, my late grandfather, the press photographer James Jarché. Without him in my life, first of all, I would not have been born (!) but would never have been introduced into the wonderful world of photography.

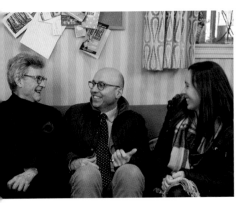

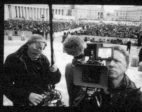
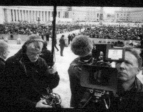
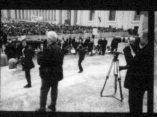